T0251979

After Effects Expressions

After Effects Expressions

By
Marcus Geduld

Routledge
Taylor & Francis Group

LONDON AND NEW YORK

First published 2009
This edition published 2013 by Focal Press

Published 2017 by Routledge
2 Park Square, Milton Park, Abingdon, Oxon OX14 4RN
711 Third Avenue, New York, NY 10017, USA

First issued in hardback 2017

Routledge is an imprint of the Taylor & Francis Group, an informa business

Library of Congress Cataloging-in-Publication Data
Geduld, Marcus.
 After Effects Expressions/by Marcus Geduld.
 p. cm.
 Includes index.
 ISBN 978-0-240-80936-6 (pbk. : alk. paper) 1. Cinematography—Special effects—
Data processing. 2. Adobe After Effects. 3. Computer animation. I. Title.
 TR858.G35 2008
 778.5′345—dc22

 2008034230

British Library Cataloguing-in-Publication Data
A catalogue record for this book is available from the British Library

ISBN 13: 978-1-138-40145-7 (hbk)
ISBN 13: 978-0-240-80936-6 (pbk)

To Lisa

This book is an expression of my everlasting love.

Contents

PART 1 • Using Expressions

PART 2 • Foundations for Advanced Expressions

vii

Acknowledgments

I am deeply indebted to Dan Ebberts, the world-renowned Expressions guru. Dan, thanks for the e-mails, the suggestions, and the support.

I'd also like to thank AE experts Chris Meyers, Trish Meyers, Angie Taylor and the crew at creativecow.net for ideas and inspiration. When I started this book, I was working for Future Media Concepts. I now work for nabbr.com. I thank both companies for their support and for their stimulating work environments. Special thanks to Paul Temme, Dennis McGonagle, and Lianne Hong at Focal Press and my colleague Rich Harrington at Rhed Pixel. Most of all, thank you, Lisa, for putting up with all my geeky passions.

Introduction

WHAT ARE EXPRESSIONS?

Expressions are tools. Just as you use the Rotation tool and the Pen tool, you can use Expressions to control animation and composition in After Effects (AE).

Whereas you use most tools by clicking on their icons (e.g., the pointer or the pen) and clicking or dragging with the mouse, you use Expressions by typing commands on the keyboard. That's what Expressions are: typed commands. You type these commands to tell AE what to do, and—assuming AE understands your commands—it does what you want it to do.

But you don't always have to type to add an Expression. There are some clever click-and-drag tools that will save you time. But these tools just do the typing for you. Expressions are still typed commands.

Expressions are also like recipes—directions for baking some yummy dessert: First, mix eggs and flour; then add sugar; then bake at 375 degrees for 20 minutes. Imagine you wrote such a recipe, and a helpful robot (wearing a chef's hat and apron) read it, followed the directions, and baked you a cake. With Expressions, you type out the instructions, and the robot—After Effects—bakes you a cool effect.

Most Expressions command AE to bake numbers. For instance, the Expression 1 + 2 commands AE to bake the number 3. It's as if you've typed, "take a yummy one and a scrumptious two, and pop them in the addition oven." The AE robot does so, and a few nanoseconds later, it hands you a steaming, delicious 3 on a plate. (Don't worry; most of the Expressions you'll use, at least when you're starting out, won't look like math problems.)

I'M AN ARTIST! WHY SHOULD I CARE ABOUT NUMBERS?

Because numbers rule After Effects. In AE, numbers drive nearly every aspect of your work. AE tends to hide this fact from you, though not very well, because

the numbers are always right there for you to see. But you can work without paying much attention to them.

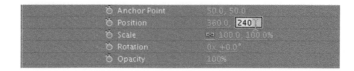

The numbers I'm talking about are the ones you see in the Timeline, to-the-right-of the Transform properties. You may think of Rotation as something you control by spinning a layer with the Rotate tool, but AE thinks of it as, say, the number 45, as in 45 degrees clockwise; you may think of Position as dragging a layer down and to the right, but AE thinks of it as, perhaps, 150 and 223, x and y coordinates.

In fact, all the user-friendly tools that manipulate layers—the Selection tool, the Rotate tool, and so on—are just widgets that let you build and change numbers. When you drag a layer to the left, you may think of yourself as, well, dragging it to the left. But what you're really doing is changing the layer's x-coordinate number. AE then uses this number to remember how far left you want the layer to be. It doesn't remember that you dragged the layer; it remembers the number. And next time you preview the Comp, it uses this number to determine the placement of the layer.

Expressions are another way to control such numbers. Expressions are typed commands that control numbers.[1] These numbers don't just control the Transform properties; they also control Effect properties, like the blurriness of a Gaussian Blur (which is a number too).

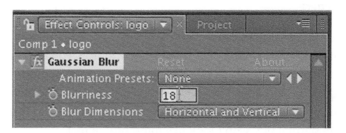

[1]There are a few exceptions. For instance, there are Expressions that are commands for building the type of text you would normally build with the Type tool. Because text is not numbers, it's more accurate to say that Expressions are typed commands that control layer-property values. Most property values are numbers, but a few aren't. By the way, you might think that some property values are colors, such as the Color property of the Fill effect, but AE thinks of colors as numbers (red, green, blue, and alpha values).

Because nearly everything you do to layers involves manipulating some property's numbers (an Effect property's numbers or a Transform property's numbers) and because Expressions let you control a properties' numbers, Expressions are very powerful.

WHAT CAN I DO WITH EXPRESSIONS?

At their most basic (but still very powerful) level, Expressions can act as super-parenting tools. If you've ever used the parenting feature in AE, you know that it allows you to make one layer the parent of another. The child layer will move when its parent moves, scale when its parent scales, and rotate when its parent rotates. But that's all. If you fade a parent by adjusting its opacity, the child does not fade; if you blur the parent (saw with the Gaussian Blur effect), the child does not blur.

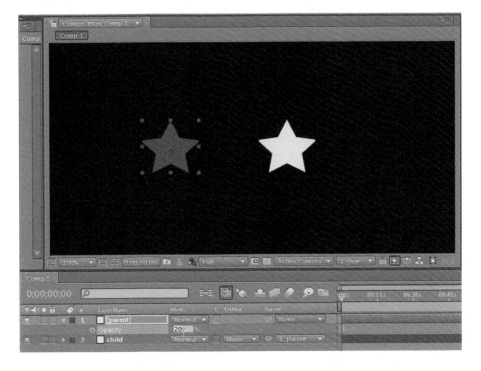

xiii

Expressions crash through these fences. They allow you to hook any two properties together. That's properties, not layers. So layer A's scale property can control layer B's scale property so that when A gets bigger, B gets bigger.

More intriguing, you can create an "opposite" Expression so that when A gets bigger, B gets smaller. Or, even more intriguing, you can hook A's position to

B's scale, so that when A moves to the left, B gets smaller, and when A moves to the right, B gets bigger. You can throw a glow effect onto a Text layer and use an Expression to make the text resize as the glow becomes more intense.

Expressions give you a mechanism for allowing any property to control any other property (or properties) in all sorts of complex, useful, and creative ways. With Expressions, it's as if you live in a wacky house where you can connect your toaster to your hair dryer and your washing machine to your garage door. Start the washing machine, and the garage door opens.

But that's not all. Expressions provide you with commands, like wiggle and loopOut, which cause layers to behave in complex ways. You don't need to spend hours animating them with keyframes; you just issue a command and the layer does your bidding. (Wiggle lets you randomize a property, so, for instance, the layer might randomly change colors as it moves across the screen; loopOut allows you to selectively loop one aspect of a layer, so you could make the layer bounce up and down repeatedly while, at the same time, it moves once from left to right and fades out.)

Expressions let you link several (dozens, even hundreds) of layers together so that they act as a team; with Expressions, you can create complex movements, such as pendulum swings and elliptical orbits, which are really hard to animate with keyframes. Expressions also let you use sound to control an animation (e.g., as the volume gets louder, the layer gets bigger).

Like all the complex, creative tools in AE (masks, transfer modes, 3D, etc.), Expressions are bottomless. They are limited only by your creativity. So it's impossible to list everything you can do with Expressions. All I can do is teach you the Expressions language, show you a bunch of examples, and then let you take it from there. The more you work with Expressions, the more uses you'll find for them.

WHAT IS JAVASCRIPT?

Expressions are commands, and commands must be written in a language: wiggle (English), meneo! (Spanish), iggleway (Piglatin), wiggle ().

That last language is JavaScript. JavaScript is the language of Expressions. It's a lot like English (notice that it includes the English word "wiggle"), but it's not quite English. It's English simplified so that a computer can understand it. It's more formal than English. In English, we can say, "I took the dog for a walk"

or "The dog was taken for a walk by me." The latter is awkward, but it still makes sense. We can understand it. But that's because we're smart. Computers are dumb. They only understand commands that follow rigid rules, so when we write JavaScript, we need to follow these rules.

That actually makes JavaScript much easier to learn than a human language. If you learn French or German, you need to expend a lot of energy memorizing irregular verbs and genders. Because JavaScript is so rigid, there are few irregularities. Wiggle is always wiggle. It's never wiggled, wiggler, or wobble.

You may have heard of JavaScript before. It's built into web browsers, such as Safari, Firefox, and Internet Explorer. It's also built into Photoshop, Illustrator, After Effects, Dreamweaver, and many other graphics and design applications. Flash employs a JavaScript-like language called Actionscript. The Expressions language is based on a subset of JavaScript, with a bunch of AE-specific additions thrown in by Adobe.

If you're like many designers I've met, you're probably starting to hyperventilate about now. "I didn't sign aboard to be a programmer!" you're thinking. "Where's the exit?"

I started out as a designer with no interest in programming. But I had to do some web design, and I needed to learn JavaScript to create some animated effects. My intention was to learn just a tiny bit of programming: just enough to achieve the effects I was working on. But as my projects grew in complexity, I gradually found myself learning more and more. After a while, I understood JavaScript as well as, say, an American might understand French if he's lived in Paris for a few years and has had to use it each day to ask, "How much does that cost?" and "Where's the bathroom?"

When I got into AE, I was thrilled to discover that it spoke the same language as web browsers. If it hadn't, I might never have learned Expressions. I really didn't want to learn a second language. Luckily, I didn't have to. And as I leveraged my JavaScript skills within AE Comps, my programming skills got stronger. Eventually, I learned Flash programming, and once again found myself speaking JavaScript—this time like a native.

You may have no interest in becoming a computer programmer, but if you learn some JavaScript, even if you learn it kicking and screaming, you'll have new tools that can help you out in many of the applications that you use every day.

AE lets you use JavaScript in two different ways: Expressions and application scripting. Expressions let you manipulate effects and transforms in the Timeline. In other words, they are tools to help you create animation and compositing effects. Application scripting allows you to control After Effects itself. With scripting, you can add new commands to AE's menus. You could, for instance, add a command that automatically renders out a Comp at 3:30 on Wednesday and e-mails you when it's done. Such scripting is also available in Photoshop and Illustrator to help you extend the feature sets of those applications.

Because this is an Expressions book, that's all I'm going to say about application scripting. But it's nice to know that, once you learn Expressions, you won't have to learn a whole new language for scripting. (If you want to play with some sample scripts, you can find them in the File > Scripts menu.)

One more note about JavaScript. It's not the same as Java. Java is a completely different language (used mostly on web servers and never in AE). Not surprisingly, people always confuse Java and JavaScript with each other. JavaScript is not a "lite" version of Java. JavaScript is as distinct from Java as Spanish is from Portuguese. Why do they have such similar names? Because the company that developed JavaScript (Netscape) had a partnership with the company that developed Java (Sun Microsystems). Rumor has it that the Sun developers drink a lot of coffee. Go figure.

DO I NEED TO BE A PROGRAMMER?

No. Although you write Expressions in JavaScript, which is a programming language, you don't need to be a programmer to craft useful Expressions. You don't even need to know much about JavaScript. In fact, the beginning chapters of this book will show you tons of useful techniques you can use without any programming knowledge at all. And although it's true that you can go on to do even more useful things if you do know how to program, you're not limited to boring, 101-type effects if you don't. You can create complex, original effects without coding.

In fact, most of the time you won't even have to type. AE includes an amazing, magical tool called the Pick Whip, which allows you to create JavaScript with your mouse. You drag, point, and click; AE writes the code for you. You don't even have to understand the code. It just works.

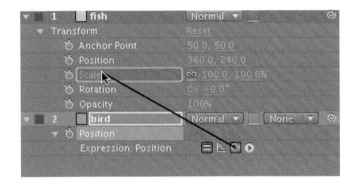

For readers who want a deeper understanding, I've included advanced steps in later chapters. You can decide, in your own time, whether or not you want to tackle these chapters. It's my sincere hope that this book will be useful to you, even if you only read 50% of it. (Of course, I'd be thrilled if you read the whole thing.) For those of you who do want to learn it all, I promise to hold your hand through the process and gradually guide you from the simple to the complex, without making any sudden leaps.

Even if you never delve into complex JavaScript yourself, you can still use other people's scripts. JavaScript is just text, and text can be copied and pasted. Back when I first started to use Expressions, I needed to create a pendulum. But I had no idea how to write such an Expression. Luckily, I was able to find one online. I read it and was totally baffled by it. It looked like a scary mathematical equation. For a second, I felt panicked. Then I calmed down, selected the text of the Expression in my browser, copied it to the clipboard, switched over to AE, and chose Edit > Paste. Voila! My pendulum swung back and forth beautifully. I had no idea how it worked, but it worked, and that's what mattered most.

This book is for those of you who don't care how it works, as long as it works. It's also for those of you who *do* care how it works and want to be able to customize it and write other Expressions that are just as complex. This book is for the auto mechanic. But it's also for the guy who just wants to drive his car to work and doesn't really care what goes on under the hood.

DO I NEED TO BE GOOD AT MATH?

No. Many Expressions don't use math at all (even though, in the end, they spit out numbers). If you have to type at all, you'll type friendly words like "wiggle." Of the Expressions that do use math, most use simple arithmetic. So you may have to strain your brain by adding and subtracting, on occasion.

xvii

Readers who want to use more complex math and coding will enjoy some of the later chapters in this book. The math phobics can avoid these chapters (though I hope they'll give them a glance) or simply use the copy-paste method to use the fruits of these chapters without understanding. I promise that when I do use math, I'll walk you through it gently.

Remember, at heart AE is a number-based system. But it's packed with tools to help us creative types forget that. Expressions are among those tools. Though they can be mathematical if that's what you want them to be, they needn't be if you don't want them to be. Like English, French, and German, Expressions allow you to, well, express yourself using mostly words, not numbers. And these words give you great power. Like magic spells, they allow you to transform the world—at least the world of After Effects. So let's dust off our magic wands and get to work.

NOTES ABOUT USING THIS BOOK

I'm not a big fan of computer books that drone on and on about "how to use this book" before getting started. So I'm going to keep this short and sweet and tell you just two things before we dive in and start crafting Expressions:

1. Sometimes, when I type Expressions, I type relatively long instructions. They fit on one line on my computer screen, but they don't fit well within the margins of this book. So when you see this symbol at the end of a line ⬎, it means that though the text is taking up multiple lines in this book, it only takes up one line on screen.

   ```
   Example: [thisComp.layer("fish").transform.scale + ⬎
   wiggle(1,27)[1].valueAtTime(time-45), wiggle(1,300)[1]]
   ```

   ```
   [thisComp.layer("fish").transform.scale + wiggle(1,27)[1].valueAtTime(time - 45), wiggle(1,300)[1]]
   ```

2. Throughout the text, I refer to example files. You can download those files here: www.focalpress.com/9780240809366

 That's it. On with the show!

About the Author

Marcus Geduld has written extensively about After Effects, Flash, Premiere Pro, and other software. He's also spent years teaching classes and teaching about technical topics at National Association of Broadcasters (NAB), MacWorld, and other conferences. When he's not teaching, speaking, and writing, he works as a Flash developer. He is also the artistic director of Folding Chair Classical Theatre. He lives in Brooklyn, New York, with his wife, actress Lisa Blankenship.

PART 1
Using Expressions

Creating Simple Expressions

ADDING EXPRESSIONS

How do you create an Expression in After Effects (AE)? The easiest way is to Option click (PC: Alt click) any stopwatch in the Timeline or Effect Controls panel. I like to think of Expressions as another *option* (or another *alternative*) to keyframes, which helps me remember to hold down the Option (PC: Alt) key when I'm adding them. To animate with keyframes, you click a stopwatch; to animate with Expressions, you Option click (PC: Alt click) a stopwatch.

Let's say you want an Expression to control a layer's position: create a small solid—say 100 by 100. Or you can use the little guy in Chapter01.aep, Comp1. Now do this:

1. Twirl open the layer's properties in the Timeline.
2. Twirl open the Transform group.
3. Option click (PC: Alt click) the stopwatch by the Position property.

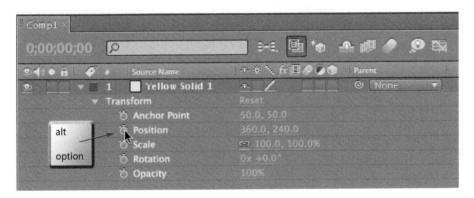

Don't be alarmed when the Comp window turns black and a scary-looking message appears underneath it in red. Starting in AE6, Adobe introduced a minor bug that causes the display to freeze while you're adding an Expression.

3

(It's still with us in CS4, so maybe Adobe has grown fond of it.) The display will unfreeze as soon as you're done adding the Expression.

4

What's more important is that you notice several changes in the Timeline near Position: a bunch of new buttons and a text-entry area, in which you'll see the following text: `transform.position`. That's a default, placeholder Expression. I'll have more to say about it shortly, but it doesn't do anything. If you preview the Comp now, you'll see that nothing happens, so try this:

4. Select the text `transform.position` and delete it (the same way you select and delete text in a word processor).

Actually, the text is selected by default. When you add an Expression, AE auto-selects the text. So if you just start typing, whatever you type will replace the placeholder Expression.

5. Type "`wiggle(1,40)`." Don't type the quotation marks or the period.

Make sure wiggle is all lowercase and that you've included the parentheses and the comma.

> **Note:** I printed the default Expression, `transform.position`, in red and the one
> I asked you to type, `wiggle(1,40)`, in blue. Throughout this book, auto-generated
> Expressions (the ones AE types for you) will be red; manual Expressions (the ones you
> type) will be blue.

6. With your mouse, click anywhere outside of the text-entry area, say on a gray area of the Timeline. That tells After Effects you've finished typing the Expression. (It "finalizes" the Expression.)

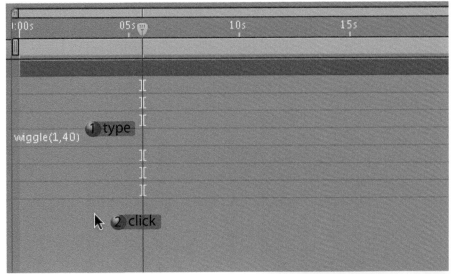

If you see an error message, it means you made a typo. Don't fret. Just click back inside the text-entry area, edit the Expression until it's correct, and then click outside the text-entry area again.

7. Preview the Comp by pressing the spacebar.

We'll delve into the meaning of that Expression later. But hopefully you noticed that the layer did, in fact, wiggle. For some fun, try changing the numbers inside the parentheses—for example, change

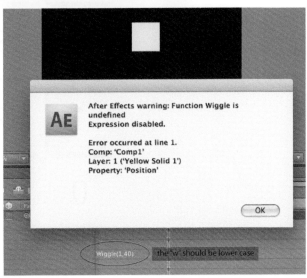

them to `wiggle (3,100)`—and see what happens. Don't worry; you can't break anything.

In short, use these steps to add an Expression:

1. Option click (PC: Alt click) a stopwatch.
2. Enter the Expression.
3. Finalize the Expression by clicking outside the text-entry area.

You can also finalize an Expression by pressing the Enter key on the numeric keypad. (Mac users: Never press the Return key on the main keyboard to finalize an Expression. PC users: Never press the Enter key on the main keyboard. Those keys drop the cursor down to the next line in the text-entry area, just as they would in a word processor. To finalize an Expression, always use the Enter key on the numeric keypad or click outside the text-entry area.)

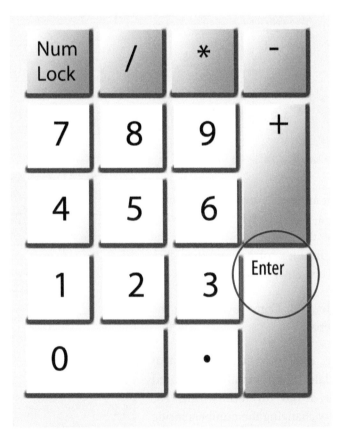

If you're into menus, you can also add an Expression by following these steps:

1. Clicking a Property name (e.g., Position) to select it.
2. Choosing Animation > Add Expression or clicking Option Shift Equals (PC: Alt Shift Equals). That's the keyboard shortcut for the menu option.

DISABLING AN EXPRESSION

Let's say you want to stop the wiggle. Simply click the equal-sign button in the Timeline. It will become a not-equal-sign button, and the Expression will stop working.

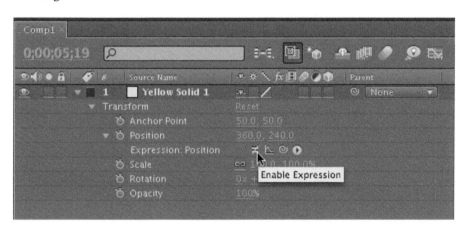

Try previewing the Comp, and you'll notice that wiggling has stopped. Click the not-equal sign again, and it will toggle back to an equal sign. The layer will wiggle once again. This button is called the Enable Expression button, but a better name for it would be the Disable/Enable Expression button, because it's a toggle.

Next, I'll explain how to permanently remove an Expression, but in general I suggest that you disable them rather than remove them. That way, if you change your mind and want them back, you won't have to type them all over again.

REMOVING EXPRESSIONS

You remove an Expression exactly the same way you create one: by Option clicking (PC: Alt clicking) a stopwatch. Option click once to add an Expression; Option click the same stopwatch again to remove the Expression. This is exactly the same toggle pattern you use with keyframes: You click a stopwatch to add keyframes and click it a second time to remove keyframes. The only difference is that with Expressions, you add in the Option key (PC: Alt key).

You can also remove an Expression by selecting the property it's applied to (e.g., by clicking the word "Position") and choosing Animation > Remove Expression. Or you can select the property and type Option shift equals (PC: Alt shift equals).

One other way to remove an Expression is by deleting the Expression text and then clicking outside the text-entry area (or pressing Enter on the numeric keypad).

BASIC EXPRESSIONS

Now that you know how to add, disable, and remove Expressions, let's explore what they are and how they work. As I explained in the Introduction, Layer properties are controlled by numbers (with rare exceptions like the Source Text property of Type Layers, which is controlled by text).

This is as true with keyframes as it is with Expressions. Let's say you turn on the stopwatch for a layer's Rotation property. You then move the Current Time

Indicator (CTI) to 3 seconds and, with the Rotation tool, rotate the layer to 19 degrees. After Effects will plop a keyframe in the Timeline at 3 seconds. This keyframe is "remembering" the number 19. Whenever you scrub the Current Time Indicator to 3 seconds (or play the Comp through the 3-second mark), the keyframe reminds AE to rotate the layer to 19 degrees. At 3 seconds, the number 19 is controlling the layer's Rotation property.

Expressions give you an alternative way to make the numbers that control properties (e.g., the wiggle Expression spits out random numbers, and those random numbers control the property). Let's watch this in action in the simplest possible way:

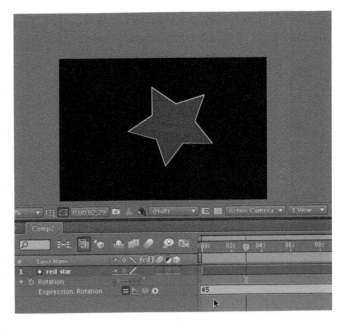

1. In an empty Comp, create a solid. Or you can use the Red Star layer in Chapter01.aep, Comp2.
2. Twirl open its Transform properties.
3. Add an Expression to the Rotation property.
4. Remove the default Expression, and type "45" (without the quotation marks) in its place.
5. Click outside the text-entry area, or press Enter on the numeric keypad.

> **Note:** This is the last time I'm going to tell you to finalize an Expression. You'll thank me for saving you from having to read "click outside the text-entry area, or press Enter on the numeric keypad" over and over. But please remember that Expressions must be finalized before they can work.

This is the stupidest Expression you'll ever write. If you want a layer to be rotated 45 degrees, it's much easier to just use the Rotation tool or scrub the property value. My point here isn't to show you how to do something useful;

9

it's to teach you something about the basic mechanics of Expressions. And even with this simple (useless) one, there's plenty to talk about.

If you took a screenshot of the Timeline and grayed out everything except the name of the property, the equal sign (the Enable Expression button), and the Expression itself (45), you'd see what was really going on.

```
Rotation = 45
```

That's a great way of thinking about Expressions. Expressions set a Property equal to some number.

If you click the equal sign, it becomes a not-equal sign. Now,

```
Rotation ≠45
```

The layer returns to its default rotation (zero degrees) or to whatever degree of rotation you left it at before you added the Expression, because now Rotation is not equal to 45 degrees.

Reenable the Expression and change it to the following, remembering to click outside the text-entry area when you're finished typing. (Okay, this is *really* the last time I'm going to remind you to finalize Expressions.)

```
45 + 10 - 2
```

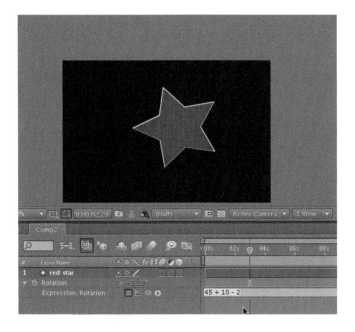

This will set the Rotation to 53 degrees. Again, I can't think of a good reason to do this, but it shows off a little more about how Expressions work.

Properties eat numbers for breakfast. They crave numbers. As long as AE can resolve an Expression into a number, it will work. That number will drive the property. And it can resolve 45+10−2 into the number 53 by doing some simple arithmetic, which it knows how to do.

If AE could somehow count the number of eggs in my refrigerator, I could write the following Expression.

```
Rotation = the number of eggs in my refrigerator
```

Maybe someday.

By the way, you could have written that earlier Expression as 45+10−2 (without the spaces) or, if you're a bit eccentric, as 45 +10 − 2. JavaScript is pretty lax about spacing. Different people will space out Expressions in different ways. So you should get used to slight variations in people's styles of Expression-writing.

```
45    +10  − 2  and  45+10−2    both work the same way.
```

You'll rarely (if ever) write Expressions that are just arithmetic problems, so I don't want to bore you with them for much longer. But I *do* want to point out a couple more things: assuming that an Expression is still controlling Rotation (add one back or enable one if necessary), notice that the display values have turned red.

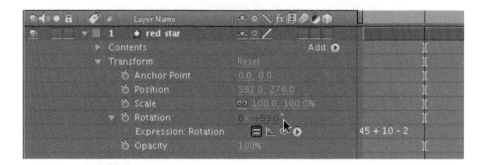

This signifies that the property they're associated with is controlled by an Expression. This is useful if you ever twirl closed the property. If you do, you'll no longer be able to see the Expression. The red value will be your only clue an Expression is controlling the property.

12

TIP

To reveal any Expressions on a layer, select it and press ee. That's the E key, twice in rapid succession. AE will twirl open all properties controlled by Expressions. You can also select multiple layers and type ee. AE will reveal the Expressions on all the selected layers.

Try scrubbing or changing the red value to 90 degrees. Don't change the Expression. Just use the Rotation tool or scrub the value of Rotation in the Timeline.

AE appears to let you do it, but as soon as you quit scrubbing, the value pops back to whatever it's set to by the Expression. As long as the Expression is enabled, it—not you—controls the property. But AE remembers your 90 degrees. If you disable or remove the Expression, your layer will rotate to 90 degrees.

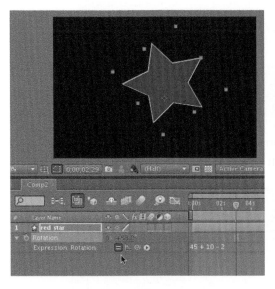 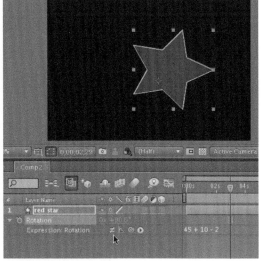

13

EXPRESSIONS IN WHICH ONE PROPERTY CONTROLS ANOTHER

We're about to leap out of useless-Expression world and land on a much more interesting planet. Try the following:

1. If you still have an Expression on Rotation, remove it.
2. Add a new Expression to Rotation. This time, instead of a number, type "`transform.opacity`" (without the quotation marks).
3. Finalize the Expression by pressing the Enter key on the numeric keypad or clicking outside the text. (I said I wasn't going to remind you to do

this any more. Well, I lied. But this really, *really* is the last time. Finalize your Expressions!)

> **Note:** If you make a typo, AE will display an error message and disable the Expression. Once you find the mistake and fix it (and finalize the fixed Expression), AE will reenable the Expression.

Your Expression is

rotation = transform.opacity

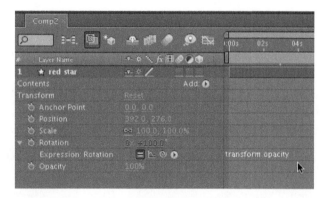

Transform refers to the Transform group in the Timeline, and opacity refers to the Opacity property within that group.

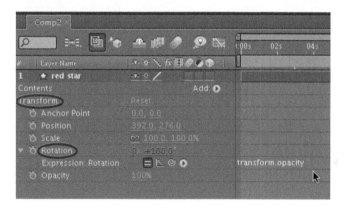

Written in English, your Expression would read

Set Rotation's value to the same number as Opacity's value.

Because Opacity is 100 (unless you've messed with it), Rotation should also be 100. Okay, that's a little weird. Opacity's 100 means 100%; Rotation's 100 means 100 degrees. Rotation and Opacity use completely different number systems. It

doesn't matter. In the wacky world of Expressions, it's just the number itself that counts.

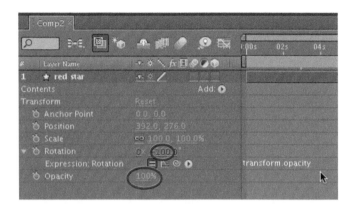

Remember my silly example? Rotation = the number of eggs in my refrigerator? Rotation and eggs have nothing in common, except a number (degrees and number in the fridge). Same with Rotation and Opacity. They're two entirely different sorts of properties, but they now share a controlling number.

Note that you haven't permanently set Rotation to 100. Instead, *you've set Rotation to the value of Opacity, and the value of Opacity can change.* In essence, you've said, "Let Rotation's number be whatever Opacity's number is *right now*. If Opacity changes, let Rotation change too." Opacity is the "parent" of Rotation. As you animate or adjust Opacity, Rotation will change automatically.

To test this relationship, try scrubbing Opacity: take it down to zero, and you'll see the layer rotate to zero degrees as it fades out. Now set Opacity to 50%; Rotation will be 50 degrees.

15

Take a deep breath and think about the ramifications of this. With Expressions, you can link any two properties so that one controls the other: Opacity can control Rotation, Rotation can control Opacity, Position can control Scale, The Blurriness of a Gaussian Blur can control the strength of Gravity in Particle Playground.

But before you get carried away, consider this problem: Opacity's total range of possible values is constrained to numbers between (and including) 0 and 100. It can never be set to −5 or 210. Because Opacity controls Rotation, this means Rotation is also constrained to a number between 0 and 100. Given our Expression, there's no way you can possibly rotate the layer to, say, 180 degrees; 100 is as high as Opacity will let Rotation go.

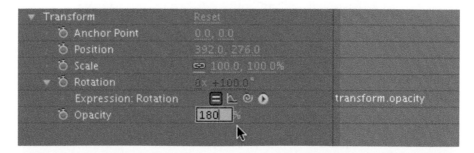

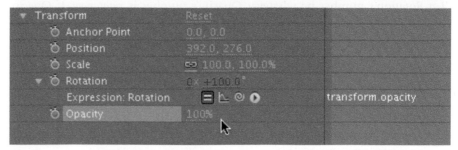

Let's play around with the Expression and see if we can break through the 0-to-100 barrier:

4. Click the end of the Expression, placing a cursor after the "y" at the end of `transform.opacity`.

If necessary—if you didn't click in exactly the right place—use your right-arrow key to nudge the cursor into position, right after the "y."

5. Add the following to the Expression: `+ 10`. (Don't include the period. That's just the end of my sentence.)

The Expression should now read as follows:

```
transform.opacity + 10
```

or

```
transform.opacity+10
```

> **Note:** Spacing around calculations is optional.

6. Scrub Opacity, watching both its value and Rotation's value.

Notice that when Opacity is 0, Rotation is 10; when Opacity is 25, Rotation is 35; and when Opacity is 100, Rotation is 110. We've broken through the barrier! This works because we're now saying, "let Rotation be the value of Opacity *plus 10*." As long as AE can turn that command into a number, it's happy, and because the value of Opacity is a number, and 10 is a number, AE can add those two numbers together to get a final number.

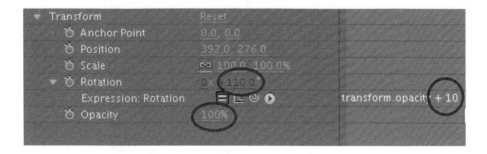

Now try this:

7. Edit the Expression so it reads `transform.opacity * 2`. (Don't include the period at the end.)
8. Scrub Opacity to see what happens.

Now you'll see that when Opacity is 5, Rotation is 10; when Opacity is 50, Rotation is 100; and when Opacity is 100, Rotation is 200. This is because, to JavaScript, an asterisk means multiply. Computers don't have a multiplication symbol on their keyboards (and you can't use an "X" because that's the letter "X").

Transform	Reset	
⏱ Anchor Point	0.0, 0.0	
⏱ Position	392.0, 276.0	
⏱ Scale	⊝ 100.0, 100.0%	
▾ ⏱ Rotation	0x +200.0°	
Expression: Rotation	▤ ⌐ ⊚ ◯	transform.opacity * 2
⏱ Opacity	100%	

If you have trouble remembering that an asterisk is the multiplication symbol, take a look at your numeric keypad. You'll see the familiar + and − symbols, for addition and subtraction. You'll also see * and / for addition multiplication and division. To JavaScript, "2 times 2 = 4" is "2 * 2 = 4" and "10 divided by 2 = 5" is "10 / 2 = 5."

Back to our Expression: It's saying, "Let Rotation be the value of Opacity times 2." So whatever Opacity is, Rotation will be double that.

We'll soon leave arithmetic and not return to it for a while. So if you hate math, you can heave a big sigh of relief. But before we move on, spend a little time playing around with the Expression. Modify it as follows, or come up with your own variations:

- `tansform.opacity − 15`
- `transform.opacity/3`
- `transform.opacity + 1 + 1 + 1 + 1 + 1 + 1`

All of those—especially the last one—are silly, but they prove, once again, that as long as the Expression resolves into a number, it will control Rotation.

Finally, one advanced move for readers who aren't math-phobic:

- `transform.opacity * 3.6`

Now, as you scrub Opacity from 0 to 100, the layer will rotate from 0 to 360—a full circle! We've *really* broken through the 0-to-100 barrier now. It's not important that you understand how that last Expression works. I use many Expressions that I don't understand. Smarter people than me figured them out, but—heck—, they work. I just copy them into AE, and they do their job. (But if you want to understand how an Expression works, check out the sidebar titled "Under the Hood of `transform.opacity * 3.6`.")

Incidentally, you should now be able to understand the (useless) default Expressions that After Effects adds when you Option click (PC: Alt click) a stopwatch. For instance, when you added an Expression to Rotation, AE typed "`transform.rotation`." In other words,

`Rotation = transform.rotation`

This is like saying, "let Rotation get its number from itself" or "let Rotation be whatever it already is" or "if you set rotation to 23 degrees before adding this Expression, let it still be 23 degrees."

Boring! Good thing you'll be in charge of Expressions. If After Effects baked a cake, I bet it wouldn't have any icing.

SIDEBAR

Under The Hood of `transform.opacity * 3.6`

For those of you with inquiring minds, I'll explain `transform.opacity * 3.6`. If you hate math, just cover your ears and shout la! la! la! Or skip to the next section, when math goes underground and hibernates.

We usually write percentages as numbers between 0 and 100. For instance, 50%. But really, a percentage is a number between 0 and 1, which means it's a decimal (or fraction) such as 0.7. That would be the same as 70%; 0.03 is 3%, 0.5 is the same as 50% and 1 is the same as 100%.

A full rotation is 360 degrees. If you want half of that, you can multiply 0.5 times 360. Think of it this way: 1 times 360 is 360 (1 = 100%, meaning all of 360); 0.5 is less than 1. In fact, it's half of 1 (0.5 + 0.5 = 1). So if 1 times 360 is 360, half of 1 times 360 must be half of 360, or 180. So 0.5 times 360 is 180.

That's the way percentages work. Want to know what 10% of 77 is? Multiply 0.1 (10%) times 77. Want to know what 20% of 189 is? Multiply 0.2 times 189. Want to know what 80% of 4 is? Multiply .8 times 4. Want to know what 100% of 843 is? Multiply 1 times 843. Take any number and multiply it by a number between 0 and 1, and you get a percentage of the original number.

Trouble is, Opacity doesn't spit out numbers between 0 and 1. It spits out numbers between 0 and 100. But we want to use those numbers to derive a percentage of 360. So we do a little trick. We note that 50 and .5 are similar numbers. The difference between them is the placement of the decimal point. If you think of 50 as 50.0 and .5 as 0.50, it may make things clearer:

```
50.
```

```
.50
```

If we take the 50 and shift the decimal point two places to the left, we get .50 (which is the same as 0.5 or .5). That's all well and good, but Opacity doesn't shift its decimals. When it's halfway to its maximum, it's 50, not .5. So our little trick is to shift the decimals on the 360 instead, two places to the left, just as we'd like to do with 50. And that gives us 3.6 (which is the same as 3.60).

```
transform.opacity * 3.6
```

This would also work:

```
(transform.opacity * .01) * 360
```

But it's more complicated. I leave you to work out why it works by yourself—if you really want to.

THE PICK WHIP

One problem with Expressions like `transform.opacity` is that they're a bit long. And the longer the Expression, the greater the chance you'll make a typo while you're typing it. An Expression is an instruction to After Effects. Alas, software is stupid. Or maybe it's more accurate to say that software is incredibly literal minded. If you make the slightest mistake while you're typing, the Expression won't work, and AE will bark at you with one of its embarrassing error messages.

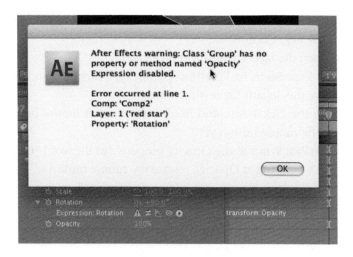

For instance, you'd screw things up if you typed `transform.Opacity`. What's wrong with that? The "O" in Opacity is capitalized. JavaScript is case sensitive, and it expects layer properties to be lowercase. That's what I mean by literal minded. "What the heck is Opacity?" AE's Expressions interpreter can't tell that you mean "opacity" when you type "Opacity".

Here are some more typos that would cause the Expression to fail:

- `Transform.opacity` (capital "T" in Transform)
- `transform opacity` (no period)
- `trandfarm.opacity` (transform misspelled)
- `transform.opasity` (opacity misspelled)

Luckily, there's an easy way to eliminate 90% of typos in basic Expressions: let me introduce you to the Pick Whip. The Pick Whip is a wonderful tool that's located two icons to-the-right-of the equal sign (the Enable Expression button). Its icon looks like a little spiral.

21

Here's an example of how to use it.

1. Create a Comp with a single layer in it (a small solid) or use the layer in Chaper01.aep, Comp3.
2. Twirl open the layer's Transform Properties.
3. Add an Expression to Rotation. (Don't type anything in the text area. Just leave the default Expression there.)
4. Point to the Pick Whip, and hold down the left mouse button. (Don't release the mouse button yet.)
5. Drag the Pick Whip to the Opacity property (to the word "Opacity").
6. When it's pointing at Opacity, release the mouse button.

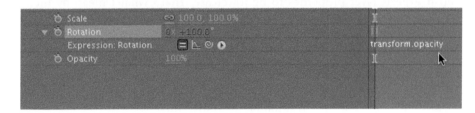

A more compact way of stating steps 4 through 6 is "drag the Pick Whip, and drop it on Opacity" or simply "Pick Whip Opacity." That last one sounds kinky!

Notice that AE wrote the Expression for you: transform.opacity. Notice also that I printed that last Expression in red. In this book, I will print any Expression—or any part of an Expression—created using the Pick Whip in red type. Later in this book, when you're used to using the Pick Whip, I won't even

have to mention it. I'll just print Expressions in red type and you'll know that means "use the Pick Whip."

Let's try some more Pick Whipping:

7. Remove the Expression.
8. Add an Expression to Scale.
9. Pick Whip Position.

I've used some shorthand here. By "Pick Whip Position," I mean drag the Pick Whip and drop it on the Position property (on the word "Position").

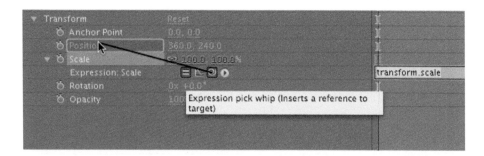

10. Drag the layer around in the Comp window.

Notice that as you drag it, it changes size. That's because the Pick Whip wrote this Expression:

```
transform.position
```

So Scale is being controlled by Position. Watch the value-numbers in the Timeline to see exactly how Position is controlling Scale. Position's X value gets fed into Scale's width, and Position's Y value gets fed into Scale's height. So if Position is 123x by 87y, Scale will be 123% wide by 87% high.

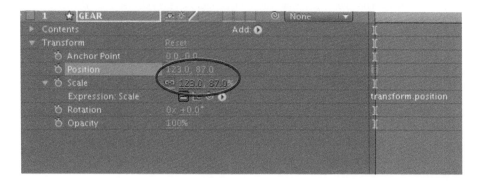

23

SIDEBAR
Pick Whip Problems: What Can Go Wrong

If you get errors when you use the Pick Whip, it's probably because you've been messing around in the text-entry area. When you first add an Expression, AE performs two actions: it enters the default Expression, and it selects (highlights) the default Expression. Just so you know what I'm talking about, here's a default Expression that is *not* selected.

Here's one that has been selected.

If text is selected and you type, whatever you type replaces the selected text. This isn't just true in AE; it's true in pretty much any computer program you own. For instance if you select the word "cat" in MS Word and type "dog", the word "dog" replaces the word "cat".

As far as AE is concerned, using the Pick Whip is just like typing. When you use it, AE types for you, but whether AE is typing or you're typing, typing still occurs. If the default Expression is selected before you use the Pick Whip, all will go well, because AE will replace the default selection with the autotyping. This is what should happen, because the default Expression is automatically selected. It's selected, so it will be replaced—that is, unless you deselect it! If you add the Expression and then (for some reason) click inside the text-entry area, you will deselect (unhighlight) the default Expression. And now, instead

of replacing the default Expression, when you use the Pick Whip, AE will just add the auto-type wherever you left the cursor. (If you were typing by hand, your text would go wherever you left the cursor, so AE is just mimicking that process.)

For instance, say I add an Expression to Position. AE will type the default Expression: `transform.position`. Now, let's say for some reason I click in the text-entry area and leave my cursor between the letters "s" and "i" in "position."

Then I grab the Pick Whip and point to Scale. AE will autotype where I left my cursor, so I'll get this ugly mishmash:

transform.pos`tranform.scale`ition

only (outside of this book) none of it will be in red, so it will be really hard to see what's going on.

So the moral is, try not to deselect the default Expression if you plan on replacing it via the Pick Whip. Or, if you do deselect it by accident, just reselect it before using the Pick Whip.

Perhaps you're cocky enough to think you can type "`transform.position`" without making a typo. And maybe you're right, but Expressions can get much longer and more complex. For instance, try the following:

1. Create a Comp with two small solids in it, a red one and a green one. Or you can use the two layers in Chapter01.aep, Comp4.
2. Select Green and press the P key to reveal its Position property.
3. Select Red and press the S key to reveal its Scale property.
4. Add an Expression to Red's Scale.
5. Pick Whip Green's Position.

25

Now Green's Position is controlling Red's Scale. Drag Green around and watch Red's size change. Once you're done playing, take a look at the Expression:

```
thisComp.layer("Green").transform.position
```

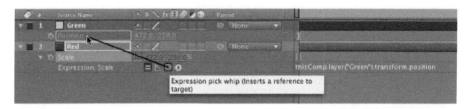

We're starting to get into major typo territory here. A single mistake (such as forgetting the quotation marks around "Green") would have botched the whole Expression. Aren't you glad the Pick Whip did all the typing for you?

Incidentally, if you're trying to understand that Expression, it's easier than it looks. Remember, the Expression is controlling Red's Scale. Red's Scale is trying to figure out where to get its width and height values. And the Expression is telling it. The Expression is saying, "Get your numbers from something in this Comp. More specifically, get them from a layer in this Comp (a layer called 'Green'). Even more specifically, get them from a property in that layer's Transform group. And even *more* specifically, get them from the Transform group's Position property."

Whenever you see a period (or, as a programmer would say, a "dot"), it means "more specifically." We're drilling down from general to specific.

It reminds me of how I'd respond to "Where do you live?" when I was an annoying kid. I'd say, "In the universe, in the Milky Way Galaxy, in the Solar System, on Planet Earth, in North America, in the United States, in Indiana, in Bloomington, on First Street, in the gray house, in my room."

If I had spoken JavaScript, I would have said thisUniverse.milkyWay.solarSystem.planetEarth.northAmerica.unitedStates.indiana.bloomington.firstStreet.grayHouse.myRoom

I'm glossing over some stuff here, like the parentheses around "Green." That's because I don't want to stray too far from the subject at hand: the Pick Whip. But I'll get back to dots and parentheses and JavaScript syntax later in this book.

The drilling down can get even more complicated, because, via the Pick Whip, you can hook up a property in one Comp with a property in another Comp. That's like making a wormhole between two universes! To get a sense of what I'm talking about, try this:

1. Open Chapter01.aep, Comp5.
2. You'll see a lone blue Solid.
3. Select the Solid, and type S to reveal its Scale property.
4. Now open Chapter01.aep, Comp6.

That's right: open a whole other Composition. In this one, you'll see a yellow solid.

5. Select the Solid and type P to reveal its Position property.

As you can see, I've animated the yellow Solid so that it moves about the screen.

6. Command + drag (PC: Control + drag) the tab for Comp 6 away from the Timeline, so that Comp 6's Timeline floats in its own window.

7. If necessary, move the floating window so that you can see the Timelines for both Comp 5 and Comp 6 at the same time.
8. Add an Expression to the blue solid's Scale property (in Comp 5).
9. With the Scale Pick Whip, point to the yellow solid's Position property.

27

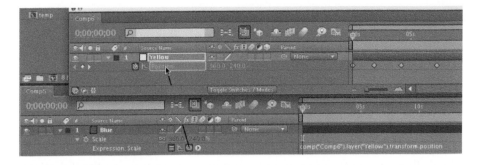

10. Preview Comp 5.

28

You'll see that the blue solid's Scale is changing. It's being controlled by the Position of the yellow solid in Comp 6.

The Expression looks like this:

```
comp("Comp 6").layer("Yellow").transform.position
```

This looks similar to the last Expression we looked at, except instead of starting with a reference to the current Composition (thisComp), it starts with a reference to Comp 6. What's controlling blue's Scale? Something in a Comp. Which Comp? Comp 6. What thing in Comp 6? A layer. Which layer? The one called "Yellow." What aspect of "Yellow?" Something in its Transform property group. What item in that group? The Position property. That's a pretty complex Expression. Aren't you glad the Pick Whip wrote it for you?

I'm thrilled that you know how to use the Pick Whip. There's not much more to say about it. It's simple and elegant. It does what it does. But if you're not appreciating how wonderful it is—how swiftly it can forge a link between any two properties—I'd better show you a few more examples.

THE PICKWHIP AND EFFECTS

For me, Expressions really became fun when I started combining them with Effects. "Oh!" I thought, "Expressions can link up *any* two properties. They don't have to be boring old Opacity and Rotation; they can be properties of Shatter or Fractal Noise!"

This is when Expressions became part of my everyday toolkit. Every time I added an Effect (or several Effects), I paused and thought about whether it would be fun to link two Effect properties so that one controlled the other. Sometimes—often—I didn't know the answer. But it just took a couple of seconds to add an Expression and use the Pick Whip. If I didn't like the result, I just disabled or removed the Expression.

Here are a couple of examples using Effects:

WRITE-ON AND BEAM

1. In a new 30-second Comp, create a Comp-sized solid (or use the one in Chapter01.aep, Comp7).

2. Select the solid and add the Write-on Effect to it: Effects > Generate > Write-on.

3. With the Current Time Indicator (CTI) at the beginning of the Timeline, turn the stopwatch on for Write-on's Brush Position property.

Just click the stopwatch; don't Option or Alt click it. You're adding keyframes now, not Expressions.

4. Move the CTI forward in time about 1 second, and then change the Brush Position so it's in a different location.

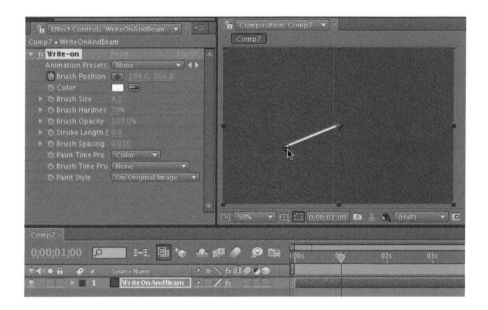

You can change it by scrubbing its x/y values, or you can click the crosshair and then click somewhere in the Comp. If the Effect's name is selected in the Effect Controls Panel (if the word Write-on is highlighted), you can change the Brush Position by dragging the control in the center of the Comp.

5. Repeat step four several times, each time moving the CTI forward in time another second and then adjusting the Brush Position so that it's in a new place.

Keep doing this until the CTI has reached the end of the Timeline. If you preview the Comp now, you'll see a scribble that paints itself on over time.

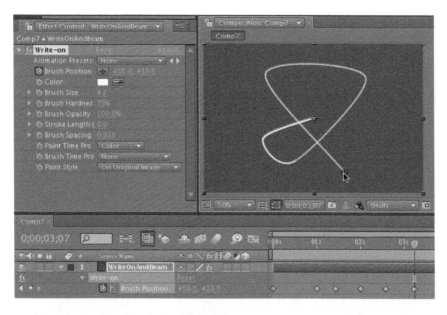

6. Adjust Write-on's Color and Brush Size properties until you like the results.

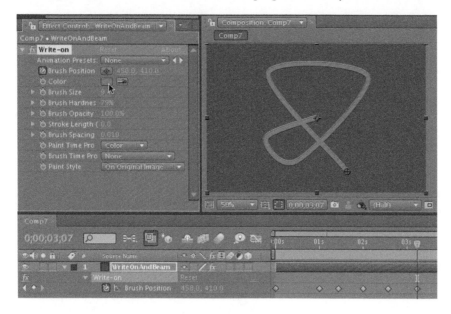

31

7. Now, with the solid layer still selected, add a second Effect: Effect > Generate > Beam.

8. Beam is one of those selfish effects that obliterate the layer you apply it to. To bring back your Write-on scribble, click the Composite on Original option at the bottom of Beam's controls.

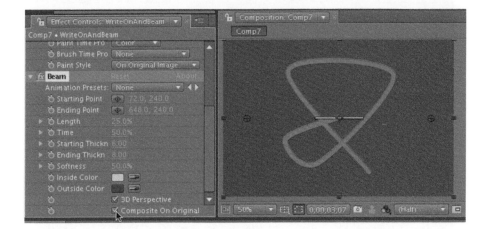

9. The beam is shorter than it could be. Scrub its Length property to 100%.

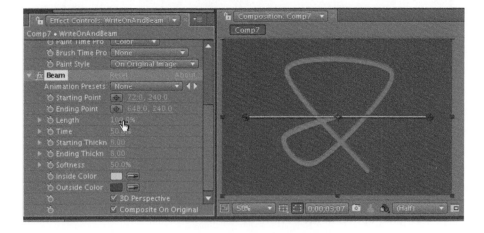

10. Make sure that the Beam effect's name is highlighted on the Effect Control Panel. If it's not, click it (click the word "Beam"). This will allow you to adjust the beam by dragging in the Comp window.

11. In the Comp window, drag the control on the right end of the beam so that it's centered and just below the bottom of the Comp. This is the Beam's ending point.

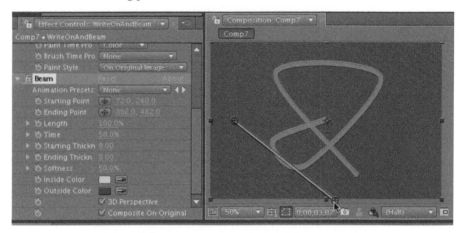

12. In the Effect Controls Panel, Option click (PC: Alt Click) the stopwatch for the Starting Point property.

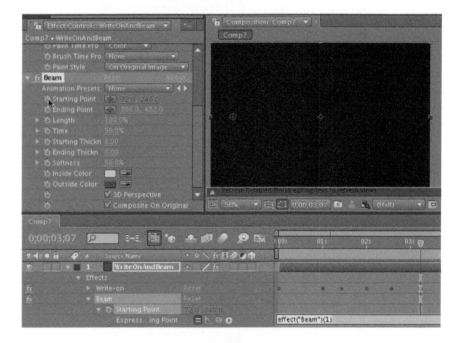

Yes, you can add an Expression in the Effect Controls Panel too. You can do it there or in the Timeline. If you do add an Expression in the Effect Controls

panel, AE will reveal the appropriate property in the Timeline. You'll type the Expression—or use the Pick Whip—in the Timeline.

13. In the Timeline, grab the Pick Whip and drag it all the way up to the Effect Controls Panel, pointing to Write-on's Brush Position. Release the Pick Whip while it's pointing at Brush Position.

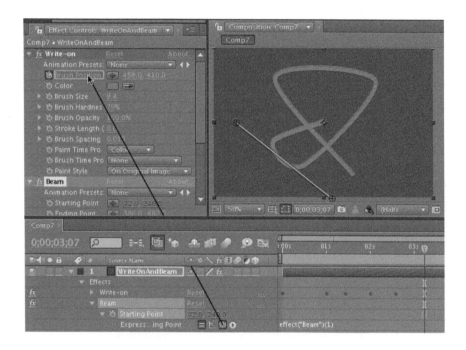

14. Preview the Comp.

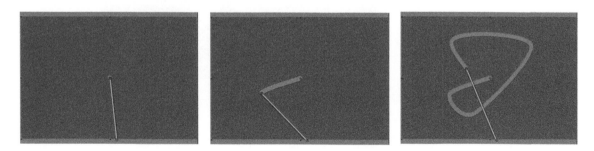

As you can see, the brush is controlling the beam (though it looks the other way around). You could try the same effect with Write-on and an image of a pencil, crayon, or marker. Just make sure to move the pencil's Anchor Point to its nib.

Why did we use Write-on instead of one of the newer, more sophisticated paint effects? Because only Write-on gives us a Brush Position with X and Y coordinates. This makes it a great effect for use with Expressions. You can use it to drive other properties (such as Beam's Starting Pointing) so that they move along with the brush.

Or you can rig things the other way around. For instance, we could have animated the Beam first, added an Expression to Brush Position and Pick Whipped the Beam's Starting Point. Along similar lines, you could motion track an airplane and then use it to control the brush, so that a painted line follows the plane's course. The possibilities are endless.

By the way, here's the default Expression that was on Starting Point before you used the Pick Whip:

```
effect("Beam")(1)
```

By Default, the Starting Point is controlled by the first property (1) of the Beam effect. Looking at the Effect Controls Panel and counting down from the top, the first property is Starting Point. So, unsurprisingly in a default Expression, Starting Point is controlled by Starting Point.

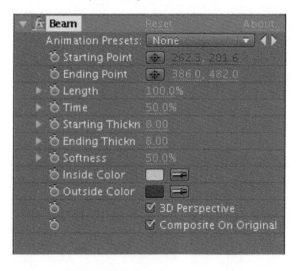

Here's the Expression that the PickwhipPick Whip created:

```
effect("Write-on")("Brush Position")
```

Hopefully, that's pretty straightforward. What's controlling the Beam? Some property of an Effect, specifically the "Write-on" Effect. Drilling down further, it's specifically the "Brush Position" property that's doing the controlling.

TRACKING AND BLURRINESS

1. Create a new 5-second Comp. With the Type tool, type the text "stay focused" in the center of the Comp window. Or you can use Chapter01. aep, Comp8.

As an alternative to the Type tool, you can use this shortcut to add text: Command Option Shift T (PC: Control Alt Shift T). That looks complicated, but it's basically mashing down all the modifier keys and pressing T. If (before using the shortcut) you've left your text alignment set to center, AE will automatically place a cursor in the center of the Comp.

2. If necessary, use the alignment options in the Paragraph panel to center the text.

37

3. In the Timeline, twirl open the Type layer and then open the Animation menu (in the Timeline).

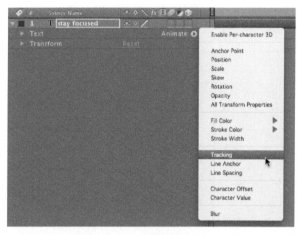

4. Select the Tracking option to add a Tracking Animator to the Timeline.
5. With the CTI at the beginning of the Comp, turn on the stopwatch for Tracking Amount.
6. Move the CTI to the halfway point, and scrub Tracking Amount until you see the letters fan way out. Track as much as you like.
7. Move the CTI to the end of the Timeline, and scrub Tracking Amount back to zero.

If you preview now, you'll see the letters fan out and then back again.

8. Select all three keyframes (click the first one and then Shift click the other two) and press F9 to add easing. (Or choose Animation > Keyframe Assistants > Easy Ease.)

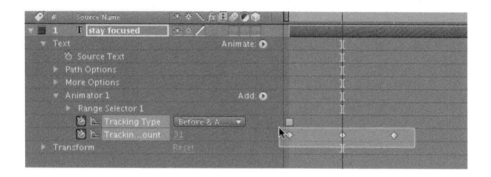

If you preview again, the movement should be a little smoother.

9. From the Effects menu, choose Blur and Sharpen > Fast Blur.
10. In the Effect Controls panel, add an Expression to the Blurriness property.
11. In the Timeline, grab the Pick Whip, point it to Tracking Amount in the Timeline, and then release the mouse.

Preview one last time, and you'll see that Tracking Amount is controlling Blurriness. As the letters spread apart, they become blurrier. As they come back together, they return to focus.

39

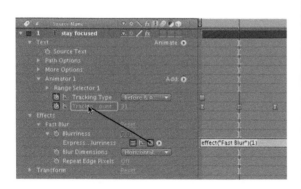

 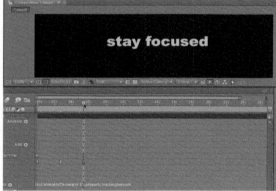

At this point, it's tempting to show you example after example of Pick Whipping. But to keep this book from becoming as long as *War and Peace,* I'll restrain myself. But in the future, as you add Effects, play matchmaker. Use the Pick Whip to bring properties closer together. It doesn't matter how different property A is from property B. Vive la difference!

Variables, Comments, and Dimensions

This chapter covers one easy topic (comments) sandwiched between two more complex topics (variables and dimensions). For the complex topics, we'll need to touch on some math, or at least numbers. Don't fret, math-phobic readers. I promise that you'll only dip your toes; you won't get your hair wet. And I also promise to hold your hand through the whole process and to go slowly. I flunked math in high school. I'm not proud of that fact, but I feel safe saying that if I can handle the math in this chapter, you can handle it too. It doesn't go beyond basic arithmetic.

Why bother with all this stuff? Because you need to understand it in order to move beyond simple, Pick Whip-based Expressions. So if you bear with me through this chapter (which I hope you'll also enjoy), you'll pop out the other end much more confident about Expressions. And you'll be able to use this chapter's concepts to craft some really cool effects.

VARIABLES

Perhaps you recall variables from high school math, and perhaps you get a queasy feeling when you think about them. Don't worry: We're not going to use them for anything complicated. But we do need to revisit them. As you may remember—or as you may not—variables are letters that stand in for numbers, as in this problem:

$$X = 4$$

$$X + 1 = ?$$

answer: 5

X = 37

X − 1 = ?

answer: 36

Variables are called variables because they can change what they stand for (they vary). In *that* problem, X means 4. But in this problem, it means 37.

By the way, the opposite of a variable is a constant. The digit 3 is a constant (as are all the other digits). It always means 3. It never means anything else.

In traditional math, variables are always letters: x, y, a, b, c, and so on. But most JavaScript programmers frown on using letters; they prefer words. If JavaScript programmers taught math, they would write problems like this on the blackboard:

And if they had 10 apples and 6 oranges, and they wanted to know how much total fruit they had, they would write the problem like this:

apples = 20

apples + 5 = ?

Answer: 25

apples = 10
oranges = 6
apples + oranges = ?

Answer: 16

Boy, I wish my math teacher had used words instead of letters! I might have liked math a little better.

If we'd used JavaScript back in school, we would have written that last problem like this:

Notice the semicolons. In JavaScript, semicolons mean the same thing that periods mean in English. In English, we say that a period marks the end of a sentence. In JavaScript, we say that a semicolon marks the end of a statement. So all this time, when we've been writing Expressions like

apples = 10;
oranges = 6;
apples + oranges = ?;

Answer: 16

`transform.opacity`

we could have written them as

```
transform.opacity;
```

But you don't have to include semicolons when your Expression is only one line long. However, you must include them when your Expression is more than one line long. For instance,

```
controller = transform.opacity;
controller
```

Don't worry (yet) about what that Expression means or does, but notice that it contains two statements. I typed each statement on its own line, pressing Return (PC: Enter) after the first statement. As you'll see, you don't have to type each statement on its own line, but doing so makes multiline Expressions easier to read, so I recommend doing it.

The key thing here is that the first statement ends with a semicolon, without which, AE wouldn't understand that the first statement was over and that a new statement was following. This is yet another way in which the Expressions interpreter is literal minded. In English, I could get away with writing, "I'm thirsty Give me some water," without a period between the two sentences. English teachers would complain, but at least everyone would know what I meant. This sort of thing won't work in JavaScript. You must end each statement with a semicolon.

Except for the final one. Notice my second (and final) line doesn't end with a semicolon. Because it's the last line, the interpreter doesn't need a separator to tell it when that line ends and the next one begins. There *is* no next one. However, it's legal to add a semicolon to the last line, if you want to:

```
controller = transform.opacity;
controller;
```

In this book, I'll generally omit semicolons on final lines. Also, I'll type each statement on its own line. But just once, to prove that you don't have to do that, here's a third legal version of the Expression:

```
controller=transform.opacity;controller;
```

43

This shows that the real function of the semicolon is to separate one statement from another. The separate-line convention does nothing, except to make the Expression easier for humans to read.

Here are a few other legal versions:

- No semicolon after the final statement:

```
controller=transform.opacity;controller
```

- Funky spacing:

```
controller=    transform.opacity;
controller
```

Note that although JavascriptJavaScript allows you to play fast and loose with spacing between words and punctuation symbols, it draws the line at spaces within words. This is *not* legal:

```
controller=transform.opacity;
contr oller;
```

Fine. Now that I've written the same Expression in a zillion ways, what the heck does it mean? Well, the first statement creates a variable called controller. To create a variable, you just make up a word and use it. I could have used

```
hippopotamus = transform.opacity;
```

or

```
empireStateBuilding = transform.opacity;
```

but I chose controller, because I thought it better described the point of making a variable in the first place. This variable is going to control the Expression:

```
controller=transform.opacity;
```

Next, I gave the variable a meaning: in *this* Expression, controller means transform.opacity, the value of the Opacity property in the Transform group. So if Opacity happens to be 50 right now, controller is 50 right now. If I change Opacity to 100, controller will be 100:

```
controller is equal to whatever Opacity is equal to.
```

I like to think of variables as cardboard boxes in the attic. By typing controller = transform.opacity;, I'm putting a box in the attic and writing "controller" on it in magic marker. Then I'm sticking the value of Opacity

in the box. If I later want the value of Opacity, as I do on the second line of the Expression, I can go back to the box and get it, just as if I later want some socks that I've put in a box, I'll find them in the box labeled socks:

what's in the box

```
controller = transform.opacity;
```

the label on the box

In reality, variables are little chucks of RAM. RAM is your computer's temporary memory (as opposed to its permanent memory, its hard drive). RAM is temporary, because it is erased when you turn off your computer or stop running a program.

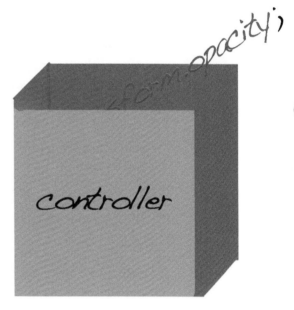

Creating a variable is like saying, "Hey, computer! Store the value of `transform.opacity` in a little chunk of RAM, and label that chunk 'controller.' And when I want to know the value of `tranform.opacity`, I'll just say 'controller.' When I say that, tell me what's stored in the chunk of RAM with that name."

(RAM stands for random access memory. The "random access" part means that the computer can access any value stored in memory without starting with the first item, moving to the second, then the third, then the fourth, and so on, until it finds the item it's looking for. Instead, it can jump right to what it wants and access it. The opposite of random access is sequential access. If you're looking for a Stephen King novel on your bookshelf, you can randomly access it, meaning you can jump right to that novel. If you had to sequentially access it, you'd have to start with the first book, check its title, move onto the next one, then

45

the next, and so on, until you found the book you were looking for. At which point, you'd be so worn out, you'd probably just turn on the TV.)

The last statement of an Expression is the most important one. It's the line that AE will use to control the property to which you apply the Expression. So if you apply this Expression to Rotation. . .

```
controller = transform.opacity;
controller
```

. . . only the second statement, controller, will control Rotation. Let's say I omit it:

```
controller = transform.opacity;
```

That's just telling the computer to store a value in a variable. Okay, it will. But so what? It's like asking an overly literal friend to pick a number between 1 and 10. She says, "okay" and then just stares at you. Why didn't she do anything? She did do something: She picked a number between 1 and 10 *in her mind*. You didn't ask her to tell you the number, so she didn't.

The last statement of an Expression tells the computer to *do* something—something you can actually see, as opposed to something "in its head." And the something it will do will always be the same something: set the property (to which you applied the Expression) equal to the value of the last statement. Because, in this case, the last statement is "controller," the property will be set equal to controller.[1]

Assuming this Expression is applied to Rotation, here it is again with an English translation:

```
controller = transform.opacity;
```

Translation: Store the value of opacity in a box called labeled "controller."

```
controller
```

Translation: Set the value of this property (Rotation) to whatever is stored in the box labeled "controller."

Now, I'll be the first to admit that this is a silly Expression. We could have eliminated the variable and just typed (or Pick Whipped)

```
tranform.opacity
```

[1]In reality, controller = transform.opacity; is a legal Expression. If After Effects encounters a one-line Expression that's a variable assignment, it will use the value of the variable as the value of the Expression. So in this case, the value of the Expression would be transform.opacity.

as we did in Chapter 1. My point wasn't to show you anything useful; it was to explain a bit about how variables work. But we'll get to useful shortly enough. Before we do, here are a few more grammatical rules about variables.

They can't contain spaces. So this is *wrong*:

```
my age in 2008 = 42;
```

If I want to simulate spaces, I can use

```
my_age_in_2008 = 42;
```

or

```
myAgeIn2008 = 42;
```

In that last example, I used what programmers call camel case, because supposedly the uppercase letters look like humps on a camel. If you're using camel case, as I will in this book, it's traditional to start the first word with a lowercase letter, as I did with "my" and all subsequent words with uppercase letters, as I did with "AgeIn2008."

You may use numbers in variables (I just used 2008), but variables can't start with a number:

```
Good: hippo1 = 10;
Bad:  1hippo = 10;
```

And the only symbols you can use besides letters and numbers are underscores and dollar signs:

```
Good: friends_who_live_near_me = 5;
Good: $$$_in_my_bank_account = 150;
Bad:  myAgeThisYear!!! = 41;
```

Finally, if you want to be formal, you can announce the fact that you're creating a new variable by preceding it with the word "var":

```
var controller = transform.opacity;
controller
```

Notice that you only type "var" the *first* time you use the variable:

```
Bad:
var controller = transform.opacity;
var controller
Good:
var controller = transform.opacity;
controller
```

47

I like "var" because it makes it clear that controller is a variable that I'm defining (and not some already defined word in the JavaScript language), so I'm going to continue using it throughout this book. But you'll see Expressions made by other people besides me, and each programmer has his or her own habits. So get used to sometimes seeing "var" and sometimes not seeing it.

SIDEBAR

Reserved Words

Words that are part of the Expressions language are called reserved words, and you should never use them as variable names. If you do, After Effects won't necessarily display an error (I wish it would). Instead, your Expression will just behave in some odd, unpredictable way.

Reserved words include the following: abstract, as, boolean, break, byte, case, catch, char, class, continue, const, debugger, \default, delete, do, double, else, enum, export, extends, false, final, finally, float, for, function, goto, if, implements, import, in, instanceof, int, interface, is, long, namespace, native, new, null, package, private, protected, public, return, short, static, super, switch, synchronized, this, throw, throws, transient, true, try, typeof, use, var, void, volatile, while, with.

Those are standard JavaScript reserved words, meaning you shouldn't use them as variable names in any system that uses the language (web browsers, Flash, etc.). In addition to those words, After Effects users should avoid naming variables after words that stand for Comp and layer properties. For instance, you should never name a variable position. You can see a complete list of special AE reserved words in the Expressions language menu.

As you can see here, time is a reserved word. So you should never write a statement like this:

```
time = 23;
```

For instance, if you see code that looks like this,

```
var apples = 100;
oranges = 200;
```

understand that both apples and oranges are variables, even though the programmer only preceded apples with the optional "var." Why would a programmer do this? Because, like most humans, programmers are often sloppy. When programmers are paying attention, most of them try to be consistent.

Okay, let's put variables to real-world use. In the following example, the goal is to position four layers at various places in the Comp window and to make a fifth layer automatically move to the average location of the other four. So if the four are stationed at the four corners of the Comp, the fifth will be in the center.

To complete this task, we'll have to use a tiny bit of math. We'll use math for averaging. For instance, if my friends Mary, Bert, and Doug are playing Tetris and I want to know their average score, I'd first need to list their individual scores:

Next, I'd add the three scores together:

Mary -- 800
Bert -- 140
Doug - 300

Mary -- 800
Bert -- 140
Doug - 300

1,240

1. Mary
2. Bert
3. Doug
Three friends, so...
1240 ÷ 3 = 413.3

Finally, I'd count the number of Tetris-playing friends and divide the total by that number:

(I used a calculator for that last part.)

That's it. Their average score is 413.3. If you want an average, add up all the individual values and then divide by the number of values.

So to get the average position of four layers, we'll have to add all their positions together and divide the result by 4. Or rather, *we* won't have to do that; AE will have to do it. But we'll have to use an Expression to tell AE to do it. Let's get started:

1. Open Chapter02.aep, Comp1 (or use a similar Comp of your own, one that contains five small graphics).

If you preview the Comp, you'll see that I've animated the food layers to move about. But the kitty just stays put.

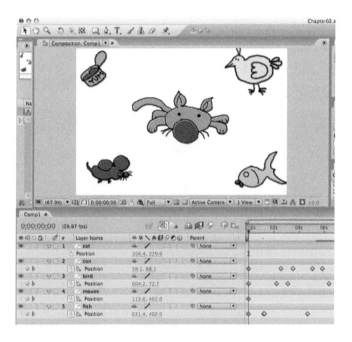

The kitty is hungry, but he doesn't want to play favorites. He's equally fond of the mouse, the bird, the goldfish, and the can of cat food. Our goal is always to keep the kitty an average distance from his prey. (If each prey layer is at one of the Comp's corners, the kitty should be in the center.)

To calculate the average, we'll have to add mousePosition + birdPosition + goldfishPosition + canPosition. Then we'll have to divide the result by 4 (because there are four food items).

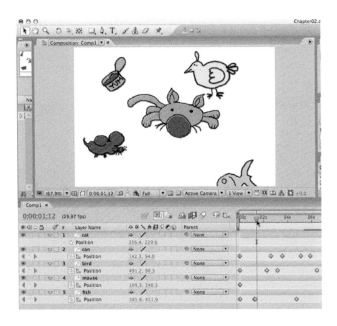

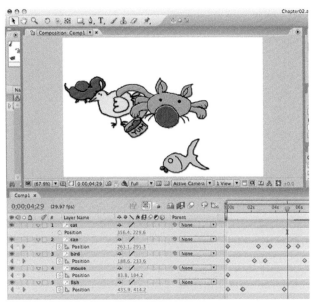

51

We could write the entire Expression as one long line:

```
(thisComp.layer("mouse").transform.position + thisComp.
layer("bird").transform.position + thisComp.layer("fish").
transform.position + thisComp.layer("can").transform.
position)/4
```

But that would be ugly and confusing. We'll use variables to make the Expression easier to read, edit, and understand.

2. Select all five layers via Command + A (PC: Control + A); then press P to reveal their Position properties.

3. Add an Expression to kitty's Position property.

4. In the text-entry area, type

```
var mousePosition =
```

You might want to add a space after the equals sign, by hitting the spacebar after typing " = ." You don't have to—the Expression will work fine with or without it—but I think it will make the Expression easier to read.

5. Pick Whip the mouse layer's Position property.

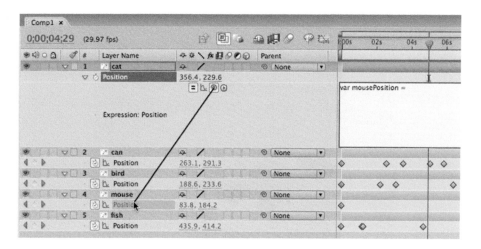

The Expression now reads

```
var mousePosition = thisComp.layer("mouse").transform.position
```

Remember, I'm printing Pick Whip–generated text in red and text that you type in blue.

6. Because this is only the first line of a multiline Expression, type a semicolon.

The Expression now reads

```
var mousePosition = thisComp.layer("mouse").transform.position;
```

7. Press Return (PC: Enter), and on the next line, type

```
var birdPosition =
```

TIP
If you need more space to type a multiline Expression, point your mouse at the lower lip of the text-entry area. When your cursor turns into a double-headed arrow, drag downward:

8. Pick Whip the bird layer's Position property. Then type a semicolon:

   ```
   var birdPosition = thisComp.layer("bird").transform.
   position;
   ```

9. On the next line, type "var fishPosition =" (without the quotation marks), Pick Whip the fish's Position property, and type a semicolon.

   ```
   var fishPosition = thisComp.layer("fish").transform.
   position;
   ```

10. On the next line, type "var canPosition =" (without the quotation marks), Pick Whip the can's Position property and type a semicolon.

    ```
    var canPosition = thisComp.layer("can").transform.
    position;
    ```

So far, your Expression should read

```
var mousePosition = thisComp.layer("mouse").transform.position;
var birdPosition = thisComp.layer("bird").transform.position;
var fishPosition = thisComp.layer("fish").transform.position;
var canPosition = thisComp.layer("can").transform.position;
```

11. On the next line, type

    ```
    var averagePosition = (mousePosition + birdPosition +
    fishPosition + canPosition)/4;
    ```

12. On the final line, type "averagePosition" (no quotation marks). Remember, it's the final line that actually controls the property. So kitty's Position will be controlled by the averagePosition of the other layers.

53

The final Expression reads

```
var mousePosition = thisComp.layer("mouse").transform.position;
var birdPosition = thisComp.layer("bird").transform.position;
var fishPosition = thisComp.layer("fish").transform.position;
var canPosition = thisComp.layer("can").transform.position;
var averagePosition = (mousePosition + birdPosition + ⤵
fishPosition + canPosition)/4;
averagePosition
```

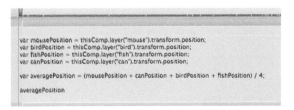

The final line doesn't need to end in a semicolon.

13. Now try previewing the Comp. The kitty should always stay at the average position of the other layers. (How is the poor kitty ever going to eat?)

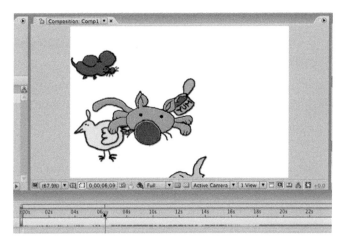

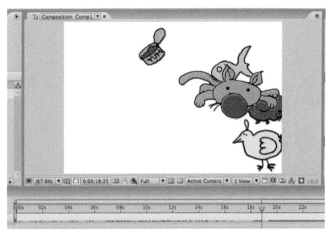

I want to make sure that you really understand variables. So please take a look at these alternate versions of the same Expression. I've printed changes in bold and, following each version, added some comments.

Alternate 1

```
var mousePosition = thisComp.layer("mouse").transform.position;
var flyingSaucer = thisComp.layer("bird").transform.position;
var fishPosition = thisComp.layer("fish").transform.position;
var canPosition = thisComp.layer("can").transform.position;
var averagePosition = (mousePosition + flyingSaucer + ↴
fishPosition + canPosition)/4;
averagePosition
```

Comments: This is an absurd Expression. Why flyingSaucer? My point is that variable names can be whatever you want them to be. It makes sense to name them something relating to their function, like "birdPosition." But I wanted to make clear that they're not part of the JavaScript language. They're words that you make up. Another programmer might make up totally different words, such as m_Position and b_Position (instead of mousePosition and birdPosition). Get used to seeing different styles for variable names.

Alternate 2

```
mousePosition = thisComp.layer("mouse").transform.position;
birdPosition = thisComp.layer("bird").transform.position;
fishPosition = thisComp.layer("fish").transform.position;
canPosition = thisComp.layer("can").transform.position;
averagePosition = (mousePosition + birdPosition + ↴
fishPosition + canPosition)/4;
averagePosition
```

Comments: This time I removed all the "vars." I like adding them, because they make it clear that what follows is a variable. But they're optional, so some people omit them.

Alternate 3

```
var mousePosition = thisComp.layer("mouse").transform.position;
var birdPosition = thisComp.layer("bird").transform.position;
var fishPosition = thisComp.layer("fish").transform.position;
var canPosition = thisComp.layer("can").transform.position;
var numberOfFoodLayers = 4;
var averagePosition = (mousePosition + birdPosition + ↴
fishPosition + canPosition)/numberOfFoodLayers;
averagePosition
```

Comments: Some programmers like to assign all numbers to variables. That way (they argue), numbers are labeled and you know what they stand for. Without the variable, someone might look at the Expression and wonder, "Why is there a 4 in it?" The variable explains what it's doing there. It doesn't help the computer at all, but it's useful for humans who have to read and edit the Expression.

SIDEBAR
The Power of Parentheses

Can you solve this simple arithmetic problem?

If you answered 9, you're right—maybe. If you answered 10, you're also right—maybe. Huh? Well, let's look at two ways you can work this out.

Let's say you do the multiplication first. Forgetting the "+1" for second, you multiply 2 by 4 and get 8. Now, adding the 1, you get 9.

On the other hand, if you start with the addition, you add 4 + 1, which gives you 5. Then, if you multiply that result by 2, you get 10.

$$2 \times 4 + 1 = \,?$$
$$4 + 1 = 5$$
$$\times 2 = 10$$

Either answer is (possibly) correct, because the problem is ambiguous. Is it "2 times…4 plus 1" or "4 plus 1…times 2"?

Mathematicians have come up with a complex set of rules to follow when they come across ambiguous problems,* but you don't need to learn them. Instead, you can use parentheses. Just put the calculations that you want to be done first in parentheses. For instance,

$$(2 \times 4) + 1 = \,?$$

means *first* multiply 2 times 4, *then* add the 1. Whereas,

*Here is an abridged version of the rules: First complete any calculations inside parentheses. If there are parentheses inside parentheses, calculate whatever is inside the innermost parentheses first. Then do all multiplication and division calculations, running from left to right. Finally, do all addition and subtraction calculations, running from left to right. According to these rules, there's no need for parentheses in this calculation: 1 + (3 * 5). Multiplication is done before addition. Still, I always add the parentheses. It makes it clear to me which calculation will be done first, and it keeps me from having to memorize all of the complex rules.

means *first* add 4 plus 1, *then* multiply the result by 2.

This is why I used parentheses in the second-to-last line of the "averagePosition" Expression:

```
var averagePosition = (mousePosition + birdPosition + ↴
fishPosition + canPosition)/4;
```

If I'd left them off, the Expression would be ambiguous:

```
var averagePosition = mousePosition + birdPosition + ↴
fishPosition + canPosition/4;
```

What do I want AE to do first, the addition or the division? To clear up the ambiguity, AE would fall back on the complex rules that mathematicians have worked out. Among other things, these rules state that (unless there are parentheses) division should always be done before addition.

So first, AE would have divided canPosition by 4. Then it would have added mouse-Position, birdPosition and fishPosition to the result. But that's not what I meant at all. I didn't mean for canPosition to be special. I didn't mean for it to be the only variable divided by 4. I meant that all the variables should be added first. *Then* I wanted the resulting number to be divided by 4. Parentheses make my intentions clear.

COMMENTS

You can leave notes—comments—for yourself (or other coders) in Expressions. For instance,

```
var mousePosition = thisComp.layer("mouse").transform.position;
var birdPosition = thisComp.layer("bird").transform.position;
var fishPosition = thisComp.layer("fish").transform.position;
var canPosition = thisComp.layer("can").transform.position;
var numberOfFoodLayers = 4; //there are four "food" layers
//to get an average, divide the sum of all the values
```

```
//by the total number of values
var averagePosition = (mousePosition + birdPosition + ⬎
fishPosition + canPosition)/numberOfFoodLayers;
averagePosition
```

In JavaScript, everything following two forward-slashes is a comment. Comments are for people to read. The computer ignores them.

You can also include comments between a slash-asterisk and an asterisk-slash. This second kind of comment can span multiple lines:

```
/* this Expression was created by Marcus Geduld in 2008.
It ensures that the kitty layer stays at the average
position of the other four layers */
var mousePosition = thisComp.layer("mouse").transform.position;
var birdPosition = thisComp.layer("bird").transform.position;
var fishPosition = thisComp.layer("fish").transform.position;
var canPosition = thisComp.layer("can").transform.position;
var numberOfPreyLayers = 4;
var averagePosition = (mousePosition + birdPosition + ⬎
fishPosition + canPosition)/numberOfPreyLayers;
averagePosition
```

DIMENSIONS

I pulled a fast one on you in the previous chapter. I Pick Whipped willy-nilly, or created the illusion of doing so, and made it look like you could connect any property to any other property. In fact, you *can* connect any property to any other property, but in Chapter 1, I was careful to connect certain properties and to not connect certain others. Specifically, I only connected properties that had the same number of dimensions.

Dimensions? Am I talking about parallel worlds, time travel, or 3D modeling programs? Nope. I'm talking about how many numbers are associated with a particular property.

For instance, when you're working in 2D space,[2] Position has two dimensions, x and y. In other words, there are two numbers associated with Position. You can't say a layer is at Position 120. You *can* say it's at 120x and 253y. Position needs two numbers. Or, if Position is controlling some other property, you can say that it spits out two numbers. Scale is also two-dimensional (in 2D space): it has a width

[2] If you turn on a layer's 3D switch, Anchor Point, Position, Scale, and Rotation become three-dimensional. For instance, Position gains a third dimension, called z; x is the left/right dimension, y is the up/down dimension, and z is the closer/farther dimension. A particular layer might have a 3D position of 120x, 253y, 80z.

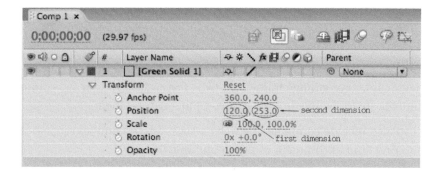

dimension and a height dimension. We worked with some other 2D properties: Write-on > Brush Position and Beam > Starting Position.

One-dimensional properties include Rotation (when you're not working in 3D mode), Opacity, Gaussian Blur > Blurriness, and Text Animation > Tracking Amount. Each of these properties has just one number associated with it. For instance, Opacity can be 62%, but it can't be 62%, 49%.

After Effects contains 1D, 2D, 3D, and 4D properties. The 3D properties include Position, Anchor Point, and Rotation, if you're working in 3D mode.

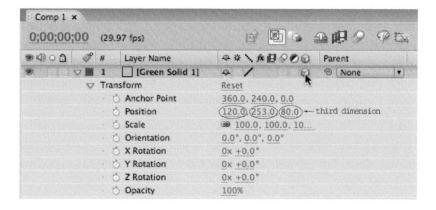

I used to wonder why Scale also gained a third dimension. If we were working in Maya or 3D Studio Max, we'd say Scale's third dimension is depth (of width, height, and depth fame). But in AE, if you scrub a 3D layer's third Scale dimension, it does not gain more depth. It always stays flat, like a postcard. In fact, some people call AE's 3D mode "postcards in space." So what's the purpose of Scale's third dimension? It has several purposes, but here's the one that's applicable to this book: making Scale 3D allows it to better hook up to other 3D Properties. If 3D Scale is controlling 3D Position, the dimensions will "line up." Scale's dimension order is width,

then height, then depth; Positions is x, then y, then z. So width will control x, height will control y, and depth will control z.

There's only one 4D property, and that's Color (in various Effects, such as Generate > Fill). What can that mean? It means Color has four numbers associated with it: a number for how much red is in the color, a number for how much green is in the color, a number for how much blue is in the color, and a number for how transparent the color is (its amount of "alpha").

When you pick a color from one of those handy little color chips, AE converts your choice into four numbers. It doesn't show you these numbers; it just shows you a color, but as we'll discover soon enough, if you understand the four dimensions of color, you can do some neat tricks.

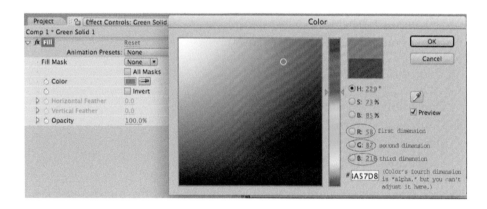

One quick detour before we start to play with dimensions: You need to know how they're numbered. Let's use 2D Position as an example. As you know, Position has two numbers associated with it: x and y. AE always lists dimensions in a specific order. It's always x and then y. It's never y and then x. Along the same lines, Scale is always listed as width and then height. It's never height and then width. Given this fact, a normal person would number Position's dimensions as

Dimension 1: x
Dimension 2: y

And a normal person might say x is Position's first dimension, and y is Position's second dimension. But JavaScript was invented by programmers, and programmers are not normal. (I should know. I program for a living.) Programmers count like this:

Dimension 0: x
Dimension 1: y

61

Programmers generally start counting with 0, not 1. So x is the zeroth dimension and y is the first dimension. In 3D, the dimensions are numbered:

Dimension 0: x
Dimension 1: y
Dimension 2: z

This isn't too hard to understand, but it's a little odd: there are three dimensions (three numbers associated with 3D Position), but the third dimension (z) is dimension 2, not dimension 3.

For width, the dimensions are numbered:

Dimension 0: width
Dimension 1: height
Dimension 2: depth (if the layer is 3D)

For color, the dimensions are

Dimension 0: red
Dimension 1: green
Dimension 2: blur
Dimension 3: alpha (Transparency/Opacity)

Because programmers always start numbering with 0, the highest-numbered dimension is always one-less-than the total number dimensions (so if we're working in 3D, the highest numbered dimension is 2).

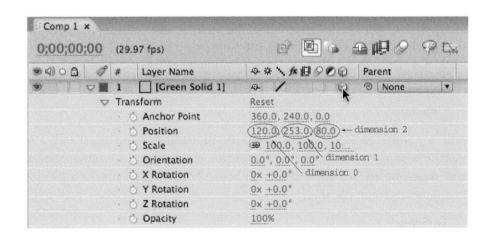

Sometimes I think that when programmers count on their fingers, then say, "I've got 10 fingers. See: 0, 1, 2 3, 4, 5, 6, 7, 8, 9. Like I said, 10 fingers!" And, when a programmer's first child is born, he calls it his zeroth child.

Let's take a look at the properties we connected in Chapter 1:

Rotation (1D)—Opacity (1D)
Position (2D)—Scale (2D)
Fast Blur: Blurriness (1D)—Text: Tracking Amount (1D)
Write-on: Brush Position (2D) —Beam: Starting Point (2D)

Not very adventurous. With Expressions, you can connect 2D properties to 3D properties, 1D properties to 2D properties, 4D properties to 2D properties, and every other permutation you can think of. But it's important to understand what happens when you mix dimensions. If you don't understand this outcome, you're likely to get a result that's very different from whatever you're trying to achieve. But let me make it crystal clear that you *can* use the Pick Whip to connect any two properties. Somehow, AE will make it work, something interesting will happen, and you'll never get an error.

How can properties with different numbers of dimensions communicate with each other? Think about it for a minute. Imagine you're trying to use Position to control Rotation. Position spits out two numbers (x and y), but Rotation can only eat one number. It's like you're trying to stick two keys into the same lock at once. So what happens? Let's see:

1. Open Chapter2.aep, Comp2. (Or create your own Comp containing one small solid.)
2. The Comp only contains one layer. Twirl open its properties, and add an Expression to Rotation.
3. Pick Whip Position.
4. Try dragging the layer around.

Notice that when you drag the layer left and right, it rotates.

63

But when you drag it up and down, it doesn't rotate.

65

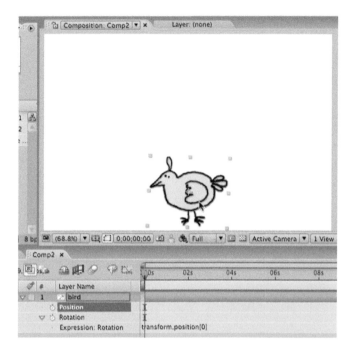

Why not? Because Position isn't controlling Rotation. Position's *x dimension* is controlling Rotation, and x is the left/right dimension. Remember, Rotation is 1D, so it can only eat one number. But Position spits out two numbers. So Rotation must eat one and ignore the other. But why eat x and ignore y?

Because x is Position's first dimension (or, as a programmer would say, its zeroth dimension), and degrees is Rotation's first dimension (it's zeroth dimension). Sure, Rotation only has one dimension, but if you only have one child, that child is still your first child. AE lines up the same-numbered dimensions.

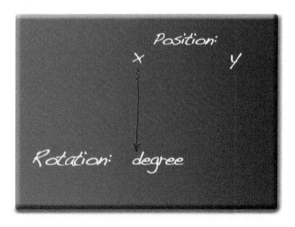

Let's take a look at the actual Expression on Rotation, created by the Pick Whip:

```
transform.position[0]
```

Notice the "[0]" after "position." That refers to Position's zeroth dimension, which is x. Try carefully editing the Expression, changing the 0 to a 1 (don't accidentally delete the brackets):

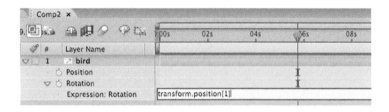

```
transform.position[1]
```

Now, once again, try dragging the layer around. Now, when you drag left and right, nothing happens:

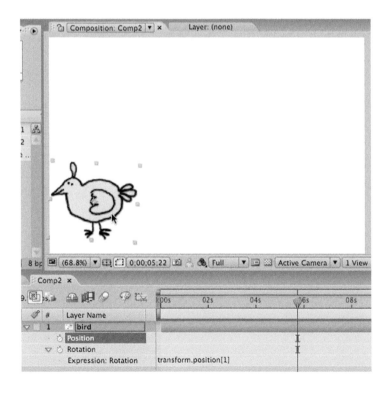

67

But when you drag up and down, the layer rotates:

This is because dimension 1 (what programmers call the second dimension) is y:

Here's the same chart with dimension numbers added:

By the way, if this is the effect you want, there's an easier way to achieve it than Pick Whipping and then changing the 0 to a 1.

Instead of dragging the Pick Whip to the word "Position," drag it directly to Position's y value. AE will put a 1 between the brackets instead of a 0, because

it will know—via your Pick Whipping—which dimension you want to use to control the Expression.

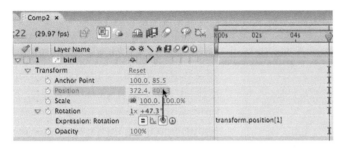

But if you just point to Position, how is it supposed to know which of Position's two dimensions you want to pipe into Rotation, a one-dimensional property? It doesn't, so it just falls back on a default rule, which is to line up same-numbered dimensions (dimension 0 to dimension 1). Even though I know this, I always forget to Pick Whip the dimension I want. But I don't fret about it. It's pretty easy to change a 0 to a 1.

Let's try another experiment, this time in 3D:

1. Remove the Expression from Rotation.
2. Turn on the layer's 3D switch.

Position and Rotation will now expand to three dimensions. In fact, Rotation will turn into four properties: X Rotation, Y Rotation, Z Rotation, and Orientation. X, Y, and Z Rotation are 1D properties. Orientation is a 3D property that single-handedly controls X, Y, and Z. We'll experiment with both.

3. Add an Expression to Z Rotation, and Pick Whip Position.

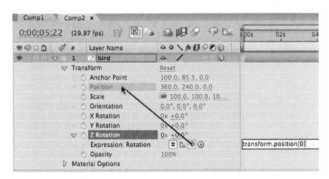

Try dragging the layer around. Once again, dragging left/right rotates the layer and dragging up/down doesn't. If you try scrubbing the layer's z Position, you'll see that, as with y, the layer doesn't rotate.

71

The Expression looks like this:

```
transform.position[0]
```

4. Change the 0 to a 2.

```
transform.position[2]
```

Now when you drag the layer left and right (or up and down), it doesn't rotate. But because dimension number 2 is z, if you scrub Position's z value, you'll see the layer rotate. You've created this sort of relationship.

Here's the same chart with dimension numbers added:

Before we move on, try removing the Expression from Z Rotation and adding one to Orientation. Then Pick Whip Position (the word "Position").

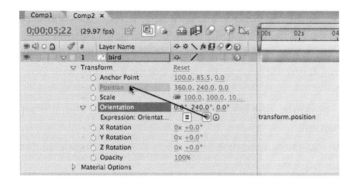

Unlike Z Position, which is 1D, Orientation is a 3D property. It can hook directly up to another 3D property, such as 3D Position, with no fuss. Try scrubbing the x, y, and z values for Position. Predictably, when you move the layer back and forth, it rotates around its x axis; when you move it up and down, it rotates around its y axis; and when you move it in and out, it rotates around its z axis.

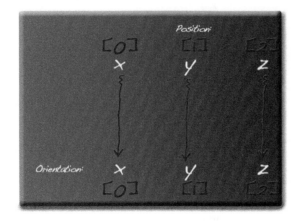

Earlier, we connected a 2D property (Position) to a 1D property (Rotation), so that the 2D property controlled the 1D property. Let's try it the other way around. What if you want to control a 2D property with a 1D property? Using our old friends Position and Rotation, what if we added an Expression to Position (2D) and Pick Whipped Rotation (1D)? Position *needs* two values, but Rotation only has one value to feed it. Where will the other value come from?

Before I answer that question, let's backtrack to the simplest possible sort of Expression: a number. In Chapter 1, we added an Expression to Rotation and typed "45." That makes sense: 45 degrees. But what if you wanted to write a similar Expression for Position. You can't just type 45, because Position

demands two numbers, one for x and another for y. Let's say you wanted to set x to 150 and y to 300. How would you type that as an Expression?

1. Open Chapter02.aep, Comp3 (or create a Comp with one small solid in it).
2. Twirl open the one layer's transform properties, and add an Expression to Position.
3. In the text-entry area, type "[150,300]" (no quotation marks) and finalize the Expression.

The layer moves to 150x, 300y.

In JavaScript, a comma-separated list, surrounded by brackets, is called an array. "Array" is just a fancy programmer's term for a list. Because Position is a 2D (or sometimes 3D) property, it can't accept just one number; it requires a list of numbers. You must type that list in a way that JavaScript understands, and JavaScript understands array lists, which are surrounded by square brackets.

4. Turn on the layer's 3D switch.
5. Update the Expression so that it looks like this

 [150,300,1800]

Arrays can contain as many, or as few, values as you like, but the values must be separated by commas and be enclosed within brackets. And the order is important. Because Position's dimensions are ordered x, y, and z, the array's values will be piped into Position in that order:

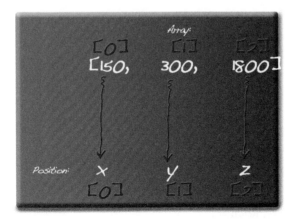

The array values needn't be simple numbers. Try updating the Expression as follows:

```
[10 + 10 + 10, 100 + 100 + 100, 1000 + 1000]
```

I can't think of a good reason to write an Expression like that, but it works.

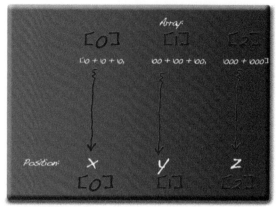

> **SIDEBAR**
>
> **Arrays for All Properties**
>
> Many properties, even the 1D ones, accept arrays. For instance, Rotation can be [45] and Opacity can be [50]. An array is a list, and you use it to list all the values for a property's dimensions. Rotation and Opacity only have one dimension, so it makes sense to give them lists that only have one item in them.
>
> There's no advantage to typing [50] instead of 50. Either works. The second is shorter, so most people use it. But there's a neat logic to arrays:
>
> - Rotation [45]
> - Scale [210, 80]
> - 3D Position [150, 200, 900]
> - Color [.5, 1, 0, 1]

Here's another variation you can try:

1. Remove the Expression from Position. Add it back. (Add a new Expression to Position.)

2. Type an open bracket:

   ```
   [
   ```

3. Pick Whip X Rotation:

   ```
   [transform.xRotation
   ```

4. Type a comma and a space. The space is optional:

   ```
   [transform.xRotation,
   ```

5. Pick Whip Y Rotation:

```
[transform.xRotation, transform.yRotation
```

6. Type another comma and a space:

```
[transform.xRotation, transform.yRotation,
```

7. Pick Whip Z Rotation.

```
[transform.xRotation, transform.yRotation, transform. ⤾
zRotation
```

8. Type a close bracket:

```
[transform.xRotation, transform.yRotation, transform. ⤾
zRotation]
```

Try rotating the layer around its different axis. As you do, it will also change its position.

That Expression works fine, but I find it a little hard to read. So here's my rewrite, using variables to clarify what's going on:

```
var xPosition = transform.xRotation;
var yPosition = transform.yRotation;
var zPosition = transform.zRotation;
[xPosition,yPosition,zPosition]
```

Now, just to prove to you that all work and no play makes Marcus a dull boy, I'm going to show you a great practical joke you can play on an AE-using friend. First ask him, "Have you read *After Effects Expressions*?" If he says no, you're on:

1. Wait until he leaves his desk for a minute and then quickly reveal the Position property of any layer in his Comp. (You can practice with Chapter02.aep, Comp4 or any Comp with a solid in it.)
2. Add an Expression to Position.
3. Type an open Bracket.
4. Pick Whip Position's y value:

```
[transform.position[1]
```

Yes, you're controlling Position with it's own y value.

5. Type a comma and a space.
6. Pick Whip Position's x value.
7. Type a close bracket:

```
[transform.position[1], transform.position[0]]
```

77

8. Quickly hide the Position property and dash back to your seat. When your friend returns, he'll try to drag the layer up and down, but it will move left and right. He'll try to drag it left and right, but it will move up and down.

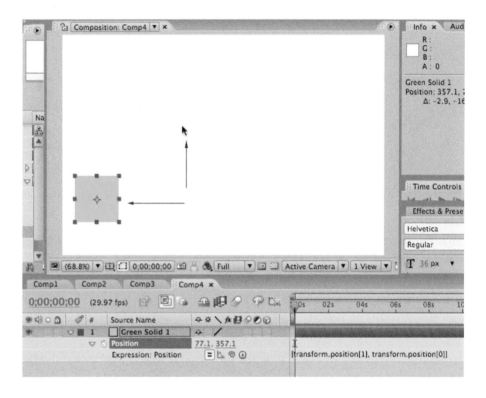

Why does this trick work? Because `transform.position[1]` is Position's y value and `transform.position[0]` is its x value. And you're listing them in the wrong order.

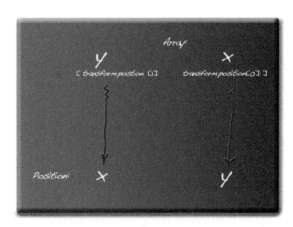

Here's a variation on the practical joke that I've actually used in a couple of projects:

1. Open Chapter02.aep, Comp5, or create your own Comp with two solids in it, a red one and a green one
2. Select both layers and press the P key to reveal their Position properties.
3. Add an Expression to Red's position.
4. Type an open bracket; then Pick Whip Green's y-position value:

```
[thisComp.layer("Green").transform.position[1]
```

5. Type a comma and a space, Pick Whip Green's x-position value, then type a close bracket:

```
[thisComp.layer("Green").transform.position[1], this
Comp.layer("Green").transform.position[0]]
```

6. Drag the green layer around. The red layer will mirror it, but in an odd way. When Green moves up and down, Red moves left and right; when Green moves left and right, Red moves up and down. If you understand the Expression, you know what's going on, but to the casual observer, the layers just seem to have an interesting relationship.

Here's a rewrite of the Expression, for clarity:

```
var xPosition = thisComp.layer("Green").transform.
position[1];//green's y
var yPosition = thisComp.layer("Green").transform.
position[0];//green's x
[xPosition, yPosition]
```

79

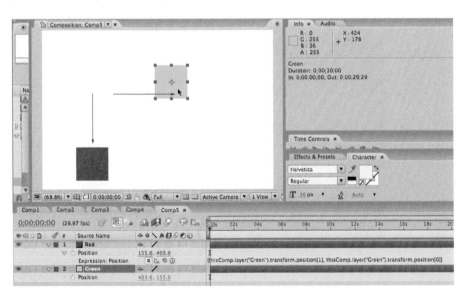

Using this Comp as a starting point, I added two more pairs of layers: a Blue and Yellow pair that mirror each other and a Cyan and Magenta pair that mirror each other. I then animated the "leader" layers (the ones without Expressions: Green, Blue, and Cyan) moving randomly around the screen. Their mirrors followed suit. Finally, I topped all the dancing layers with an adjustment layer, to which I added a Gaussian blur. You can check out the result in Chapter02.aep, FunkyBackground.

Before moving on, I'd like to suggest some simple variations of the sort of array Expression we've been making. Starting with a one-layer Comp, such as Chapter02.aep, Comp6, try adding the following Expression to Position:

```
[transform.position[0], transform.opacity]
```

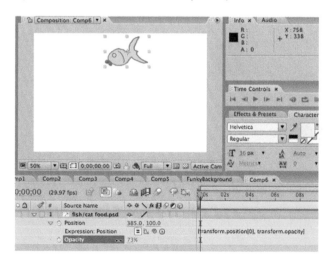

You'll be able to drag this layer left and right, because its x is value `transform.` `position[0]`, which is its x. It's like saying, "let this layer's x be whatever it is." On the other hand, you won't be able to drag it up and down. Instead, scrub its Opacity value to change the layer's y Position.

Here's another variation:

```
[300,transform.position[1]]
```

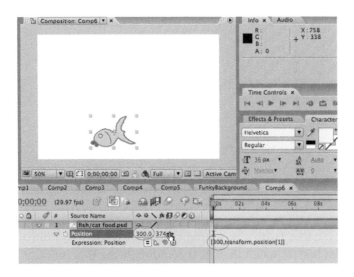

You won't be able to drag this layer left and right. It's x Position is frozen at 300. On the other hand, you can drag it up and down.

One more:

```
[transform.opacity, transform.rotation]
```

You can't drag this layer in either dimension, but you can scrub Opacity to move it left and right; and you can scrub Rotation to move it up and down.

Now that you understand arrays, variables, and dimensions, I can finally show you what happens when you add an Expression to a two-dimensional property and Pick Whip a one-dimensional property:

1. Staying with our current Comp, remove the Expression from Position.
2. If necessary, press Shift+R to reveal the Rotation property.
3. Add an Expression back to Position.
4. Pick Whip Rotation.

AE adds an Expression to Position. It's two lines long, but you can only see the first line by default.

5. Point to the lower lip of the text-entry area. When your cursor becomes a double-headed arrow, drag the lip downward to reveal the whole Expression:

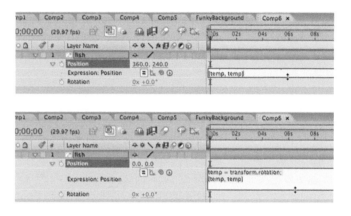

```
temp = transform.rotation;
[temp,temp]
```

AE used a variable (with the boring name of "temp") to hold the value of Rotation. If it had skipped this step, it could write the Expression as

```
[transform.rotation, transform.rotation]
```

6. Rotate the layer, and you'll see it move diagonally. This is because the same value (Rotation) is being fed to both x and y. So if Rotation is 45 degrees, Position is 45x, 45y.

You can think of Rotation's relationship with Position like this:

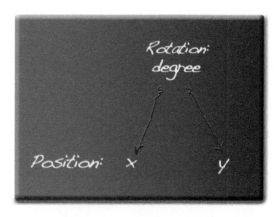

And if you factor in the variable temp, you get this:

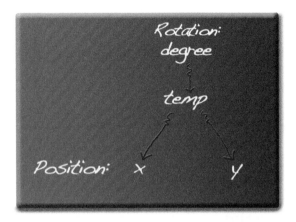

The variable version is useful if you want to add additional calculations to the Expression:

```
temp = transform.rotation + 10;
[temp,temp]
```

That's easier to write, make changes to, and understand than

```
[tranform.rotation + 10, transform.rotation + 10]
```

If you use this second version and decide to change the 10 to a 20, you might accidentally forget to change both 10s:

```
[tranform.rotation + 20, transform.rotation + 10] //oops!
```

If you stick to the variable version, you can change the 10 in one place, and both dimensions will be updated.

Before we move on from dimensions (and from this chapter), a word about color. I mentioned that AE sees a color as four-dimensional. Getting more specific, it sees color like this:

```
[red, green, blue, alpha]
```

(Alpha is the same as opacity.)

Color is an array of four values. In a real Expression, those values would have to be numbers, not the words "red," "green," "blue," and "alpha." But what numbers?

If you've spent years working with the RGB-color system, you're probably used to thinking of each color's value as being a number between 0 and 255. Alas, AE doesn't work this way. It sees each color's value as a number between 0 and

1. 0 means "none of that color," whereas 1 means "100% of that color." For instance,

```
[1, 0, 0, 1]
```

means red: 100% red, no green, no blue, and completely opaque (100% for alpha);

```
[1, 0, 0, 0]
```

is also red, but it's invisible, because the alpha is 0;

```
[1, 0, 0, .5]
```

is 50% transparent red.

[0, 0, 1, 1] is blue.
[0, 0, 0, 1] is black.
[1, 1, 1, 1] is white.
[1, 0, 1, 1] is magenta.
[.2, .2, .2, 1] is a very dark shade of gray.

To test out this wacky version of color, open Chapter2.aep, Comp7 (or any Comp containing a solid):

1. Select the layer and, from the menu, choose Effect > Generate > Fill.

 Fill is a really simple effect that colorizes all opaque pixels in a layer with a color of your choice.

2. In the Effect Controls panel, add an Expression to Fill's Color property.

3. In the Timeline, enter the Expression [0,0,1,1].

The layer will turn blue. You can now play around with some of the color Expressions we just went through (and some more of your own), but note that the Fill effect ignores the alpha value. You can set it to 0, 1, or something in between. It won't make any difference. The color will always be opaque.

It would be fun to hook those color values up to other properties, such as Rotation. For instance, you could write an Expression that makes a layer get redder as you rotate it. The problem is that red needs to be a value between 0 and 1, but Rotation is going to spit out values much higher than that. There are various ways to deal with this problem. For the time being, we'll solve it by using an equation. Don't worry right now if you don't understand how it works.

Let's say you have a range of numbers, such as 0 to 360. You'd like to convert those numbers to the range 0 to 1, as follows:

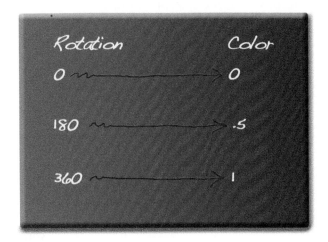

Note: In AE, Rotation can go over 360. I'm going to assume here that you're not going to let that happen. (You'll just have to restrain yourself from rotating the layer more than one time around. You'll also have to restrain yourself from rotating it counterclockwise, because that yields negative numbers for degrees.)

To make the conversion, you take the Rotation value and divide it by 360. For example, if Rotation is 180 degrees:

Generalizing this equation, to make it more useful, we get

`ORIGINAL_VALUE/MAXIMUM_VALUE = NEW VALUE`

Putting this to use, let's change the Expression to

```
var redPart = transform.rotation/360;
var greenPart = transform.pacity/100;
var bluePart = transform.position[1]/486; //assuming an NTSC
D1 Comp
var alphaPart = 1;
[redPart, greenPart, bluePart, alphaPart]
```

If you rotate the layer clockwise, it will get redder; if you make it more opaque, it will get greener; if you move it down, it will get bluer:

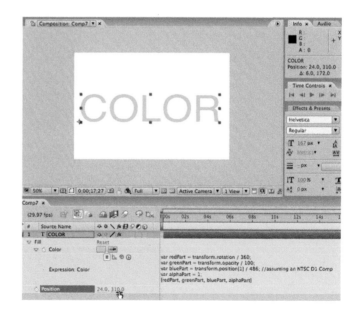

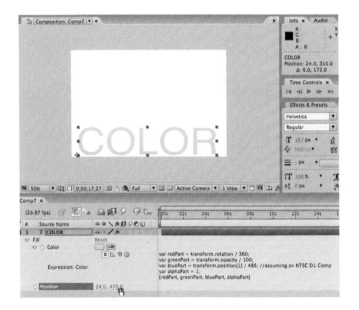

There's a big problem with this conversion method: it only works if both ranges start at 0 (0 to 360, 0 to 1). It will fail if, say, a range runs from 10 to 110 or −200 to 200. Never fear. We'll solve that problem in Chapter 3.

Commands

You can give a dog English commands: Sit! Stay! Fetch! What if dogs understood JavaScript? If they did, you'd type out commands to them like this:

```
sit()
```

or this:

```
stay()
```

In JavaScript, commands are orders, telling After Effects to *do* something. And most JavaScript commands end with parentheses. Why? Well, what if they didn't? What if commands looked like this?

```
sit
```

or this?

```
stay
```

How could the computer tell that these aren't variables? Both commands and variables are words, but otherwise they are very different from each other. Variables store values; commands tell AE to do something. So there needs to be some kind of marker that tells the computer when a word is a variable and when it's a command. And the marker is (). If a word ends in parentheses, AE knows it's a command.

(As I mentioned in Chapter 2, you need to be especially careful not to use a reserved word as a variable name. If you do, AE will assume you're refer-ring to the reserved word, not your variable. You *can* use a reserved word as a command name, as long as you follow the name with open-close parentheses.)

Getting back to dogs, let's examine the fetch command. Sometimes you want Rover to fetch a stick, sometimes you want him to fetch a ball, and some-times you want him to fetch your slippers. It seems wasteful to have three commands:

```
fetchStick()
fetchBall()
fetchSlippers()
```

If we go down that road, we'll need an infinite number of commands:

```
fetchNewspaper()
fetchSqueekyToy()
```

and so on.

JavaScript solves the problem of similar but slightly different commands in an elegant way:

```
fetch(stick)
fetch(ball)
fetch(newspaper)
```

There's just one command—fetch()—but that command accepts *parameters*. Parameters are extra bits of information that refine the command. Or you can

think of them as inputs—information that you're feeding into the command. In either case, you put parameters inside the parentheses that follow commands.

Some commands accept multiple parameters. In doggie JavaScript, you can tell a dog to fetch three things at once this way:

```
fetch(stick,ball,slippers)
```

So if there are multiple parameters, you separate them with commas.

SIDEBAR

Words! Words! Words!

In my view, the most confusing thing about programming is all the jargon that programmers use. I'm trying to cut through some of it here, by using the word "command." It's a nice, easy-to-understand word. But it's not the term programmers use for statements that look like this: sit().

Programmers have two words for such things: "function" and "method." A programmer might talk about the sit function or the sit method. There's a technical difference between functions and methods, which I'm not going to get into yet. Most programmers I know use the two words interchangeably.

As you know, functions (or commands/methods) can accept parameters. Programmers actually *do* use the word "parameters." They also use the word "arguments." Given the command fetch(slippers), one programmer might say that "slippers" is a parameter, whereas another might say that it's an argument. If you showed that second programmer this command:

```
fetch(stick,ball,slippers)
```

that programmer would say, "You're giving the fetch method three arguments." The first programmer might say, "You're giving the fetch function three parameters."

THE WIGGLE() COMMAND

My favorite AE Expression command is wiggle(). The wiggle command randomizes a property (I'll explain more about what that means shortly); wiggle accepts two parameters (actually, it will accept up to five parameters, but I generally give it only two). So you might type

```
wiggle(2,100)
```

or

```
wiggle(5,12)
```

The first parameter (2 and 5 in the examples) means *how often* (in times per second) you want the property to wiggle; the second parameter is *how much* you want it to wiggle.[1]

In "template" form, wiggle looks like this:

```
wiggle(HOW_OFTEN,HOW_MUCH).
```

Sometimes I'll show you Expressions in this form, with parameters as words in all caps. You should never actually type them like that. Rather, you should replace the all-caps words with specific values, usually numbers.

I find templates useful for showing the general usage of an Expression. I'm being a little like your old English teacher, when she wrote this template on the board: SUBJECT VERB OBJECT. She didn't mean for you to write "SUBJECT VERB OBJECT" in your essays. She meant for you to replace the template words with actual subjects, verbs, and objects.

I find templates useful in my own notes. If I see a specific Expression in a book, online, or in a colleague's .aep file, I often write it down for myself in template form. When I look back at my notes, wiggle(HOW_OFTEN,HOW_MUCH) is more meaningful than wiggle(5,12), although I often write such a real-life example next to the template.

One more thing about wiggle() (and all the commands) before we start using it: it's "wiggle," not "Wiggle." JavaScript is case sensitive, and commands *always* start with lowercase letters. If a command is more than one word long, you type it in camel case, such as with the valueAtTime() and loopOut(), commands that we'll explore later in this chapter. But the first word (e.g., "value" and "loop") always starts with a lowercase letter. Because wiggle is only one word, all of the letters are lowercase.

Okay, let's start wiggling:

1. Open Chapter03.aep, Comp1, or create a Comp with one small solid in it.
2. Twirl open the layer's Transform properties, and add an Expression to Position.
3. Type the following:

```
wiggle(1,40)
```

[1]Officially, these properties are called *frequency* (how often) and *magnitude* (how much).

4. Preview the Comp.

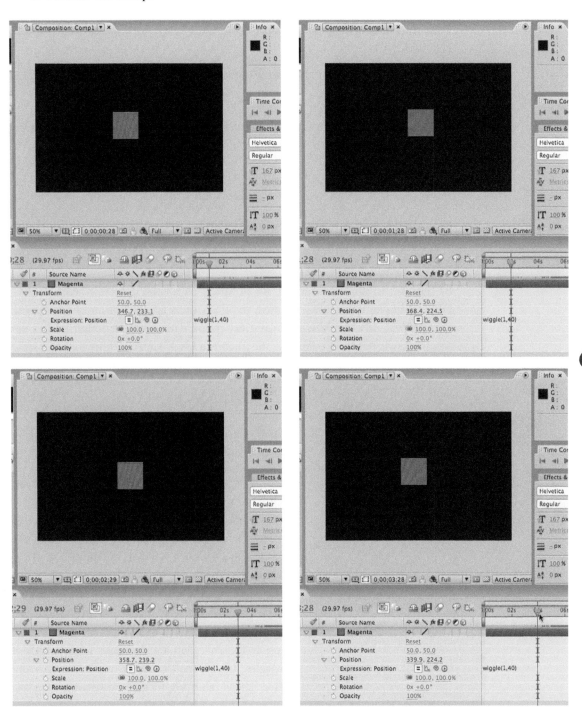

You'll see the layer happily wiggling around randomly. Specifically, this layer is moving to a new location one time per second (HOW_OFTEN). Each time it moves, it moves up to 40 pixels away from its starting position (HOW_MUCH).

5. Now try changing the 1 to a 7, and then preview the Comp again:

```
wiggle(7,40)
```

As you can see, the layer is moving much faster (and more often). It's wiggling seven times every second.

6. Try changing the 7 to .5 (point 5) and previewing:

```
wiggle(.5,40)
```

Now the layer moves slowly. Because 7 means "seven times per second" and 1 means "one time per second," .5 means "every other second" (or "once every 2 seconds").

By the way, in an NTSC Comp, it's pointless to set the first parameter (HOW_ OFTEN) higher than 29.97. Because, in NTSC, there are 29.97 frames per second, wiggle(29.97,40) would wiggle on every frame. There aren't enough frames per second to wiggle(31,40). For PAL the maximum is 25, and for film it's 24.

7. Now change the 40 to 400. Play the Comp:

```
wiggle(.5,400)
```

Wow! Each time the layer moves, it moves up to 400 pixels away from its starting position.

"Away from its *starting position*" is key here. Our layer is in the center, so when it moves, it moves 400 pixels away from there. Had we started with our layer near the right edge of the Comp, we wouldn't see it much of the time. That's because whenever it happened to move (via the wiggle) to the right, it would be off screen. When applying wiggle, think carefully about the starting value of whatever property you're applying it to. That will be the base from which it wiggles. If you look carefully, you'll see that the layer keeps returning to its base between wiggles.

8. Leaving Position set to wiggle(.5,400), add an Expression to Scale:

```
wiggle(1,200)
```

97

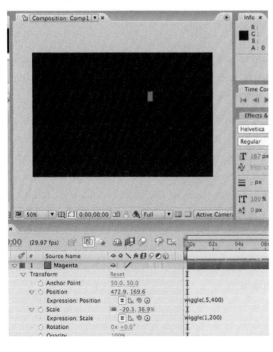

We're asking the layer to change its size once per second. Scale's values are always in percentages, so by setting HOW_MUCH to 200, we're telling the layer to veer up to 200% from its starting Scale, each time it wiggles. Its starting Scale is 100%, so our Expression lets it veer all the way up to 300% its original size (100% + 200% = 300%). It can also go down to negative 100% (100% − 200% = −100%).

98

The key point here is that, in this case, wiggle() is generating percentages, whereas when we used it on Position, it generated pixels. It outputs in units of the property at hand.

Actually, it would be more accurate to say that wiggle() generates a type of random numbers. The specific property you apply it to interprets those numbers as percentages, pixels, degrees, or whatever is appropriate to it.

(Note that wiggle() generates new random numbers on each frame, but the numbers from one frame to the next are really close to each other, so that values don't wildly jump from frame to frame. Imagine strange dice that, once they rolled a four, could only role a three or five. They couldn't roll a one, because that would be too much of a jump from four. However, if on the next throw, they rolled a three, they could then roll two or four on the throw after that.)

9. Add this Expression to Rotation:

```
wiggle(1,360)
```

10. Add this Expression to Opacity:

```
wiggle(1,100)
```

11. Preview the Comp.

99

Your layer is moving, resizing, spinning, and fading. But we're not done.

12. From the menu, choose Effects > Generate > Fill.

13. In the Effect Controls panel, click the little chip and set the color to medium gray.

The easiest way to do this is to use the HSB controls. Set H to 0 (gray has no hue), S to 0 (gray has no saturation), and B to 50 (50% bright). Or you can set RGB to 128, 128, 128.

14. Add this Expression to Color:

```
wiggle(1,.5)
```

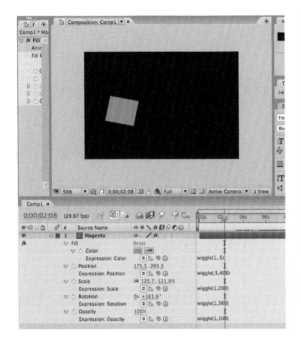 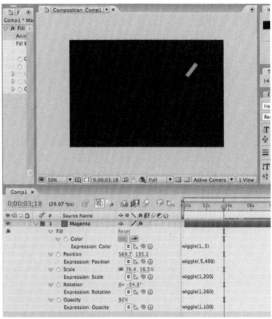

Why point 5? Remember that AE sees color values as ranging from 0 to 1. By starting the color at medium gray, you're setting red, green, and blue to .5, because medium gray is halfway between 0 and 1. True, in the color-picker dialog, the numbers say 128. That's because most designers are used to a 0-to-255 range for color values; 128 is halfway between 0 and 255. AE is being user-friendly by displaying 128. Internally, it's thinking .5.

So we're starting the color at .5. Our Expression's HOW_MUCH parameter lets it veer .5 above or below that:

```
.5 + .5 = 1 (two halves equal a whole)
.5 - .5 = 0 (any number minus itself equals 0)
```

Via our Expression, we're letting our starting value—medium gray—morph into any color of the rainbow. This is another example of how vital starting values are to wiggle(). The color is wiggling away from (and back to) medium gray. Let's say you wanted to constrain wiggle to shades of blue. The easiest way to do this is to handpick blue as the starting color and then to wiggle slightly away from it. Maybe wiggle(1,.09); wiggle(1,.2) would veer a bit farther.

15. For a final bit of fun in this Comp, select the solid and press Command + D (PC: Control + D) many times—say, 15. Little wiggling solids will appear all over the place.

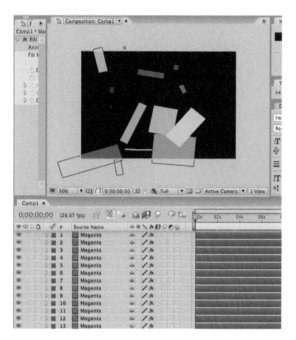

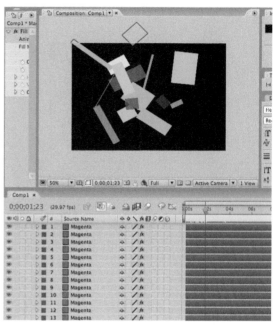

Why are they all different? Because wiggle() "rerolls the dice" for each layer.

WIGGLE() WITH EFFECTS

The wiggle() command is one of those gifts that keeps on giving. It's useful any time you want to inject a little randomness into your Comp. I've found that randomness is much easier for my computer than it is for me. For instance, if I wanted to simulate a trail or smoke blowing this way and that, I'd leave the heavy work up to wiggle(). Here's how:

1. Open Chapter03.aep, Comp 2, or create a 10-second Comp with a Comp-sized solid in it. The solid's color doesn't matter.
2. Apply Effect > Simulation > Particle Play-ground to the solid.
3. In the Effect Controls panel, twirl open the Cannon properties.
4. Move the Cannon position to just below the bottom center of the Comp.

If you have the Particle Playground effect's name selected in the Effect Controls panel, you can drag a little crosshair in the Comp window to move Cannon.

103

 5. Twirl open Gravity, and set Force to 0.

If you play the Comp, you'll see a little stream of particles shoot upward from the Cannon. Because you turned off gravity, the particles never fall.

6. In the Cannon property group, change the color to white.

7. Also in the Cannon group, set Direction Random Spread to 4. This will tighten up the stream, preventing it from fanning out as much. Smoke streams tend to be pretty thin.

8. Add an Expression to Cannon > Direction (not Direction Random Spread).

Remember, you can Option click (PC: Alt click) right in the Effect Controls panel. But you'll write the Expression in the Timeline.

9. Type `wiggle(.3,90)`.

After Effects will randomly veer the stream's direction up to 90 degrees clockwise or counterclockwise from its starting position. Play with the .3 to make the stream veer faster or slower. Play with the 90 to loosen or tighten the veering.

10. Apply Effects > Blur & Sharpen > Fast Blur to the layer.
11. Set Effect Controls panel > Fast Blur > Blurriness to 16.

Now all you need is a cigarette smoldering in an ashtray, or a roof with a chimney. Alas, Expressions can't make those for you. You'll have to use good old human creativity.

WIGGLE() WITH KEYFRAMES

In most instances, you'll use either keyframes or an Expression, not both, to animate a property. Remember, Expressions are options (or alternatives) to keyframes, which is how we remember the key to press when adding them. The wiggle() command is a rare exception. Because wiggle() randomizes away from the current value, it's okay to set the current value with keyframes and then use wiggle to veer away from it:

1. Open Chapter03.aep, Comp3.
2. Select the white dot layer and type P to reveal its Position property.
3. With the Current Time Indicator (CTI) at the start of the Timeline, click the stopwatch to set a keyframe.
4. Move the CTI to 2 seconds.
5. Drag the dot to the right side of the Comp, so that it moves from left to right, over the course of 2 seconds.

If you preview the Comp now, you'll see that the dot moves horizontally in a straight line. That's pretty boring. Let's add some spice with wiggle().

6. Option click the Position stopwatch (PC: Alt click it), and add this Expression:

```
wiggle(2,80)
```

If you preview the Comp again, you'll see some healthy wiggling, as the dot veers away from your keyframed movement. But note that it's still obeying the general pattern you laid down with keyframes.

107

As always, have fun playing around with HOW_OFTEN and HOW_MUCH parameters.

7. For some pizzazz, add Effect > Blur & Sharpen > Fast Blur and set Blurriness to 5.

8. Add Effect > Stylize > Glow. Set Glow Threshold to 40, Glow Radius to 24, Glow Intensity to 5, Glow Colors to A & B Colors, and Color B to Yellow.

9. With the layer selected, Choose Layer > Precompose… from or press Shift + Command + C (PC: Shift + Control + C).

10. In the Precompose dialog, set the name to Wiggling Dot and choose the option called "Move all attributes into the new composition." Then click the OK button.

109

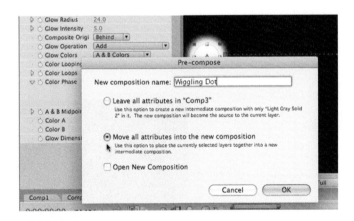

11. Select the Wiggling Dot layer and apply Effect > Time > Echo. Set Number of Echoes to 11, starting intensity to 0.74, and Decay to 0.74 also.

Because you "baked" the blur and glow effects into the layer by precomposing them with the dot, the Echo effect adds those effects to all of the echoes.

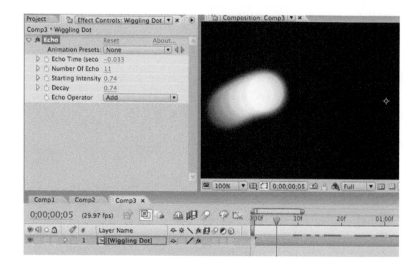

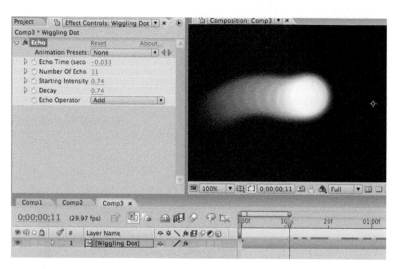

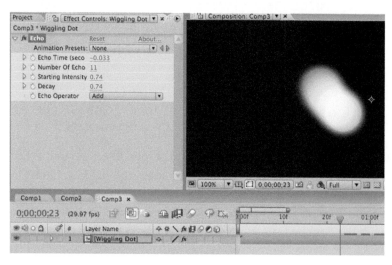

As you preview the Comp, you'll notice that though the effect is pretty cool; the dot keeps wiggling after if reaches the right edge of the Comp. Here's how to stop the wiggle:

12. Option + double-click (PC: Alt + double-click) the Wiggling Dot layer to open the precomp.
13. If you can't see your original Expression, select the white dot layer and type EE (the E key twice, fast).
14. Edit the Expression, so that it reads as follows:

```
if (time < 2) { wiggle(2.80) } else { transform.
position }
```

> **Note**: That's a less-than symbol between "time" and "2." It's Shift + comma on your keyboard. And those are curly braces around "wiggle(2.80)" and "transform.position." An open curly brace is Shift + [. A closed one is Shift +].

That's a complicated Expression. I threw an advanced one at you, just to keep you on your toes. It's not important that you understand all of it right now. (We'll be delving into such Expressions later.) But here's a brief overview:

- "If (time < 2)" means "only do the following if the CTI is before (less than) 2 seconds in the Timeline." Remember, at 2 seconds, the dot stops moving from left to right.
- The text between the first set of open-close curly braces tells AE what to do if, indeed, the CTI is at some time before 2 seconds. If it is, we want the dot to wiggle. And "else" means "here's what I want you to do if the CTI is at 2 seconds or later."
- Everything after that, within the second set of curly braces, tells AE what to set Position to after 2 seconds have passed. In this case, we want to leave it as it is, so we give it the default Expression—transform.position—which means "leave Position unchanged."

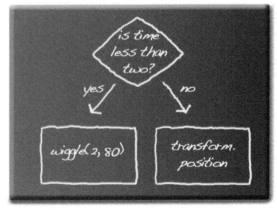

Here's another version that does the same thing:

```
if (time < 2) { wiggle(2.20) } else { value }
```

In this example, "value" means the current property's value without the Expression. So if time is less than 2 seconds, wiggle the layer; however, if time is 2 seconds or later, leave the layer at its keyframed value.

WIGGLE AND DIMENSIONS

The wiggle() command is great, but it can be a little hard to control. For instance, if you apply wiggle() to Scale, the layer will randomly grow bigger and smaller in both the width and height dimensions. What if you want it to stay at its original width and just randomly grow taller and shorter? What if you want it to just grow randomly taller but not shorter? What if you want an eyeball to randomly look left and right but never up and down? We'll solve that problem, now:

1. Open Chapter03.aep, Comp4.

It's an eye, which I created using three layers. The bottom layer, "eye bg," is an ellipse; the middle layer, "eyeball," is a circle; the top layer is another ellipse (it acts as a matte for the eyeball layer, making sure that if you move the eyeball, you can only see it when it's inside the boundaries of the background).

2. Select the "eyeball" layer, and type P to reveal the Position property.
3. Add an Expression to Position.

You may need to grab the text entry area's lower edge and pull down. You'll be writing a three-line Expression. But first, let's write a simple one-liner to illustrate what won't work.

4. In the text-entry area, type

```
wiggle(1,100)
```

5. Preview the Comp.

We just want the eyeball to move left and right. But because Position is a 2D property, wiggle() spits out two numbers, one for Position's x axis and another for Position's y axis. So the eyeball is wiggling up and down as well as left and right.

If you imagine that wiggle() is a dice-rolling machine, you should think of it as one that can roll any number of dice. For instance, if you apply wiggle() to a one-dimensional property, such as Opacity, wiggle() is a one-die-rolling machine. Each time it is turned on (each time its HOW OFTEN happens), it rolls one die.

If you apply wiggle() to Position (on a 2D layer), wiggle() turns into a two-dice-rolling machine. Every time it's turned on, it rolls one die for x and another for y.

By now you should know that if you apply this Expression to a layer's Position property, the layer will wiggle up to 100 pixels both horizontally and vertically:

```
wiggle(1,100)
```

Here's another version of the Expression, which will do exactly the same thing:

```
var twoDice = wiggle(1,100);
twoDice
```

There's no good reason to write that second version, because it takes longer to type than the first one, but it will illustrate some key points, so let's go through it.

On the first line, I created a variable called twoDice, in which I stored two numbers—the two numbers that "wiggle(1,100)" generates. Why does "wiggle(1,100)" generate two numbers? Because I applied the Expression to Position, which is a two-dimensional property.

On the second line, I used the two numbers in twoDice to control Position. (Remember, the last line of the Expression sets the value of the property that the Expression is applied to, so that last line is like saying "Position = twoDice.")

For the last line, I could also write

```
[ twoDice[0], twoDice[1] ]
```

and the Expression would have the same effect.

Here's a third (even more verbose) way of writing the same Expression:

```
var twoDice = wiggle(1,100);
var dieA = twoDice[0];
var dieB = twoDice[1];
[dieA,dieB]
```

Just as you can get at the x dimension of Position by typing position[0] and the y dimension by typing position[1], you can access the two dimensions of a Position wiggle() with [0] and [1].

Here, I've changed the names of the variables, getting rid of the dice metaphor:

```
var bothDimensions = wiggle(1,100);
var horizontal = bothDimensions[0];
var vertical = bothDimensions[1];
[horizontal,vertical]
```

Let's say that we only want the layer to move up and down. Horizontally, we want it to stay static at 300 pixels in from the left edge of the Comp:

```
var bothDimensions = wiggle(1,100);
var horizontal = 300;
var vertical = bothDimensions[1];
[horizontal,vertical]
```

Or if we've animated the layer, so that it's moving from left to right, and we want it to wiggle up and down while it's doing that, we could rewrite the Expression as

```
var bothDimensions = wiggle(1,100);
var horizontal = transform.position[0];
var vertical = bothDimensions[1];
[horizontal,vertical]
```

Now, the y axis (vertical) is being controlled by the wiggle(); the x axis is being controlled by itself (transform.position[0]).

We're finally ready to fix our eyeball animation.

6. Rewrite the Expression on the "eyeball" layer as follows:

```
var bothDimensions = wiggle(1,50);
var horizontal = bothDimensions[0];
var vertical = transform.position[1];
[horizontal,vertical]
```

7. Preview the Comp.

The eye moves left and right, just as ordered.

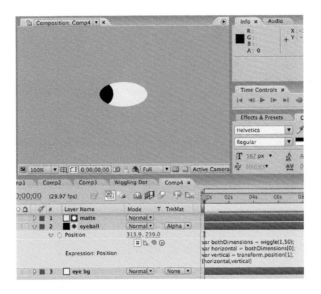

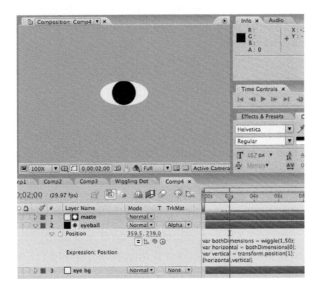

117

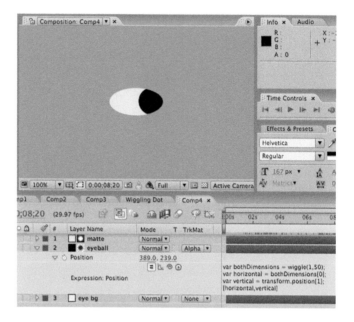

Incidentally, here's another way you could have written the Expression, which would have worked identically:

```
var horizontal = wiggle(1,50)[0];
var vertical = transform.position[1];
[horizontal,vertical]
```

Rather than storing the two "dice rolls" in a variable (bothDimensions), you can just grab die roll[0] right away. And there's nothing magical about die[0]. This would work just as well:

```
var horizontal = wiggle(1,50)[1];
var vertical = transform.position[1];
[horizontal,vertical]
```

Note that wiggle() (when applied to a 2D property) has two dimensions, but both of those dimensions are random numbers, so it really doesn't matter if you grab dimension [0] or dimension [1].

Careful! Be aware that wiggle(1,50)[2] and wiggle(1,50)[3] will cause problems. The 2D version of Position doesn't have a third dimension, and no version of Position has a fourth dimension. So if you apply wiggle() to a 2D Position property, you can only access dimensions [0] and [1] of the wiggle(), never dimensions [2], [3], or higher.

118

Here's yet another way you could have rewritten the Expression:

```
[ wiggle(1,50)[0], transform.position[1] ]
```

Very compact. But it's a bit hard to read, don't you think? I prefer to use variables. But while we're at it, here's a final version, making use of the fact that the two wiggle() dimensions are interchangeable:

```
[ wiggle(1,50)[1], transform.position[1] ]
```

Once you understand that wiggle() has its own dimensions, you have much more control over it. For instance, in Chapter03.aep, Comp5, you'll see I've added an Expression to the Scale property of the left layer, wiggling it once per second:

```
wiggle(1,200)
```

> **Note:** If you don't see the Expression, select the layer and type EE (type the E key twice, very fast).

That layer grows and shrinks, both height-wise and width-wise. Whereas the middle layer only randomizes its width. The Expression on its Scale property is

```
var bothDimensions = wiggle(1,200);
var widthDimension = bothDimensions[0];
```

```
var heightDimension = transform.scale[1];
[widthDimension, heightDimension]
```

> **Note**: I was originally going to call the variables bothDimensions, width and height, but it turns out width and height are reserved words. So I renamed those variables widthDimension and heightDimension.

Finally, the rightmost layer only gets taller and shorter. Its Scale Expression looks like this:

```
var bothDimensions = wiggle(1,200);
var widthDimension = transform.scale[0];
var heightDimension = bothDimensions[0];
[widthDimension, heightDimension]
```

In Chapter03.aep, Comp6, I have another problem. I've animated a face, using two of the eyes I created earlier. They work perfectly. The problem is the mouth. I'm wiggling its lower lip layer up and down (not left and right) using the following Expression, applied to Position:

```
var bothDimensions = wiggle(2,80);
var horizontal = transform.position[0];
var vertical = bothDimensions[1];
[horizontal,vertical]
```

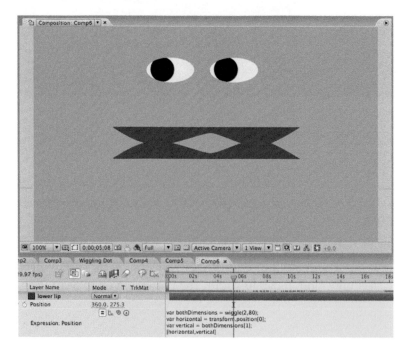

The problem is that the lower lip is sometimes wiggling above the upper lip. Think of it this way: if the upper lip's y axis is at 200 (before the Expression), the Expression will randomly move it up to 80 pixels above and below 200:

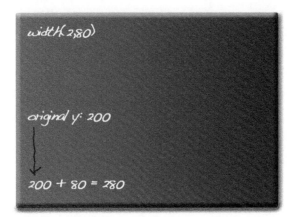

What I want looks more like this:

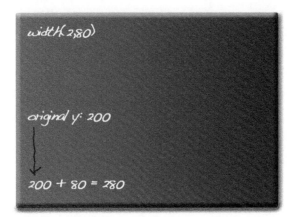

So I have to make sure that when wiggle() generates a number that is less than the original position, the lip stays at its original position rather than moving above it. It should only move when wiggle() generates a number bigger than the original position.

In Chapter03,aep, Comp7, you can see my solution:

```
var bothDimensions = wiggle(2,80);
var horizontal = transform.position[0];
var currentY = transform.position[1];
```

```
var secondWiggleDimension = bothDimensions[1];
if (secondWiggleDimension > currentY ) { var vertical = second
WiggleDimension } else { var vertical = currentY };
[horizontal,vertical]
```

Don't worry if you have trouble understanding this Expression. That long line that starts with "if" will make more sense after you read Chapter 5. But here's the gist of it:

On the fourth line, I store the lip's current y position in the variable currentY. And on the next line, I store the second wiggle() dimension in secondWiggle-Dimension. I need to compare these two values and only use secondWiggle-Dimension if it's larger than currentY.

In other words, if the wiggle() comes up with a number that's greater than the current y position of the lip, I should use the wiggle number as the lip's new vertical position, because that will lower the lip, creating the illusion of an open mouth.

But if the wiggle() number is less than (higher than) the current y position, I should just keep the lip where it is. It will look like the mouth is closed.

This line takes care of that decision:

```
if (secondWiggleDimension >
currentY ) { var vertical =
secondWiggleDimension } else
{ var vertical = currentY };
```

123

A clearer way of typing that would be

```
if (secondWiggleDimension > currentY)
{
        var vertical = secondWiggleDimension;
}
else
{
        var vertical = currentY;
};
```

Note: I indented those two lines by pressing the tab key before typing them.

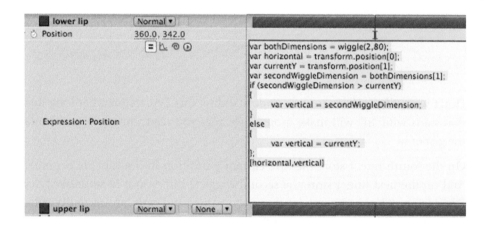

WIGGLE CONTROLLED BY TIME

What if you want a wiggle() that gains momentum over time? That's easy, as you can see in Chapter03.aep, Comp8.

Notice the cursor to the right of the Comp. Early on, the ground is hardly moving at all. Later in the Comp, it's moving quite a bit.

I'm using the following Expression to animate Earthquake's Position property:

```
wiggle(3,time)
```

Time is not a variable. You can't type

```
time = 5;
```

Instead, time is a special value that holds the position of the Current Time Indicator. So if the CTI is at 3 seconds, time is equal to 3. If it's at 8 seconds, time is equal to 8. Though time is not a variable, it's like a variable. It's like a variable that AE creates for you. AE also keeps changing its value. In fact, time is a property, similar to transform.rotation. Properties are autocreated variables. Variables are manually created properties.

When my Expression first starts running, the CTI is at the start of the Timeline, at second 0, so the Expression is equivalent to wiggle(3,0). The HOW MUCH is 0, so the layer doesn't move at all. Gradually, the value of time gets larger, and so the Expression changes to wiggle(3,1), wiggle(3,2), wiggle(3,3), and so forth.

You should take some time to play around with that Expression. If you'd like the wiggles to get bigger than they do, try changing the Expression to

```
wiggle(3,time *10)
```

Now the time property will be multiplied by 10. It will still start at 0, because 0 times 10 equals 0. Then it will increase by multiples of 10: `wiggle(3,0)`, `wiggle(3,10)`, `wiggle(3,20)`, `wiggle(3,30)`, and so on.

You're not stuck with 10. Try other values, like `wiggle(3, time * 2)` and `wiggle (3, time * 50)`. You may even want to clarify what that number means by adding an explanatory variable:

```
var increaser = 10;
wiggle(3, time * increaser);
```

You can also use time to set the HOW OFTEN value, so that as the CTI moves forward, the layer wiggles more and more often:

```
wiggle(time,20)
```

You can even try `wiggle(time,time)`, `wiggle(time*2,time*10)`, and so forth. Have fun!

Wiggle Controlled by Other Properties

Just as wiggle() can be controlled by time, it can also be controlled by other layer properties.

In Chapter03.aep, Comp9, we'll add a blur to our wiggling earthquake, and we'll make it get blurrier as the layer moves farther away from its starting y position:

1. Select the earthquake layer.
2. If necessary, type EE to reveal the wiggle() Expression on Position.
3. Add the Fast Blur effect to it, via Effects > Blur & Sharpen > Fast Blur.
4. Add an Expression to Blurriness by Option clicking (PC: Alt clicking) its stopwatch in the Effect Controls panel.
5. Grab Fast Blur's Pick Whip in the Timeline and drag it to Position's y dimension.

127

The Expression will now read

```
transform.position[1]
```

If you play the Comp now, you'll notice that the layer is invisible. This is because the y position, even though it is wiggling, is always very large, 460 or greater. The Expression we just added is making that number control the amount of blurriness, and 460 is so blurry, it blurs the layer out of existence.

To fix this problem, let's subtract a big number from the Expression, so that the layer only gets a little blurry.

6 Edit the Expression so that it reads as follows:

```
transform.position[1] — 455
```

Note that 460 is the starting y position of the layer. This means that when the layer is at its default position (before wiggle() can move it), its y position will be 460; 460 minus 455 is 5, so when the layer is at its starting position, it will be just slightly blurry.

If wiggle() raises the y-position number a bit, say bringing it to 470, the Expression will set Blurriness to 470 minus 455, which is 15. Preview the Comp and see if you like the amount of blurriness.

You may want to play around with that 455, raising it or lowering it, to make the blur more or less extreme as the layer moves. To clarify that process, I suggest you change the Expression, so that it reads

```
var dampener = 455;
transform.position[1] — dampener
```

Of course, if you want the layer to blur when it moves horizontally instead of vertically, try changing the [1] to a [0].

The wiggle() command is so much fun, I could easily write a whole book about it. In fact, we'll be revisiting wiggle() (and other randomizing Expressions) later in *this* book. But for now, let's move on to other commands.

THE LOOPOUT() COMMAND

I often need to create loops in After Effects: animations that repeat over and over again. Before I learned Expressions, I created them by copying and pasting keyframes. But there's a serious problem with that technique.

Let's say I want to animate a bouncing ball. I can make one bounce with three keyframes: ball up, ball down, ball up. Then I can copy and paste the second

two (ball down, ball up), so that the sequence repeats: up, down, up, down, up, down, up, down, up, down:

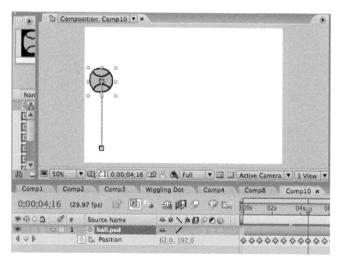

But what if, after doing that, I decide that when the ball is up, it's not high enough. At that point, either I need to adjust the ball's height at every up key-frame or I need to start over from scratch. Neither option sounds like much fun. If you're in my situation, you'll love loopOut(). You start by keyframing just a single bounce—up, down, up. The loopOut() command makes that one bounce repeat. And if you make a change to your original three keyframes, the repeats automatically update.

Let's try this out in Chapter03.aep, Comp10, in which we find a basketball already performing a single bounce:

1. Select the ball, and reveal its Position property.

Be careful to Option click (PC: Alt click) the Position stopwatch when adding the Expression. If you accidentally click the stopwatch without holding down the Option key (PC: Alt key), you'll remove the keyframes. If this happens, type Command + Z (PC: Control + Z) to undo.

As you can see, I've animated Position using three keyframes: up, down, and up again.

2. Add the following Expression to Position:

```
loopOut("cycle",0)
```

Watch for typos! Type every character in lowercase, except for the "O" in "Out," which you must capitalize. The word "cycle" needs double quotes around it. And after the comma, that's a zero, not a letter O.

3. Preview the Comp to see a bouncing ball.

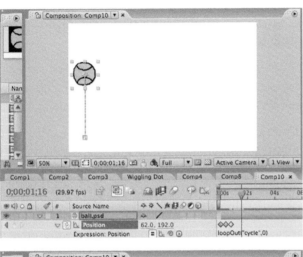

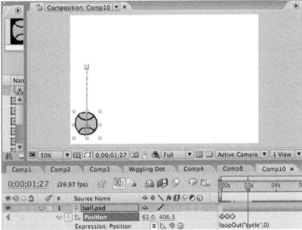

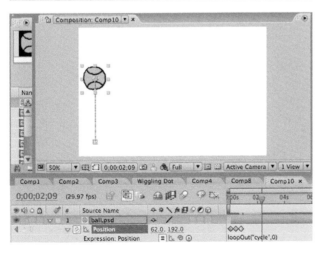

Great, but what does the Expression mean? Well, loopOut() means "repeat the animation when you've reached the out point." The out point comes after the final keyframe. So that's up, down, up (out point), up, down, up (out point), up, down, up (out point).

"cycle" specifies the type of loop. There are other types, such as "pingpong," which we'll explore shortly, but "cycle" is the most common type. It means "when you get to the end (the out point), start over again at the beginning."

Finally, the 0 means "loop the entire animation." In other words, loop up, down, up; not just "down, up." It's a little odd that if you want the whole animation to loop, you should have to type a 0, instead of, say, something like this: loopOut("cycle","all"). But the value after the comma must be a number, and I'm betting you're almost always going to use 0.

But just so you can see what would happen if you typed some other number, open Chapter03.aep, Comp11. Select the ball, and type EE to reveal the Expression. Play the Comp, and then experiment by changing the number after the comma.

The second parameter of loopOut, the number, tells AE how many keyframes to "rewind" at the start of each loop. So if your Comp has four keyframes—key1, key2, key3, and key4—and your Expression reads loopOut("cycle",1), AE will go one keyframe back from the end at the start of each loop.

All keyframes will play once: key1, key2, key3, key4. Then, counting back from the end, the loop will go back one keyframe to key3. Key3 and key4 will play, and then the loop will run again, counting back one keyframe from the end. The sequence will look like this:

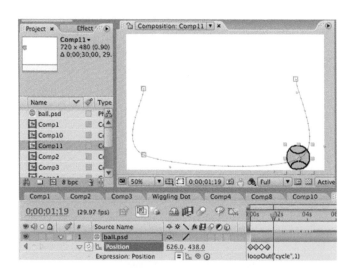

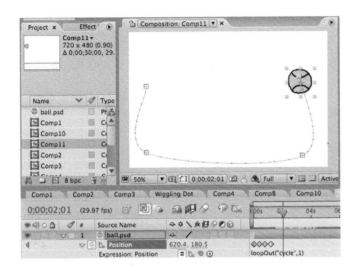

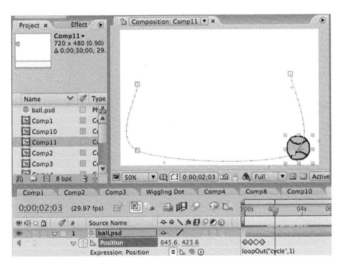

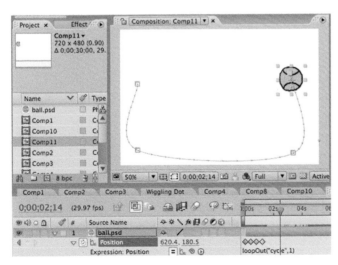

Key1, key2, key3, key4, key3, key4, key3, key4, key3, key4…

If you want to loop all the way back to the beginning (as you usually will), you can use loopOut("cycle",4). Because there are four keyframes, that Expression will count four back from the end each time it starts a loop. So each loop will start on the first keyframe.

But you can also use loopOut("cycle",0), which makes no sense. Zero back from the end shouldn't take you anywhere. It should just leave you at the end. But in the loopOut() command, 0 is a shortcut. It means "I don't want to count my keyframes. Just start over at the beginning each time."

So in a four-keyframe sequence, these two Expressions do the same thing:

loopOut("cycle",4)

and

loopOut("cycle",0)

If all that keyframe counting hurts your brain, just stick to 0 as the second parameter. It will work for you most of the time.

In Chapter03.aep, Comp12, you can see the difference between a "cycle" loop and a "pingpong" loop.

Select both layers and type EE; "cycle" means "once you've reached the end, start over at the beginning" and "pingpong" means "once you've reached the end, play backward, then forward, then backward, then…"

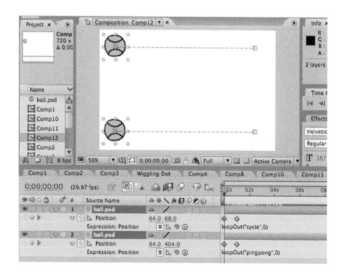

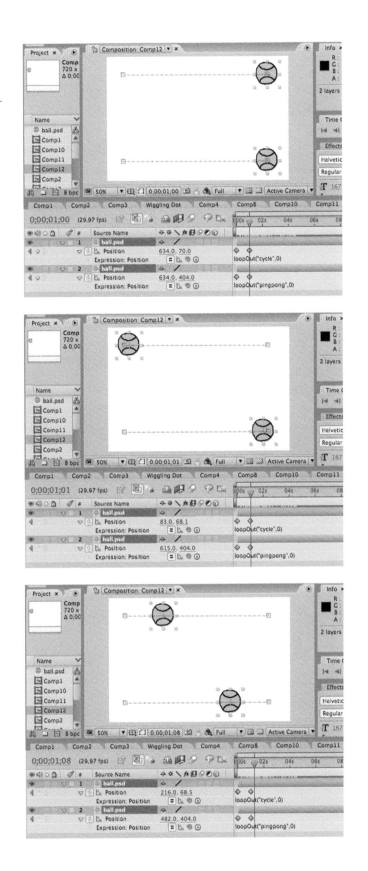

Note that loopOut() works on Properties, not layers. This is very powerful. It means you can loop some aspects of a layer without being forced to loop all aspects. If you open Chapter03.aep, Comp13, select the layer, and type UU (that's the U key twice, very fast, which reveals all changes to properties, keyframes, *and* Expressions), you'll see I've looped position but not scale.

Preview the Comp to see the result.

136

THE VALUEAT TIME() COMMAND

You'll like valueAtTime(). It allows you to link multiple layers so that they follow the leader. It's great for schools of fish and fleets of flying saucers:

1. Open Chapter03.aep, Comp14. Select the red fish and type P. Preview the Comp so that you can see the fish move.
2. Select the green fish and type P. Option click (PC: Alt click) green's Position stopwatch.
3. Grab green's Pickwhip, and drag it to red's Position property:

```
thisComp.layer("red").transform.
position
```

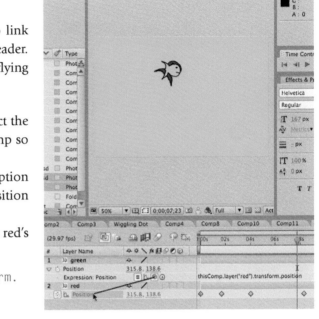

We've seen this drilling down before. It means "control green's Position with the numbers coming from something in this composition, specifically something from the 'red fish' layer—even more specifically, a property in the Transform group. And that property is Position."

4. Preview the Comp. You'll see that the green fish is always exactly at the red fish's position.

Not very useful.

5. Carefully click the end of the Expression, placing a cursor after the "n" in "position."

If necessary, use your right-arrow key to nudge the cursor into position.

6. At the end of the Pick Whip–generated Expression, type ".value AtTime(3)" (without the quotation marks), so that the Expression reads

```
thisComp.layer("red").transform.position.valueAtTime(3)
```

Careful: You must capitalize the "A" in "At" and the "T" in "Time." Type all other letters as lowercase.

This means "put the green fish where the red fish is at 3 seconds."

137

7. Preview the Comp.

138

The green fish no longer moves. It's stuck at exactly the position the red fish was at 3 seconds. If you scrub the CTI to 3 seconds, you see both fish are at exactly the same place. Interesting, but still not very useful.

8. Carefully edit the Expression, changing the "3" to the word "time," all lowercase, without the quotation marks:

```
thisComp.layer("red").
transform.position.
valueAtTime(time)
```

Remember, "time" means the current Comp time—the current position of the CTI. So this Expression tells the green fish to be where the red fish is *now*.

9. Preview the Comp.

Once again, the green fish is glued to the red fish. Still not useful, but that's about to change.

10. Add a "−1" before the closing parentheses:

```
thisComp.layer("red").transform.position.valueAtTime
(time − 1)
```

This means "put the green fish where the red fish *was* 1 second ago."

11. Preview the Comp.

The green fish follows the red fish, lagging a second behind it. Cool!

12. Try changing the "−1" to a "−.5":

```
thisComp.layer("red").
transform.position.
valueAtTime(time − .5)
```

Now the green fish lags half a second behind the red fish.

13. Change the minus to a plus and the .5 to a 2:

```
thisComp.layer("red").
transform.position.
valueAtTime(time + 2)
```

Now the green fish leads the red fish with a 2-second head start.

14. Change the "+2" back to "−1."

```
thisComp.layer("red").transform.position.valueAtTime
(time − 1)
```

Once again, the green fish lags half a second behind the red fish.

With the green-fish layer selected, choose Layer > Transform > Auto-Orient… from the main menu. Enable the orient along path option. Now the green fish will automatically turn to face the direction it's headed.

Notice that in the Expression, the red-fish layer is specified by layer ("red"). Also notice that the red-fish layer is immediately below the green-fish layer in the Timeline.

15. Edit the Expression, changing "red " to "thisLayer, + 1":

```
thisComp.layer(thisLayer, + 1).transform.position.
valueAtTime(time - 1)
```

Make sure you delete not only "red" but also the quotation marks around it. And make sure you place a comma between thisLayer and +1. Note that the "L" in thisLayer must be uppercase.

Because the Expression is on the green-fish layer, "thisLayer" means the green-fish layer. In an Expression, "thisLayer" means the layer holding the Expression.

The +1 means "one layer below"; thisLayer, + 1 means the layer one-below the green-fish layer: the red-fish layer. So the following two Expressions do exactly the same thing:

```
thisComp.layer("red").transform.position.valueAtTime(time - 1)
```

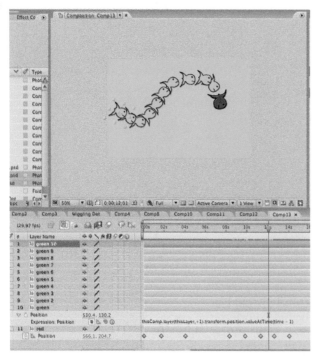

and

```
thisComp.layer(thisLayer, + 1).
transform.position.
valueAtTime(time - 1)
```

As you can see, "red" and thisLayer, + 1 are two ways of referring to the same layer. If you preview the Comp, you'll see that nothing has changed. The green fish still lags half a second behind the red fish. So what's the point?

16. Select the green-fish layer and press Command + D (PC: Control + D) nine times.

You now have 10 green-fish layers. Because each layer is a duplicate of the original green-fish layer, they all have duplicate Expressions on them.

17. Preview the Comp.

Each fish follows the one before it. Note that they don't all follow the red fish. That's because thisLayer, + 1 doesn't mean "the red-fish layer." It means "the layer below," and each green fish interprets that to mean the layer directly below it.

> **Note**: ThisLayer, −2 means two layers *above* whatever layer was holding the Expression; thisLayer, +5 means five layers below; thisLayer is a starting point; −2 (or whatever) is an offset from that starting point.

Though it takes a little while to set up, this follow-the-leader trick is too cool to resist. In fact, I can't resist showing you a few more examples:

1. Open Chapter03.aep, Comp15. Select both layers and type UU.

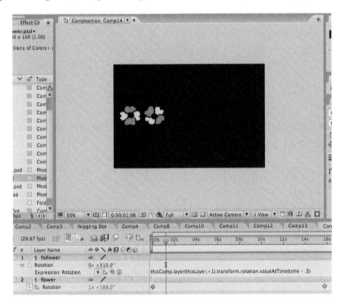

143

Notice that I've animated the bottom layer's Rotation property. On the upper layer, I've added the Expression

```
thisComp.layer(thisLayer, + 1).transform.rotation.
valueAtTime(time - .5)
```

If you preview the Comp, you'll notice the lower layer rotates, lagging half a second behind the upper one.

2. Select the lower layer, and press Command + D (PC: Control + D).

This duplicates the lower layer, which is the rightmost layer in the Comp window. You can't tell there's a dupe, because it's sitting on top of the original.

3. In the Comp window, drag the duplicate layer over to the right, so that it's now the rightmost layer.

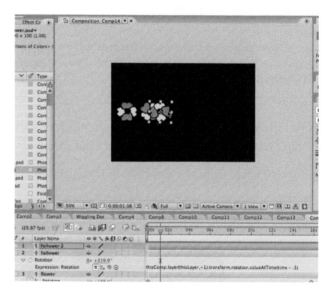

4. Repeat steps 2 and 3 until you've created a long row of layers.
5. Preview the Comp.

You'll see some nice, staggered rotations.

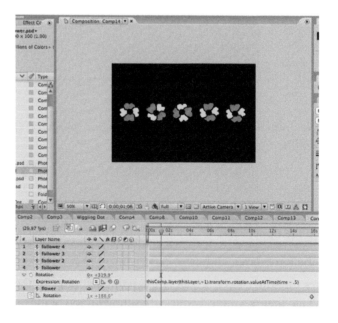

One final example, this time using an effect:

1. Open Chapter03.aep, Comp16. Select the one layer and type UU.

You'll notice that I've applied the 4-color Gradient effect to this layer, and that I've added a wiggle() Expression to the point 1.

2. Preview the Comp, and you'll see point 1, which is Red, moving randomly around the screen.

> **Note**: I dragged point 1 to the center of the Comp before applying the Expression. That way, when it wiggles, it always wiggles away from the center.

3. There's an Expression on point 2, but I disabled it because I wanted you to see just one thing at a time. Enable it now, by clicking the Enable Expression button (the not-equal sign). Now Preview the Comp again. You'll notice that point 2 is following point 1, lagging behind a bit. Here's the Expression:

```
effect("4-Color Gradient").param(propertyIndex  – ↴
2).valueAtTime(time – .5)
```

As usual, we're drilling down: Where should point 2 get its position numbers? From something in the effect called "4-Color Gradient":

```
effect("4-Color Gradient")
```

But what *thing* in "4-Color Gradient"? Why, a param (parameter), of course. A parameter is another term for a property. Each controllable part of an effect is a param. Point 1 is a param, color 3 is a param, and so on.

> **Note:** Using parameter to mean property is confusing, because earlier I told you that a parameter is one of the items you feed a command. For instance, in the wiggle() command, HOW_MUCH and HOW_OFTEN are parameters. You'll have to deal with the confusion, I'm afraid—especially if you read the online help. A parameter can also mean the same thing as a property. That's what it means in this case: a property of the 4-Color Gradient effect:
>
> ```
> effect("4-Color Gradient").param
> ```

Which param? How about the one 2 up from this one?

```
effect("4-Color Gradient").param(propertyIndex - 2)
```

param(propertyIndex −2) is similar to layer(thisLayer, −1). The latter means the layer one above *this* one. The former means the property two above *this* one. For the sake of clarity, I wish you had to type param(thisParam −2), but just as French has its irregular verbs, Expressions has its irregular commands. Luckily, there are way fewer irregularities in Expressions than in French!

Why minus two? Because pram(propertyIndex −1) would point to color 1. Color 1 is one-above point 2. And we don't want to control a position with a color. Two-above point 2 is point 1.

Had I just typed

```
effect("4-Color Gradient").param(propertyIndex - 2)
```

Point 2 would be glued to point 1, but I didn't want that. I wanted point 2 to lag behind a little. So I added our old friend valueAtTime():

```
effect("4-Color Gradient").param(propertyIndex -
2).valueAtTime(time - .5)
```

"Point 2, I want you to be where point 1 is, but lag behind by half a second. Thanks."

4. Carefully copy the Expression on point 2 by clicking in its text-entry area and dragging across the text, highlighting it as you would in a word

processor. Then type Command + C (PC: Control + C) to copy the Expression to the clipboard.

5. Add an Expression to point 3 by Option clicking (PC: Alt clicking) its stopwatch.

6. Paste the Expression you copied by typing Command + V (PC: Control + V).

7. Add an Expression to point 4. Type Control + V again.

Now each point (except for point 1) is following the point one above itself.

THE EASE() COMMAND

You'll find the ease() command useful in at least two situations: when you want to make a property change over time (nonrandomly) without keyframing it and when you want better control over the way one property plugs into another than you'd get using the Pick Whip alone.

First, we'll explore moving a layer without keyframing it:

1. Open Chapter03.aep, Comp17.
2. Select the one layer, and type EE.

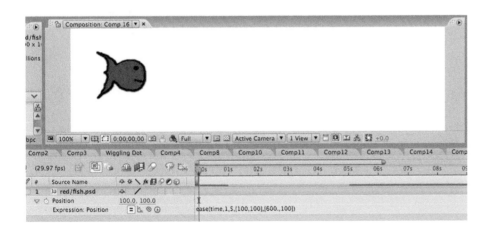

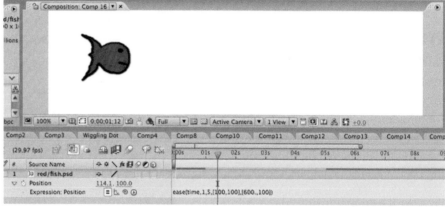

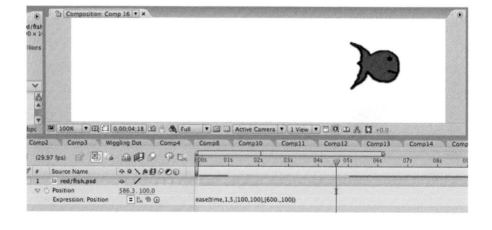

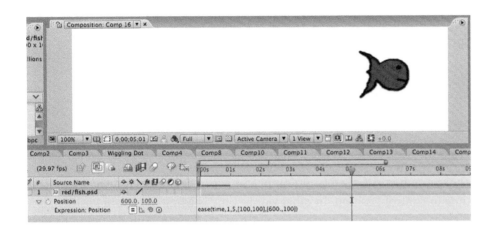

The Expression reads

```
ease(time,1,5,[100,100],[600,100])
```

Note that ease() allows one property to control another. You specify which property as the first parameter inside ease():

```
ease(time...
```

So in this case, time is the controller, and, as you know, time means the location of the CTI.

If I'd wanted to control Position with Scale instead of time, I would have typed

```
ease(transform.scale...
```

Because you have to specify which property is controlling the Expression, do you have to also specify which property is being controlled? No. The property

to which you apply the Expression is being controlled (as always). Because I applied this Expression to Position, it's controlling Position:

ease(time...

means (in this case) control Position with time.

Moving on, after the controller (time), you see two numbers, 1 and 5:

ease(time,1,5...

Those numbers specify the minimum and maximum values for when you want time to control Position. In other words, time is going to control Position, but it's not going to do so until 1 second into the Comp. And it's going to stop doing so after 5 seconds.

If you preview the Comp, you'll notice the layer doesn't move for the first second. Then it moves, moves, and moves, stopping when the CTI reaches 5 seconds. Of course, if you want the layer to start moving right away and keep moving until 8 seconds have elapsed, you'll have to change the Expression to

ease(time,0,8...

After the min and max for time, you see two sets of position coordinates:

[100,100], [600,100]

Remember, when we're talking about Position, the coordinates mean [x, y]. The first set of coordinates tells the layer to start at 100x by 100y. The second set tells the layer to end at 600x by 100y. Because y starts and ends at 100, the layer should never move up or down. But because x starts at 100 and ends at 600, the layer will move left to right. Had I wanted it to move right to left, I would have typed

[600,100], [100,100]

If you play the Comp again, you'll notice that, indeed, the layer does move left to right but not up or down.

In an ease() Expression, the min and max control the two sets of coordinates. In this example,

ease(time,1,5,[100,100],[600,100])

the 1 controls the [100,100], meaning that when the CTI is at 1 second, the layer will be positioned at [100,100]. The 5 controls the [600,100], meaning that when the CTI is at 5 seconds, the layer's Position will be [600,100].

Another way of saying this is that ease() maps the controller-minimum (1) to the controlled starting-value ([100,100]) and the controller-maximum (5) to the controlled ending-value ([600,100]).

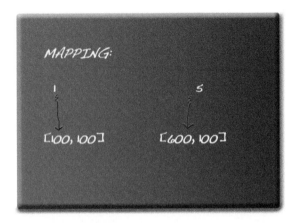

Here's a general template for ease():

```
ease(CONTROLLER,CONTROLLER_MIN,CONTROLLER_MAX,CONTROLLED_
START,CONTROLLED_END)²
```

As always with templates, you should never actually type the uppercase text. Instead, replace it with specific values, such as

```
ease(time,1,5,[100,100],[600,100])
```

In that Expression

> CONTROLLED PROPERTY = Position (not specified in the Expression itself),
> CONTROLLER = time,
> CONTROLLER_MIN = 1 second,
> CONTROLLER_MAX = 5 seconds,
> CONTROLLED_START = [100,100],
> CONTROLLED_END = [600,100].

[2]It's important to note that CONTROLLER_MIN and CONTROLLER_MAX must be one-dimensional values. This is fine: `ease(time,1,5,[100,100],[600,100])`. But this isn't: `ease(time,[1,2,3],[4,5,6],[100,100],[600,100])`. The controlled parameters can be of any dimensions, but the controlling ones must be 1D. Also, CONTROLLER_MIN must be smaller than CONTROLLER_MAX. This works: `ease(time,1,5…`. This doesn't: `ease(time,5,1…`.

ease() doesn't only work on Position. In Chapter03.aep, Comp18, I've eased
Rotation and Scale:

Rotation = ease(time,0,8,0,360)
CONTROLLED PROPERTY = Rotation,
CONTROLLER = time,
CONTROLLER_MIN = 0 seconds,
CONTROLLER_MAX = 8 seconds,
CONTROLLED_START = 0 degrees.
CONTROLLED_END = 360 degrees.
Scale = ease(time,2,10,[100,100],[300,300])
CONTROLLED PROPERTY = scale,
CONTROLLER = time,
CONTROLLER_MIN = 2 seconds,
CONTROLLER_MAX = 10 seconds,
CONTROLLED_START = 100%.
CONTROLLED_END = 300%.

And ease() doesn't always have to be controlled by time. The CONTROLLER can be any property:

1. Open Chapter03.aep, Comp19.
2. Preview the Comp.

154

The red layer is rotating.

3. Select the red layer, and press R to reveal its rotation property.

There is no Expression, just a couple of keyframes.

4. Select the green layer, and type S to reveal its Scale property. Add an Expression to Scale.

5. Type "ease(" without the quotation marks:

```
ease(
```

6. Grab the Pickwhip, and point to red's Rotation property:

```
ease(thisComp.layer("red").transform.rotation
```

7. Type a comma and then 0:

```
ease(thisComp.layer("red").transform.rotation,0
```

8. Type another comma and then 360:

```
ease(thisComp.layer("red").transform.rotation,0,360
```

9. Type another comma and then [100,100]:

```
ease(thisComp.layer("red").transform.
rotation,0,360,[100,100]
```

10. Type another comma and then [100,300]:

```
ease(thisComp.layer("red").transform.
rotation,0,360,[100,100],[100,300]
```

11. Type a close parenthesis:

```
ease(thisComp.layer("red").transform.
rotation,0,360,[100,100],[100,300])
```

155

CONTROLLED PROPERTY = scale,
CONTROLLER = thisComp.layer("red").transform.rotation
CONTROLLER_MIN = 0 degrees,
CONTROLLER_MAX = 360 degrees,
CONTROLLED_START = [100% width, 100% height],
CONTROLLED_END = [100% width, 300% height].

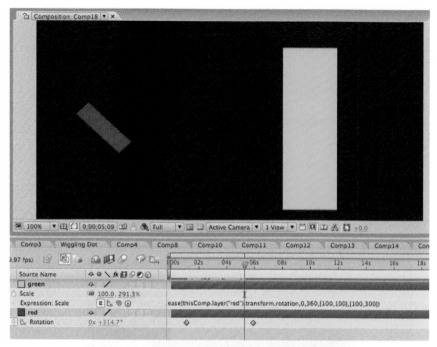

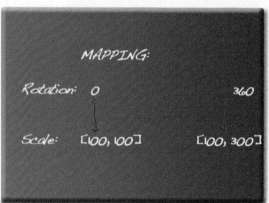

The ease() command has three sisters: linear(), easeIn(), and easeOut(). These names may be familiar to you if you've done any advanced keyframe animation. Ease in means "get faster over time" (accelerate); ease out means "get slower over time" (decelerate); ease means "speed up at the beginning and slow down at the end" (accelerate then decelerate); and linear means "move at a steady rate" (don't accelerate or decelerate):

1. Open Chapter03.aep, Comp20.
2. Select all the layers and type EE to reveal all Expressions.

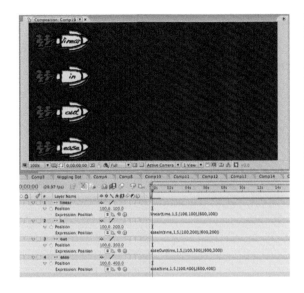

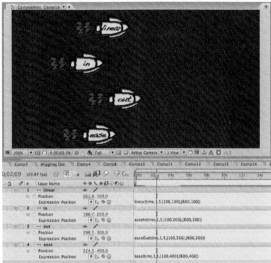

You'll notice that the Expression on each layer's Position property is exactly the same, with two exceptions: the y values are different, allowing the layers to be below each other, and the names of the commands are different:

```
linear(time,1,5,[100,100],[600,100])
easeIn(time,1,5,[100,200],[600,200])
easeOut(time,1,5,[100,300],[600,300])
ease(time,1,5,[100,400],[600,400])
```

3. Preview the Comp.

You'll notice that the top layer moves at a steady rate; the one below it accelerates; the one below it decelerates; and the bottom one accelerates and then decelerates.

In addition to using ease() to move layers around, you can also use it to map one property's range onto another's, as we did earlier in the Rotation/Scale example. This is really helpful when the two number ranges don't fit together very well.

Let me demonstrate:

1. Open Chapter03.aep, Comp21.
2. Twirl open the "stay focused" layer in the Timeline.

157

After Effects reveals the Text and Transform property groups.

3. Click the triangle to the right of the word "Animate" in the Timeline, and choose Tracking from the pop-up menu.

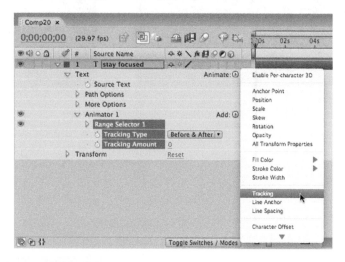

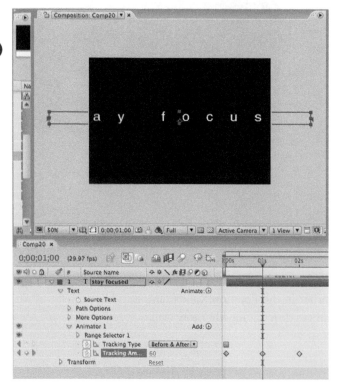

After Effects adds an Animator Group ("Animator 1") to the layer in the Timeline, containing Range Selector 1, Tracking Type, and Tracking Amount.

4. If necessary, move the CTI to the beginning of the Timeline.

5. Click the stopwatch for Tracking Amount.

Don't worry if this also sets a keyframe for Tracking Type.

6. Move the CTI to 1 second: 00;00; 01;00.

7. Set Tracking Amount to 60.

The letters will fan out, stretching to fill most of the Comp window's width.

8. Move the CTI to 2 seconds: 00;00;02;00.

9. Set Tracking Amount back to 0.

You've set three keyframes for Tracking Amount. If you preview the Comp now, you'll see that the letters start close together, fan out, and then pull back so that they're close together again.

10. Make sure the layer is selected, and from the main menu, choose Effects > Blur & Sharpen > Fast Blur.

11. In the Effect Controls panel, add an Expression to Blurriness.

12. In the Timeline, grab the Blurriness Pick Whip, and point to Tracking Amount.

Now Tracking Amount is controlling the Blurriness effect. As the letters track out, they'll get more and more blurry. As they pull back together, they'll also return to focus.

13. Preview the Comp.

It's a cool effect, but the letters get so blurry that they quickly become impossible to read. In fact, by the time the letters are completely fanned out, the blur is so intense that the letters are invisible—blurred out of existence.

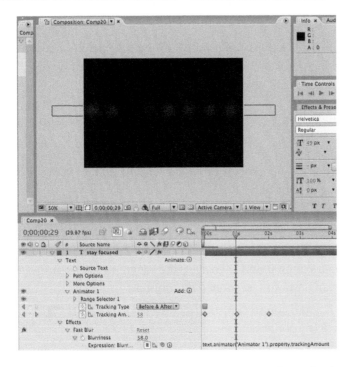

This happens because the Tracking and Blurriness numbers don't work well together. Tracking Amount maxes at 60, which is fine for Tracking Amount. But 60 is a ridiculous amount of blurriness.

Here's the current mapping:

Let's try for something more reasonable, such as the following:

We still want Tracking Amount to control Blurriness, but when tracking amount is at 60, we want Blurriness to be at 8. We want to map the range 0 to 60 to the range 0 to 8, and we can use our good friend ease() to do this.

14. Remove the Expression from Blurriness and create a new one by Option clicking (PC: Alt clicking) the Blurriness stopwatch twice.

This will allow you to start fresh with a new Expression.

15. In the text-entry area, type "ease(" without the quotation marks:

```
ease(
```

Remember, the first parameter of ease() is CONTROLLER. We want Tracking Amount to be in control, so do this:

16. Grab the Blurriness Pick Whip, and point it to Tracking Amount:

```
ease(text.animator("Animator 1").property.trackingAmount
```

17. Type a comma, and then type the range numbers (min and max) for Tracking Amount, separated by commas:

```
ease(text.animator("Animator 1").property.↰
trackingAmount,0,60
```

18. Type a comma, and then type the range numbers for Blurriness, separated by commas:

```
ease(text.animator("Animator 1").property.↰
trackingAmount,0,60,0,8
```

19. Type a close parenthesis:

```
ease(text.animator("Animator 1").property.
trackingAmount,0,60,0,8)
```

20. Preview the Comp.

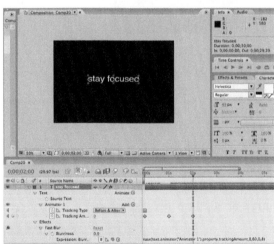

161

Now that you've remapped the ranges, the effect is much more reasonable. Although the text does get blurry, you can always read it.

21. Just for kicks, try reversing the order of the range numbers for Blurriness, changing 0,8 to 8,0:

```
ease(text.animator("Animator 1").property.
trackingAmount,0,60,8,0)
```

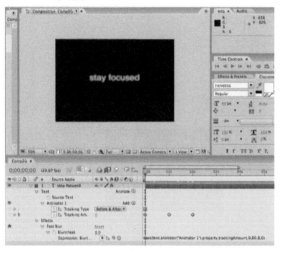

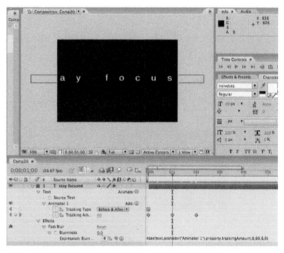

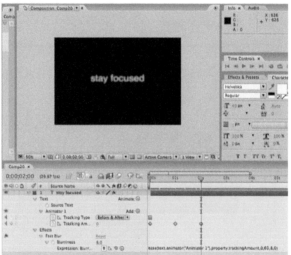

162

Now, when Tracking Amount is at 0, Blurriness is at 8, and when Tracking Amount is at 80, Blurriness is at 0.

22. Preview the Comp.

You'll notice that the text now starts blurry and comes into focus as the letters fan out; as they pull back in again, they blur.

Let's try one more example of using ease() to map ranges:

1. Open Chapter03.aep, Comp22.
2. Preview the Comp.

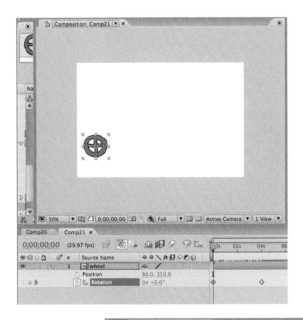

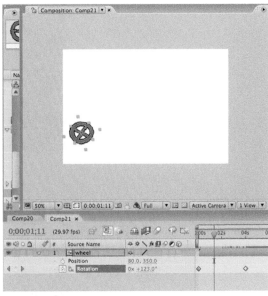

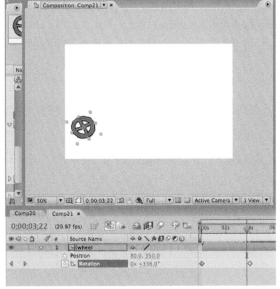

The wheel spins once. As it does so, we'd like it to roll across the width of the Comp. Because the range of rotation is 0 to 360, if we just add an Expression to Position and Pickwhip Rotation, the wheel will only roll to 360. We need it to roll much farther, to about 640. Also, note that the wheel's starting x position isn't); it's at 75. So we need to map 0–360 to 75–640.

MAPPING:

Rotation: 0 360

Position (x): 75 640

Note: We're only talking about affecting x. We'll have to find a way to keep y unaffected by Rotation.

3. Type R to reveal the Rotation property in the Timeline.
4. To also reveal the Position property, type Shift + P.
5. Add an Expression to Position.
6. Type "var yValue = " without the quotation marks:

```
var yValue =
```

7. With Position's Pick Whip, point to Position's own y property value:

```
var yValue = transform.position[1]
```

8. Type a semicolon to end the statement:

```
var yValue = transform.position[1];
```

9. Press Return (PC: Enter), and on the next line, type "xValue =" without the quotation marks:

```
var xValue =
```

10. Type "ease(" without the quotation marks:

```
var xValue = ease(
```

11. Pick Whip Rotation:

```
var xValue = ease(transform.rotation
```

12. Type a comma and then the min and max values for Rotation, separated by a comma:

```
var xValue = ease(transform.rotation,0,360
```

13. Type a comma and then the starting and ending values for Position, separated by a comma:

```
var xValue = ease(transform.rotation,0,360,75,640
```

14. Type a close parenthesis and a semicolon to complete the statement:

```
var xValue = ease(transform.rotation,0,360,75,640);
```

15. Press Return (PC: Enter) and on the next line, type "[xValue,yValue]" without the quotation marks:

```
[xValue,yValue]
```

16. Preview the Comp.

The wheel now rolls from left to right, across the Comp window, while it spins.

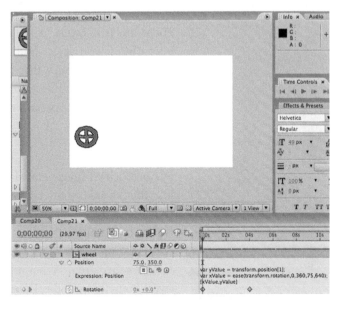

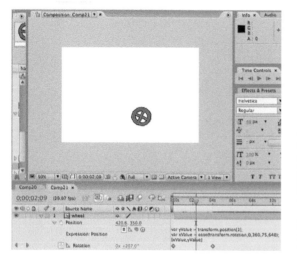 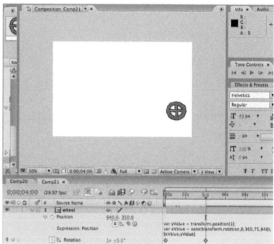

Here's the entire Expression:

```
var yValue = transform.position[1];
var xValue = ease(transform.rotation,0,360,75,640);
[xValue,yValue]
```

166

COMMANDS IN EVERYDAY EXPRESSIONS

Now that you understand commands, the anatomy of basic Expressions should make more sense. As an example, take a look at Chapter03.aep, Comp23.

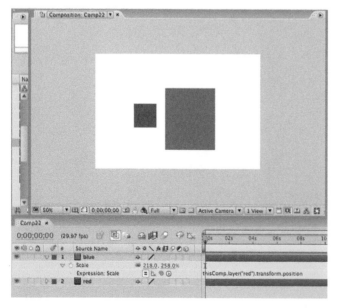

There are two layers, a red one and a blue one. If you select both layers and type UU, you'll notice that the red layer's Scale is controlling the blue layer's Position with this Expression:

```
thisComp.layer("red").transform.
scale
```

By now, Pick Whip–generated Expressions like this should seem basic to you. As you know, it's just drilling down. What is controlling blue's Position? Something in this Comp. What thing in this Comp? A layer called "red." What aspect of that layer? Something in the Transform property group. Which Property? Scale.

But if you look closely, you'll notice there's a command in the Expression:

```
layer("red")
```

You can tell it's a command, because there are parentheses after the word layer. Layer is the command, and "red" is a parameter. Note that layer() doesn't stand on its own, the way way wiggle() usually does. Instead, it follows a dot; valueAtTime() also follows a dot:

```
thisComp.layer("red")
transform.rotation.valueAtTime(time-1)
```

When a command follows a dot, we call it a "method." Methods are commands that are "owned" by a property. In these examples, thisComp owns later(), and the rotation owns valueAtTime().

Compare these examples to commands like wiggle() and loopOut(), which are more independent:

```
wiggle(1,200)
loopOut("cycle",0)
```

These commands start at the beginning of the line. They don't follow after some property and a dot. Such stand-alone commands are called "functions." Functions stand alone; methods are joined onto properties (and sometimes other commands) by a dot.

If we think back to doggy JavaScript for a minute, you can imagine a fetch method that would work like this:

```
rover.fetch("stick")
```

Or a sit method that would work like this:

```
snoopy.sit();
```

Methods are *owned*. Rover owns the fetch() method; Snoopy owns the sit() method. A programmer would say fetch() is a method of Rover, and sit() is a method of Snoopy.

Getting back to Comp 23, in the Expression

```
thisComp.layer("red").transform.scale
```

layer() is a method of thisComp.

I like to think of commands as machines. Just as you feed coal into a steam engine that will then pull a train, you feed a layer name (e.g., "red") into the layer() method and it fetches a layer for you.

167

You can also imagine that Rover has a fetching machine built into him. (Maybe he's a robot dog.) By saying rover.fetch("stick"), you're programming the fetch() machine to get you a stick.

Why do you have to use a machine to get layers when you can get the Comp and the Scale property by just typing their names? Because there's only one thisComp, one Transform group on each layer, and one Scale property in each Transform group.

On the other hand, Comp23 has two layers, and a Comp can have many more layers than that. Hence, you need a machine to help you grab the specific layer you want.

But why can't you just type this?

```
thisComp.layers.red.transform.scale
```

Because "red" is not a word in the Expressions language. When you create a layer and give it a name, that name is not automatically added to the language. After Effects would have no idea what you meant by red. Similar confusions can happen in English (though English is more forgiving). If I wrote

```
Please bring habernabberflogal with you tomorrow.
```

you'd be confused. There's no such word as habernabberflogal in English. But if I said

```
Please bring the medicine called "habernabberflogal" with you
tomorrow.
```

you'd be a bit less confused, though you might advise me to find a different doctor.

If I spoke Javascript, I'd say please bring medicine("habernabberflogal") with you tomorrow.

In the Expressions version of JavaScript, there are distinct properties called this-Layer, transform and scale. There is no property called "red."

Here's one more way to think about the difference between properties and methods: Imagine you've been hired to run a fiber-optic cable from Los Angeles to France. You've been told to run it from LA to a relay station in Ohio. From there, you can run it to New York. From New York, you'll need to run it under the sea to England. Once in England, you just have to run it across the English Channel into France:

```
la.ohio.newYork.atlanticOcean.england.englishChannel.france
```

Here's the problem: you're expert at running cable over land, but you don't have the means to run it under water. So you're going to have to rent remote-control submarines to help you string the cable across the Atlantic and the Channel:

```
la.ohio.newYork.sub("Atlantic").england.sub("channel").france
```

COMMANDS THAT RETURN VALUES

Most commands need to be fed information or they won't work. You have to feed layer() the name of one of your Timeline layers; you have to feed wiggle() a HOW_MUCH and a HOW_OFTEN. We call such food parameters.

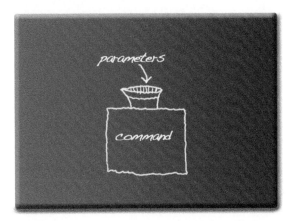

Consider this example:

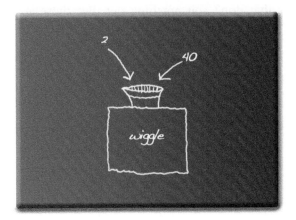

Again, I like to think of parameters as the coal you shovel into a steam engine. The steam engine itself is the command.

Just as steam engines spit out steam, most commands spit out information. For instance, if you apply wiggle() to rotation, it spits out a random angle in degrees:

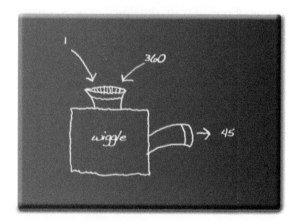

Think of commands as machines that take in input, chug and churn, and then spit out output. Parameters in; return values out. Later, we'll come across rare commands that don't need any input parameters. We'll also come across rare commands that don't spit anything out. But those are the exceptions. Most commands take and give.

Before we give the dogs a treat for being so good, let's use them one more time to demonstrate a few different kinds of commands:

```
shep.fetch("ball")
```

That command takes in a parameter ("ball") and returns a ball (once Shep fetches it).

```
rufus.bark()
```

That command doesn't need any parameters, but it returns a noise (Rufus barking).

```
rover.sit()
```

That command doesn't take in any parameters. It doesn't return anything, either. It's just a machine that causes rover to sit. Some commands are like that. They don't spit out a value; they just make something happen.

And now that you understand commands, reader.readTheNextChapter().

CHAPTER 4

Expression Helpers

Because keyframe animation is such a powerful technique, After Effects includes various tools to help make the process easier and more productive. Some of these tools, such as the Wiggler and the Smoother, live on the Window menu. Others, such as Easy Ease and Exponential Scale, live on the Animation > Keyframe Assistants menu. This book is about Expressions, not keyframes, so I won't waste space explaining keyframe helpers (however, if you don't know how to use them, you owe it to yourself to learn, so get ye to online help!); instead, I will spend this chapter introducing you to various tools that help with Expressions. I call these tools Expression Helpers. I recommend saying that with a cockney accent, dropping the "H," so that it becomes "Expression 'Elpers."

EXPRESSIONS GRAPH

The first Expression 'Elper I'd like to show you is a graph. It allows you to see at a glance what sort of grace or havoc your Expression has wrought:

1. Open Chapter04.aep, Comp1, and select the one layer.
2. Add the following (familiar) Expression to the Position property:

```
wiggle (1,20)
```

3. Press the Show Post-Expression Graph button.

It's located to the right of the Enable Expression button (the equal sign button).

The guys at Adobe didn't name the Show Post-Expression Graph button very well, because, as you just discovered, pressing it doesn't show a graph. Instead, it adds data about your Expression to a graph that isn't showing. To show the graph,

4. Click the Graph Editor button.

It's located just to the left of the ruler at the top of the Timeline.

On this graph, the horizontal axis represents time, as it usually does in the Timeline. The vertical axis represents pixels (in this case, because wiggle() is controlling a property that "thinks" in pixels). So you're looking at the velocity of your layer, which means how many pixels it's traveling per second.

If you're a cracker-jack keyframe animator, you've seen the Graph Editor before. You know that you can drag keyframe data around in the graph, altering keyframe values. Unfortunately, you can't adjust Expressions via the graph. With Expressions data, the graph is read-only. The only way to control an Expression is by editing the Expression itself.

EXPRESSIONS MENU

When I teach people how to write Expressions, they often ask me if there's some way they can get After Effects to type the Expressions for them.

"You mean like the Pick Whip?" I ask.

"No," they reply. "The Pick Whip is great for simple Expressions, but it won't type wiggle() or loopOut() for you."

That's true. Well, the good news is that there is a tool that types Expressions for you; the bad news is that it's not all that easy to use.

The suspect tool is called the Expression Language Menu. If you're like me, you won't use it much, but it's worth looking at once or twice, because it lists many commands and properties. Let's check it out:

1. Open Chapter04.aep, Comp2, select the layer, and add an Expression to Position.
2. Press the Expression Language Menu button.

It's just to the right of the Pick Whip.

173

3. From the popup menu, choose Property > Wiggle(freq, amp, octaves = 1…

After Effects types an odd-looking wiggle Expression in the text-entry area.

4. Finalize the Expression by clicking outside the text-entry area.

Oops! AE hits you on the head with a big error message. This is because the Expression it typed isn't a working Expression. It's more of a template. Let's take a look at it, and see if we can figure it out:

```
wiggle(freq, amp, octaves = 1, amp_mult = .5, t = time)
```

It looks a little like our old friend wiggle(), but more complicated. First of all, there are two too many parameters. In fact, wiggle() *is* allowed to accept more than just HOW_MUCH and HOW_OFTEN. It can also accept parameters called octaves, amp_mult and t. If you're interested in what these properties do, you can look them up in online help, but in real life, almost no one uses them.

Notice how the other extra parameters are followed by values: it's not just octaves, it's octaves = 1. That's AE's way of telling you that the octaves parameter has a default value (1); amp_mult's default value is .5, and t's default value is time. Because these parameters already have values, you don't need to include them when you type wiggle().

Note that freq and amp—AE's more technical terms for HOW_OFTEN and HOW_MUCH—don't have default values. That's AE's way of telling you that you must give them values. So do this:

5. Edit the Expression, changing freq to 1 and amp to 50:

```
wiggle(1, 50, octaves = 1, amp_mult = .5, t = time)
```

The Expression now works. As you might guess from looking at all those extra parameters, the Expression will also work if you change it to

```
wiggle(freq = 1,amp = 50, octaves = 1, amp_mult = .5,
t = time)
```

Because those last three parameters are optional, you can omit them. Though invisible, they will still be there, silently set to their default values:

```
wiggle(freq = 1,amp = 50)
```

By the way, those words "freq," "amp," "octaves," and so on are just variable names. Like all variable names, you can change them to whatever you want. For instance, you can type

```
wiggle(freak = 1,gramps = 50)
```

and the Expression will still work. Of course, you can also just type

```
wiggle(1,50)
```

I think the Expression Language menu is most useful when you already know the Expression you want to use. I use it sometimes when I remember the general idea of an Expression, but I don't remember exactly what it's called. I may wonder, is it wiggle() or jiggle()? A quick glance at the menu options jogs my memory.

At this point in your journey with Expressions, the best thing the menu can do for you is to give you a sense of how many Expressions there are. Spend some time running your mouse up and down the menu options, gazing at all the Expressions and their exotic names. By the end of this book, many of them will be familiar to you.

CONVERT EXPRESSIONS TO KEYFRAMES

Expressions are fast, but sometimes they're not fast enough. As you can see in this screenshot, I rendered two Comps: one called Expressions the other called keyframes. These Comps were identical, except that in the former, I animated with an Expression; in the latter, I animated with keyframes. The Expressions version took a second longer to render than the keyframes version.

A second is just a second, and most of the time, the difference won't be worth worrying about. But if you're doing complex work and Expressions are slowing you down, you can convert Expressions to keyframes before rendering:

1. Open Chapter04.aep, Comp3.
2. Select the layer, and type EE.

As you can see, I've once again applied a wiggle() Expression.

3. In the Timeline, click the word "Position."

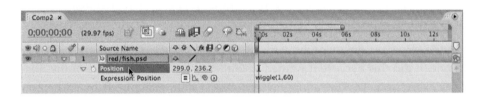

Before converting an Expression to keyframes, you must always select the property name.

4. From the main menu, choose Animation > Keyframe Assistants > Convert Expression to Keyframes.

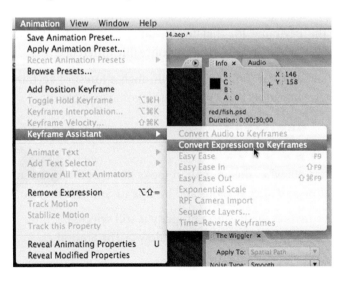

Abracadabra! AE has added a ton of keyframes to the layer. These keyframes mimic the action of your Expression, so you won't notice any difference. As an added bonus, AE didn't delete your Expression. It's still there; it's just disabled. If you want to re-enable it, just click the Enable Expression button—the one that looks like a not-equal sign.

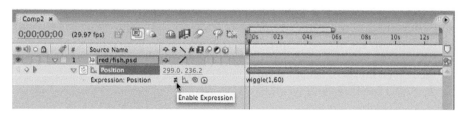

AE has to calculate Expressions, frame by frame, before their results can be rendered, whereas keyframe values are set. So keyframes will usually render faster than Expressions. Still, most Expressions are pretty darn fast. So don't feel that you have to convert all Expressions to keyframes. Just do it when render time bogs down.

By the way, you may wonder why AE decided to place a keyframe on every frame. It did this because it wanted to faithfully capture the results of the original Expression. By keyframing every frame, you're guaranteed that wherever wiggle() moved a layer on that frame, the keyframe on that frame is moving it to the same place.

That may be more accuracy than you need. Having so many keyframes makes the animation hard to manipulate. One of the benefits of keyframes over Expressions—besides a savings in render time—is that each keyframe is individually editable. You can move the Current Time Indicator (CTI) to 00;00;03;22 and adjust the keyframe for that frame. But with so many keyframes, you'd have to do a lot of adjusting to make a noticeable difference.

The Smoother is a great tool for cutting through a forest of keyframes. It's also one of the keyframe tools that I said I wasn't going to explain.

I lied.

5. Preview the Comp once.

I want you to note what the animation looks like before smoothing. That way, you'll see before and after versions and be able to compare the two.

6. Make sure that the Position property is still selected.

7. From the main menu, choose Window > The Smoother.

After Effects displays the Smoother panel.

8. In the Smoother panel, change the value of Tolerance from 1 to 20.

The Smoother removes unnecessary keyframes. Tolerance tells AE how liberal it can be when it deletes them. The higher you set Tolerance, the more keyframes it will delete. I recommend setting it to 10 or 20. AE will delete a lot of keyframes, but don't be scared. If you don't like the results, just type Command + Z (PC: Control + Z) to undo the delete. Then try again with a lower Tolerance setting.

I'm usually amazed at how many keyframes I can eliminate and yet still wind up with an animation that looks pretty much the same as it did before.

9. Press the Apply button in the Smoother panel.

AE eliminates all but a few keyframes.

10. Preview the Comp.

Notice that it looks pretty much the same as it did when you previewed in step 5.

The Smoother is a great tool, but I don't recommend applying it to cut down render time. You might think that fewer keyframes equals a shorter render, but that's generally not the case. Note that even though you've drastically reduced the number of keyframes, the layer is still moving on every frame. Movement on each frame means work for the renderer, keyframe or no keyframe. Use the Smoother if you like the resulting look or because it makes your Comp easier to edit.

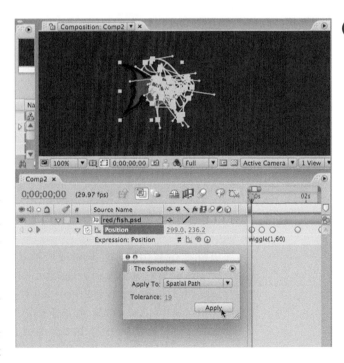

CONVERT AUDIO TO KEYFRAMES

One of the coolest things you can do with Expressions is to use audio to control a property. Yes, this means you can control Position, Scale, Blurriness, or another property with the volume of an audio layer. The louder the volume, the more the layer moves to the left, the bigger it gets, or the more it comes into focus.

When I first heard you could control properties with audio, I was excited but confused. I tried adding an audio layer, twirling it open, and looking for a property that could control an Expression. The only contender I found was Audio Levels.

The problem is, no matter how loud or soft the sound gets, Audio Levels is always set to 0. What's the deal? How can a loud noise be zero decibels? It can't, but Audio Levels is not a measure of the intrinsic levels in the audio. It's just a volume control that lets you raise or lower the total volume.

Think of it this way: Your TV set has two sorts of volume. There's the volume control you can use to raise or lower the sound coming out of your set's speakers, and there's also the recorded volume levels in the show you're watching. In other words, no matter how loud you crank up the volume, if someone on the show was whispering, that person is still whispering. The whisper may sound really loud, but it will still be way quieter than when the person is talking or shouting.

Audio Levels is like your TV's volume control. It's set to 0 unless you adjust it, making the overall volume louder or softer. It's worthwhile keyframing this property if you want to create fades or if the general sound is too loud or too soft. But because it's always set to 0 (unless you adjust it), it's not going to help much with Expressions. Imagine what would happen if you added an Expression to some layer's Opacity and Pick Whipped Audio Levels. Audio Levels would be spitting out 0, 0, 0. . . , which would set Opacity to 0. And your layer would always be invisible.

We need some way of getting at the intrinsic volume in the audio—the whispers versus shouts, the quiet piccolo versus the cymbal crash:

1. Open Chapter04.aep, Comp4.

You'll see two layers: an audio track and a graphic of a musical note.

2. Select the audio layer.
3. From the main menu, choose Animation > Keyframe Assistants > Convert Audio to Keyframes.

Note: If you do this with a long piece of audio, be prepared to wait a few minutes while AE analyzes the sound. This may be a good time to get out those fingernail clippers or pour yourself another cup of coffee.

After Effects analyzes the audio layer and creates a new layer called Audio Amplitude. This is a Null Object layer, meaning it won't render. Just so you can see something in the Comp window, AE represents it as the outline of a square. Though it won't render, it may distract you. Luckily, it doesn't matter where the Null is located. Feel free to move it off to the side. Or you can turn off its visibility eyeball.

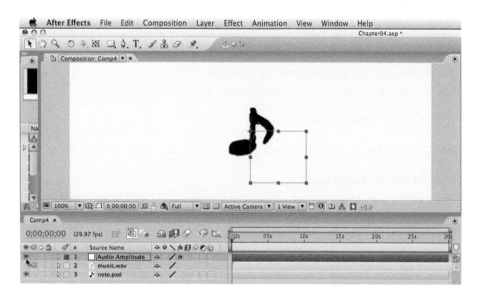

Because the Null won't render, what's the point of it? Good question:

4. Select the Null in the Timeline and type UU.

AE reveals effects it has applied to the layer. The effects are called Left Channel, Right Channel, and Both Channels.

I know it's a little odd for AE to apply effects to a layer that can't even be seen (or heard), but notice that each effect has a property called Slider, and each Slider has been animated. The Timeline is full of keyframes.

These keyframes don't do anything except hold values: the values of the intrinsic audio in the audio layer. If you scrub the CTI, you'll notice the values for the Sliders change as you move to places where the audio gets louder or softer. The Left Channel Slider holds the values of the left-stereo track; the Right Channel Slider holds the values of the right-stereo track; the Both Channels Slider holds the combined values of both tracks.

Cool as this is, there's really no point to these values, other than to drive Expressions. So let's get to it:

 5. Select the musical note layer, and press S to reveal its Scale property.
 6. Add an Expression to Scale.
 7. Grab the Pick Whip, and point to the Both Channels Slider.

 8. Preview the Comp.

183

You'll see that the volume is controlling Scale. As the audio gets louder, the musical note gets bigger; quieter audio makes the note shrink.

Sadly, bigger or smaller, the note is microscopic most of the time. Why? Well, if you scrub the CTI and look at the values for the Both Channels Slider, you'll see that they're pretty small: 7.9, 8.3, and so on. Remember that Scale is a percentage. For the note to even be its original size, the slider would have to spit out 100. As it is, most of the time, the note is getting scaled to 7.9% or 8.3% of its original size.

Never fear. That's pretty easy to fix:

Take a look at the Expression. It's two lines long. If you can't read it all, pull down the lower lip of the text-entry area:

```
temp = thisComp.layer("Audio Amplitude").effect("Both ↴
Channels")("Slider");
[temp, temp]
```

You've seen this sort of Expression before: AE created a variable called temp and stored the value of the slider in it. Then it set both of the dimensions of Scale (width and height) to the value of temp.

9. Edit the Expression so that it looks like this:

```
temp = thisComp.layer("Audio Amplitude").effect("Both
Channels")("Slider") *10;
[temp, temp]
```

You're multiplying the slider value by 10. So if it's 2.2, the note will be scaled to 22%. That's still small. Maybe you'll want to multiply the value by 25, 50, or 100. I recommend that you add a variable, so that the 10 gets a name:

```
var multiplier = 10;
temp = temp = thisComp.layer("Audio Amplitude").effect("Both
Channels")("Slider") * multiplier;
[temp, temp]
```

If you want to play around with the amount the slider value is multiplied by, just change the value of the multiplier.

Here's another variation:

```
var minimum = 100;
var multiplier = 10;
temp = minimum + (thisComp.layer("Audio Amplitude").
effect("Both Channels")("Slider")* multiplier);
[temp, temp]
```

Now temp has to be equal to at least 100. You're saying, temp = 100 + some other number. Let's say the slider has a value of 0. If the multiplier is 10, that means you're saying,

```
temp = 100 (the minimum) + (0 * 10);
```

0 times 10 is 0, so that's the same as

```
temp = 100 + 0.
```

So with this version of the Expression, the note can only stay its original size (100%) or get bigger.

By the way, the original audio layer isn't doing much for us at the moment. You can delete it if you want. You needed it there originally, so that AE could

analyze its intrinsic levels, but once that's done, the Expression is driven by the Null, not the audio layer. Of course, you should keep the audio layer if you want to render out audio.

Let's have some more fun with audio and Expressions:

1. Open Chapter04.aep, Comp5.

As you can see, in addition to some graphics, there's a Null layer already in the Comp. I imported some audio, added it to the Timeline, selected it, and chose Animation > Convert Audio to Keyframes.

About the graphics: I moved the anchor points to bottom centers of the bars. That way, scaling the bars will make them seem to grow upward (from their anchor points) like trees. I moved the arrow's anchor point to its tail (a circle). Later, I'll rotate the arrow, and I want it to rotate around this point.

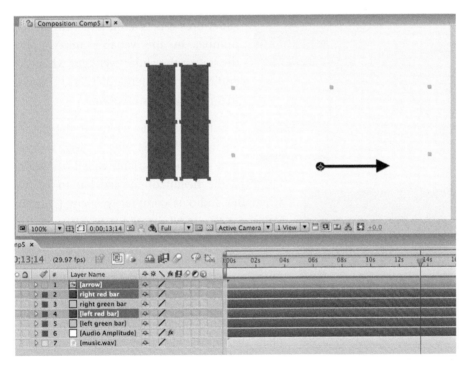

2. Select the Audio Amplitude Null and type UU.
3. Select the "left red bar" layer, and type S to reveal its Scale property.
4. Add an Expression to Scale, and using the Pick Whip, point to the Left Channel slider.

5. Edit the Expression so that it looks like this:

```
var currentVolume=thisComp.layer("Audio Amplitude"). ↴
effect("Left Channel")("Slider");
var minVolume = 0;
var maxVolume = 39; //this is the loudest the volume ↴
ever gets
var barWidth = transform.scale[0];
var barHeight = ease(currentVolume,minVolume, ↴
maxVolume,0,100);
[barWidth, barHeight]
```

Okay, that looks complex. But it's all stuff we've done before. In the first line, I created a variable called currentVolume and, using the Pick Whip, assigned the value of the Left Channel's slider.

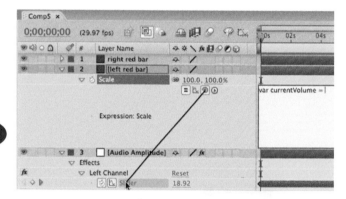

If you scrub the CTI through the Timeline, you'll see that the highest the slider ever gets is about 39. I saved that number in the variable maxVolume; the lowest the slider ever gets, when the audio is completely quiet, is 0. I saved that number in minVolume.

I didn't want the width of the bar to change. Which is why I saved its current value in a variable called barWidth. I wanted the height of the red bar to be 0% when the audio is completely silent (current-Volume = 0), and I wanted it to be at its full height, 100%, when the audio is at its loudest (currentVolume = 39). This means I needed to map the range 0–39 onto the range 0–100:

To create this mapping, I used our old friend ease(), which, I hope you remember, has a template that looks like this: ease(CONTROLLER, CONTROLLER MIN,CONTROLLER MAX, CONTROLLED START,CONTROLLED END). I saved the result in the variable barHeight.

Finally, I controlled the two dimensions of scale by using the barWidth variable (set to the bar's current width) for dimension 0 and the height variable (set to the ease() command) for dimension 1.

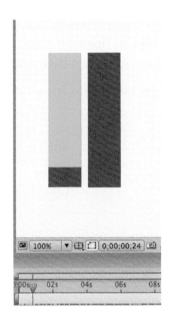

You'll notice the left red bar growing and shrinking as the sound gets louder and quieter. The green is just another layer, peeking from underneath.

6. Highlight the whole Expression, just as if it was a paragraph in a word processor, and type Command + C (PC: Control + C).

189

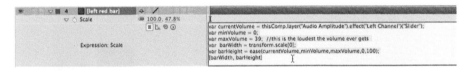

This copies the Expression to the clipboard.

7. Select the "right red bar" layer and press S. Add an Expression to the Scale property.
8. Type Command + V (PC: Control + V).

This will paste the Expression into the right bar's text-entry area.

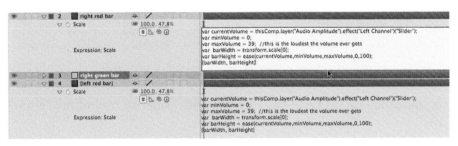

If you leave the pasted Expression as is, the right bar will move in tandem with the left bar. That's not exactly what we want. We want the right bar to reflect the volume of the right stereo channel, not the left one.

9. Edit the Expression, making the following change:

```
var currentVolume = thisComp.layer("Audio Amplitude").↴
effect("Right Channel")("Slider");
var minVolume = 0;
var maxVolume = 39; //this is the loudest the volume ↴
ever gets
var barWidth = transform.scale[0];
var barHeight = ease(currentVolume,minVolume,↴
maxVolume,0,100);
[barWidth, barHeight]
```

10. Preview the Comp.

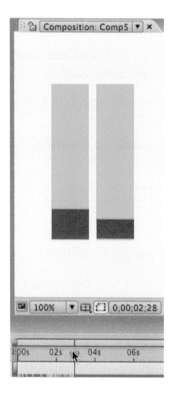

Both bars are growing and shrinking in response to the audio levels.

For added finesse, let's use the Both Channels slider to control the "arrow" layer.

11. Add the following Expression to the arrow's Rotation property:

```
var currentVolume = thisComp.layer("Audio Amplitude").
effect("Both Channels")("Slider");
var minVolume = 0;
var maxVolume = 39; //this is the loudest the volume
ever gets
ease(currentVolume,minVolume,maxVolume,180,0);
```

Here's the mapping we're creating:

Why 0 and 180? Because in AE, 0 degrees points to 3 o'clock, which is where a standard audio meter would be when the sound is at its loudest. So when the sound is at 39 (its loudest), we want the arrow to be rotated to 0 degrees.

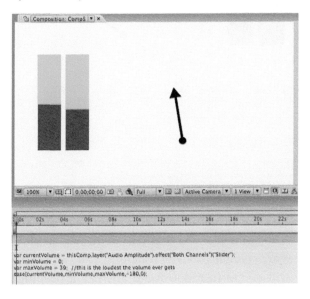

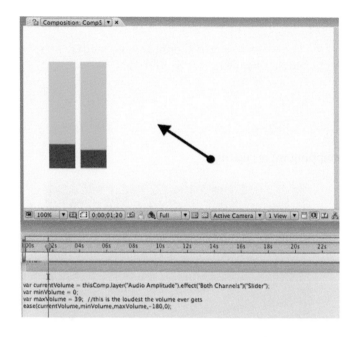

```
var currentVolume = thisComp.layer("Audio Amplitude").effect("Both Channels")("Slider");
var minVolume = 0;
var maxVolume = 39;  //this is the loudest the volume ever gets
ease(currentVolume,minVolume,maxVolume,-180,0);
```

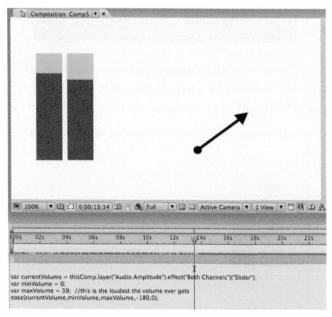

```
var currentVolume = thisComp.layer("Audio Amplitude").effect("Both Channels")("Slider");
var minVolume = 0;
var maxVolume = 39;  //this is the loudest the volume ever gets
ease(currentVolume,minVolume,maxVolume,-180,0);
```

And 180 is the opposite direction (the arrow pointing to nine o'clock), which is where we want it to point when the audio is silent. Why negative 180? Because negative degrees are counterclockwise rotations. You can use 180 if you want, but the arrow will swoop in a downward arc, like a pendulum, rather than

in an upward arc, like a rainbow. If you don't understand what I mean, try changing negative 180 to 180 and see what happens.

Here's one final audio effect:

1. Open Chapter04.aep, Comp6.

There are five layers: the topmost is a lower lip, similar to the mouth of a ventriloquist dummy. Below that is a face layer, which holds the entire face except for the lower lip and chin (it also shows what's inside the mouth when the lips are parted). Below the graphic layers, you'll find the audio (speech this time), and the Audio Amplitude Null.

2. Add the following Expression to the lower lip layer's Position:

```
var currentVolume = thisComp.layer("Audio Amplitude").
effect("Both Channels")("Slider");
var minVolume = 0;
var maxVolume = 3.6; //this is the loudest the volume
ever gets
var x = transform.position[0];
var yClosedMouth = transform.position[1];
var yOpenMouth = yClosedMouth + 20;
var y =
ease(currentVolume,minVolume,maxVolume,
yOpenMouth,yClosedMouth);
[x, y]
```

3. Preview the Comp.

Maybe I should have called this book *Expressions for Dummies*.

EXPRESSION CONTROLS

Have you ever experimented by randomly applying various effects to see what would happen? (CC Glue Gun? What's that? Cool! Timewarp? What does that do? Wow!) If you've don't done this, you've probably been confused by the

Expression Control effects. They don't seem to do anything. Ah, but they do! You can use them to control Expressions:

1. Open Chapter04.aep, Comp7.
2. Select the solid.
3. Choose Effects > Expression Controls > Slider Control.
4. In the Effect Controls panel, scrub the slider.

Nothing happens.

5. Choose Effects > Expression Controls > Angle Control.
6. In the Effect Controls panel, spin the angle.

Nothing happens.

Expression Controls aren't meant to do anything by default. They're just a basic set of controls: angles, sliders, checkboxes, and so forth. It's up to you to tell them what to do. For instance,

 7. Add an Expression to the Solid's Scale property.

 8. Type "var solidWidth =" without the quotation marks.

 9. With the Pick Whip, point to the slider in the Effect Controls panel:

```
var solidWidth = effect("Slider Control")("Slider")
```

 10. Type a semicolon:

```
var solidWidth = effect("Slider Control")("Slider");
```

 11. On the next line, type "solidHeight =" without the quotation marks.

 12. Pick Whip Angle in the Effect Controls panel; then type a semicolon:

```
var solidHeight = effect("Angle Control")("Angle");
```

 13. On the next line, type

```
[solidWidth, solidHeight]
```

 14. Scrub the slider.

The solid gets wider.

 15. Spin the angle.

The solid gets taller.

Make sure both controls are set at values greater than 0. If the width or height is 0, the solid will be invisible.

Okay, that's not very useful, because you can already adjust width and height with the Scale controls, but it shows how you can hook the raw Expression Controls up so that they control real properties.

Let's try something a bit more useful:

1. Open Chapter04.aep, Comp8.

You see a bunch of graphics.

2. From the main menu, choose Layer > New > Null Object.

After Effects adds a Null layer to the Timeline.

3. So that you don't have to look at the Null, turn its eyeball off.

4. Rename Null 1 by selecting its name, pressing Return (PC: Enter), and typing "Controls" (without the quotation marks). When you're done typing, press Return (PC: Enter) again to finalize the new name.

5. From the main menu, choose Effects > Expression Controls > Slider.

6. In the Effect Controls panel, twirl open slider to reveal a graphical slider in a groove.

Notice that the groove has 0.00 to its left and 100.00 to its right. We're going to edit this range, so that instead of running from 0 to 100, it runs from 0 to 1.

7. Right-click on the word "Slider."

Not "Slider" in the words "Slider Control." The word "Slider" directly above "0.00."

199

If you have a Mac with just one mouse button, you can press Control and click, rather than right-click.

8. From the popup menu, select Edit Value.

9. Edit the Slider Range so that it runs from 0 to 1, instead of from 0 to 100.

10. Click OK.
11. Select the Slider Control effect (click the words "Slider Control").
12. Type Command + D (PC: Control + D) twice.

AE makes two copies of the Slider Control.

13. Select the top effect (by clicking its name).
14. Press Return (PC: Enter), type "Red" (without the quotation marks), and press Return (PC: Enter) again.
15. Select the middle effect, and rename it "Green."

16. Select the bottom effect, and rename it "Blue."
17. Select the Controls layer in the Timeline, and press E to reveal the red, green, and blue effects.
18. Twirl each effect open so that you can access its slider control on the Timeline.

19. Select the Star layer.
20. From the main menu, choose Effects > General > Fill.
21. In the Effect Controls panel, add an Expression to the Color property.
22. In the Timeline, type

```
var red =
```

23. Grab the Pick W whip and point to the red effect's slider in the Timeline:

```
var red = thisComp.layer("Controls").effect("red")↴
("Slider")
```

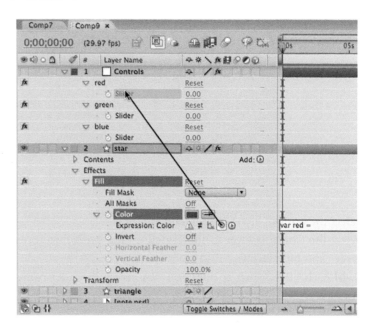

24. Type a semicolon:

```
var red = thisComp.layer("Controls").effect("red")↴
("Slider");
```

25. On the next line, type "green ="; Pick Whip the green effect's slider, and type a semicolon:

```
var green = thisComp.layer("Controls").effect("red")↴
("Slider");
```

26. Add this line:

```
var blue = thisComp.layer("Controls").effect("bluev)↴
("Slider");
```

27. Add this line:

```
var alpha = 1;
```

28. On the final line, type

```
[red, green, blue, alpha]
```

Here's the entire Expression:

```
var red = thisComp.layer("Controls").effect("red")↴
("Slider");
var green = thisComp.layer("Controls").effect("green")↴
("Slider");
var blue = thisComp.layer("Controls").effect("blue")↴
("Slider");
var alpha = 1;
[red, green, blue, alpha]
```

29. Select the Controls effect in the Timeline and, in the Effect Controls window, adjust the sliders to change the star's color.

Note: Don't try to adjust the color by scrubbing the slider's number. As you know, color values must be between 0 and 1. We adjusted the range of the graphical slider so that it stays within the correct range, but the scrubbable number won't keep within that range.

30. Select the Star layer's Fill Effect in the Timeline by clicking the words "Fill Effect."

203

31. Type Command + C (PC: Control + C) to copy the effect to the clipboard.

32. One by one, select all the other graphical layers, and type Command + V (PC: Control + V).

This will paste the Fill effect (complete with Expression) onto all those layers.

33. Select the Control layer, and, in the Effect Controls panel, adjust the graphical sliders.

You will now update all the layers' colors at once. If you want, you can turn on the sliders' stopwatches and animate the colors changing. You could also add wiggle() expressions to the sliders. If you do, make sure the HOW MUCH is set to 1 or less: wiggle(2,1).

34. Past the Fill effect onto the background layer. Select the layer and type EE to reveal its Expression. Click inside the text of the Expression to see the entire Expression.

205

Edit the Expression so that it reads as follows:

```
var red = thisComp.layer("Controls").effect("red")("Slider");
var green = thisComp.layer("Controls").effect("green")("Slider");
var blue = thisComp.layer("Controls").effect("blue")("Slider");
var alpha = 1;
var hsl = rgbToHsl([red,green,blue,alpha]);
hsl[0] += .5;
if (hsl[0] > 1) hsl[0] -= 1;
var rgb = hslToRgb(hsl);
rgb
```

That's really complicated. If you make even the slightest typo, you'll get an error message, and you'll have to edit the Expression until it's completely right.

Some things to watch out for: we've used a couple of new commands, rgbToHsl() and hslToRgb(). Make sure you've spelled them correctly, complete with camelCase.

The parameter inside the rgbToHsl() command is [red,green,blue,alpha]. Make sure you include the open bracket in front of "red" and the closing bracket after "alpha": rgbToHsl([red,green,blue,alpha]).

That's a plus, followed by an equal sign, after "hsl[0]."

The point of this Expression is to turn the background color into the compliment of the other color. A complimentary color is at the opposite side of the color wheel from the original color. Opposite points on a wheel are 180 degrees separated from each other. That's what the "hsl[0] += 180;" statement is referring to: the original hue plus 180.

I won't go into all the details of how this Expression works (just enjoy the fact that it works), but, briefly, it starts by converting the RGB color of the sliders to another color system: HSL. HSL stands for hue, saturation, and lightness. Hue is what we often think of as color. Red is a hue, purple is a hue, yellow is a hue, and so on.

On the "hsl[0]" line, we grab the first dimension of HSL, which is hue, and spin it 180 degrees around the color wheel. It would be awesome if you could spin hsl[0] around the wheel by simply adding 180 to it. But hsl[0] is stored as a number between 0 and 1, not as a more convenient number between 0 and 360. Adding .5 to a number between 0 and 1 is like adding 180 to a number between 0 and 360, hence the statement hsl[0] += .5;

`" += .5" means add .5 to whatever the value already is.`

This cryptic line ensures that the value never gets bigger than 1: if (hsl[0] > 1) hsl[0] −= 1.

Finally, we convert the result back into the RGB system, because the Fill effect expects RGB colors, not hsl colors.

That was a complex project, but I hope you enjoyed it. To wrap up our look at Expression Controls, here's one more project:

1. Open Chapter04.aep, Comp9.

You'll see another dummy, only this time, he has a body. I created his body parts in Photoshop placing each part on its own layer. Then I imported the Photoshop document into After Effects as a Composition. Finally, I moved each layer's anchor point onto the anatomically correct pivot (e.g., the lower leg's anchor point to the knee).

Just so you can get a sense of this process, I neglected the anchor point on one of the arms.

2. Select the right lower arm layer.

Note: I've named the layers after my left and right, not the character's left and right.

3. Switch to the Pan Behind tool.
4. Drag the arm's anchor point to the elbow.

This will allow the arm to rotate realistically.

5. Switch back to the Selection tool.
6. If necessary, reveal the Parenting controls by clicking the Timeline's option menu > Columns > Parent.

You'll notice I set up parenting relationships between the body-part layers. You know that old song, "The head bone's connected to the neck bone…"? That's what I did. For instance, the left lower arm is connected to the left upper arm, which is connected to the torso.

I neglected to parent the right lower arm, so that you could do it.

7. Grab the Parenting Pick Whip for the right lower arm and point it to the right upper arm layer.

Or you can choose "right upper arm" from the right lower arm's Parent menu.

8. Select the Puppet Master layer. (It's a Null object.)

In the Effect Controls panel, notice that I've added an Angle Control for each body part. I renamed the effects after the parts, but I neglected the right lower arm again.

9. Select the bottom Angle Control (select the name of the effect), press Return (PC: Enter), type "right lower arm," and then press Return (PC: Enter) again.

10. Try rotating the angle for left upper leg.

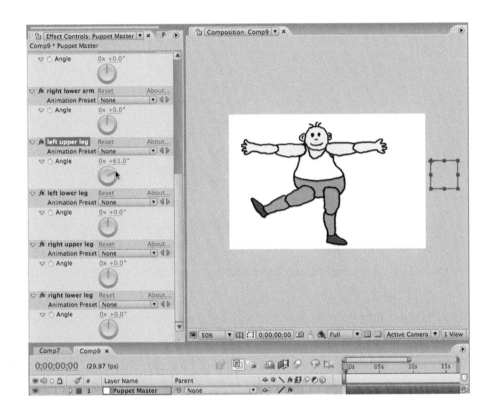

Notice that both the upper and lower legs move. This is because the angle is controlling the upper leg. The lower leg is connected to it, via parenting, so it's moving too.

11. Try rotating the right lower arm angle.

Nothing happens. As usual, I have left this for you.

12. In the Timeline, select the Puppet Master layer and press E to reveal the effects. Twirl open the right lower arm effect to reveal its Angle Control.
13. Select the right lower arm (graphic) layer, and press R to reveal its Rotation property.
14. Add an Expression to Rotation.
15. Pick Whip the Angle Control.

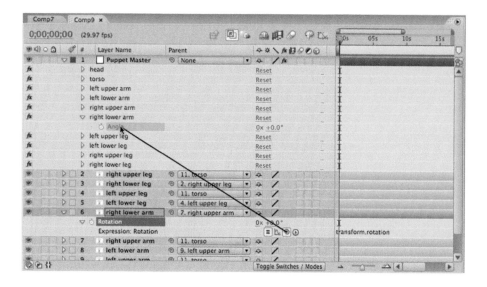

16. Select the Puppet Master layer, and try rotating the right lower arm in the Effect Controls panel.

You now have a fully rigged puppet. The next step is to turn on all the Puppet Master stopwatches in the Effect Controls panel and use the angles to animate the puppet.

You can see a finished version in Chapter04.aep, Comp10.

Just for kicks, I created another version in Chapter04.aep, Comp11. That one has wiggle() Expressions on the angles. I wanted to see what would happen if I created a totally spastic puppet.

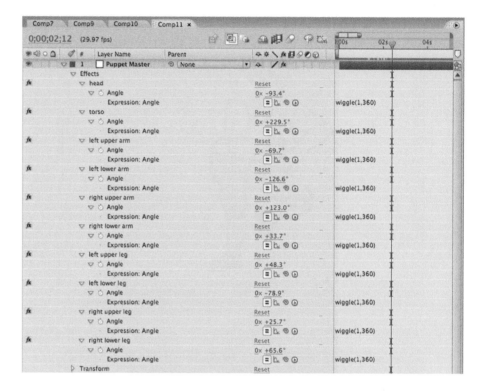

DEBUGGING EXPRESSIONS WITH SOURCE TEXT

Let's say you just learned about a new command called random(). Not being sure how it works, you decide to experiment:

1. In Chapter04.aep, Comp12, you'll find a lone solid.
2. Select it, press R, and add an Expression to its Rotation property.
3. In the text-entry area, type

   ```
   random()
   ```

> Note: The random() command doesn't need any parameters, so don't type anything inside the parentheses.

4. Preview the Comp.

You can see the solid shaking a little bit, but it's barely rotating. What's going on?

5. Switch to the Type tool, and click anywhere in the Comp window.
6. Switch back to the Selection tool.

That's right: just click with the Type tool without actually typing anything and then quit using the Type tool. You won't see any text, but you'll still have created a Type layer.

7. Twirl open the Type layer on the Timeline. Then Twirl open the Text property group.
8. Add an Expression to the Source Text property.

9. In the text-entry area, type

`random()`

10. Preview the Comp.

As you can see, random() spits out random numbers between 0 and 1. That's why the solid was just shaking. The most it was ever able to rotate was 1 degree! It was shaking between 0 and 1 degree.

Using a Type layer this way may be an interesting effect in and of itself, especially if you need to create technobabble displays for a sci-fi movie. But I tend to use this technique as a debugging tool. If I'm confused as to what sort of values an Expression is spitting out, I'll create a temporary Type layer and add the Expression to its Source Text property.

SAVING EXPRESSIONS

Some of our Expressions are getting quite long. As we proceed through this book, they'll get even longer. But the great thing about Expressions is that they're just text, and you don't always need to retype text. You can type it once, save it somewhere, and then paste it into the text-entry area the next time you need it.

Sometimes you don't even have to type it once. I found a great pendulum Expression on motionscript.com, which houses Dan Ebbert's's amazing collection of Expressions. The Expression looks like this:

```
veloc = 7;
amplitude = 80;
decay = .7;
amplitude * Math.sin(veloc * time)/Math.exp(decay * time)
```

I could tell those first three lines were variables, but I had no idea what the fourth line meant. (Though you will, dear reader, if you continue through Part 2 of this book.) But that didn't matter. I just copied the text off the web page and pasted it into a text-entry area.

Incidentally, if you want to use this Expression, make sure you first move the pendulum layer's anchor point to the top of the pendulum (the pivot). Then add the above Expression to the layer's Rotation property. You can see a working example in Chapter04.aep, Comp13.

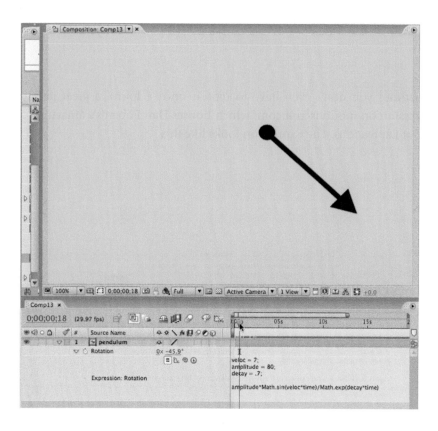

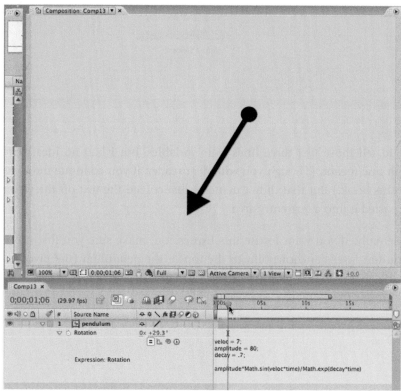

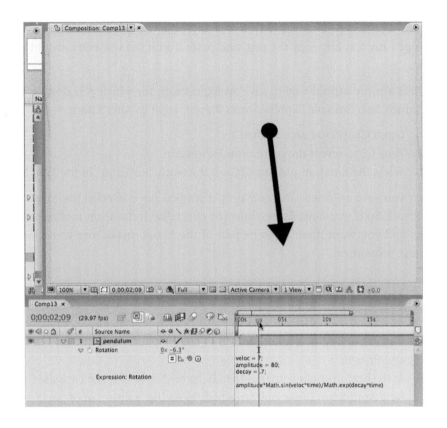

One way to save Expressions is to paste them into a plain-text document. Make sure it really is plain text, not something fancy like a Microsoft Word document. Word processors tend to gussy up your text—for instance, changing plain quotation marks into smart quotes and capitalizing words at the start of sentences. Such decorations will screw up your Expressions. If you want to save Expressions in a text file, use an application like Windows Notepad or OS X's TextExit; and if you use the latter, make sure you choose Format > Make Plain Text.

The benefit of saving Expressions in a text file is that you can add notes. My entry for the pendulum Expression looks like this:

When I want to use this Expression—or any other of the dozens I've saved—I just open my text file, copy the text, and paste it into the text-entry area in After Effects.

There is a more official way to save an Expression, for which you don't need a text editor. You can save Expressions as Presets, right in After Effects:

1. Open Chapter04.aep, Comp13.
2. Type EE to reveal the pendulum Expression.
3. Select the Rotation property. (Click the word "Rotation" in the Timeline.)

When you save a Preset, whatever properties you have selected are saved into the Preset. So if you have Expressions (or effects/keyframes) on multiple properties, and you want them all to be part of the Preset, make sure you select all of those properties.

> Note: To select multiple properties, Command click (PC: Control click) each one.

4. If necessary, display the Effects and Presets panel via Window > Effects and Presets.
5. At the bottom-right corner of the Effects and Presets panel, click the Create New Animation Preset button, which looks like a little pad of paper.

6. In the dialog, name your Preset "Pendulum.ffx" (without the quotation marks), and press the Save button.

Note: If you do a search on you system for .ffx files, you'll find a ton of them. Each one is a Preset, many of which came preinstalled with After Effects. You can share your Presets with other users by giving them copies of these files.

Let's try using the preset!

7. Open Chapter04.aep, Comp14.

I've already moved the layer's anchor point to its pivot.

8. Preview the Comp.

Nothing happens.

9. In the Effects and Presets panel, twirl open the Animation Presets group.

10. Twirl open the User Presets folder.

There's your pendulum Expression!

11. Drag the pendulum Preset, and drop it on the layer.

You can drop it on the layer in the Comp window or on the Timeline.

12. Preview the Comp.

You have your pendulum back! Now any time you need a pendulum, you can just drag and drop this Preset.

Congratulations! You've learned all you need to know about the basics of Expressions. If you like, you can stop here. You'll have decades of fun with the Pick Whip, linking properties to each another; you'll loopOut(), you'll wiggle(), and you'll do it all with ease(). Your mastery of After Effects will soar through the roof.

If you want to take it to the next level, and I hope you do, please follow me into Part 2. The woods will get a bit thicker, but you need to get through them if you're ever going to become a true Expressions guru.

I'll be waiting for you in the next chapter.

PART 2
Foundations for Advanced Expressions

CHAPTER 5
JavaScript for Expressions

Having read the first part of this book, you're able to craft some truly amazing effects with Expressions. Still, by limiting yourself to the Pick Whip and a few simple commands, you're a bit like a tourist carrying around a foreign-language phrase book. You'll never really feel at home until you master the language. Once you do, you'll be able to transcend "How much does this cost?" and "Where please is the bathroom?" and write original poems, stories, and novels.

If you want to learn a foreign language, you have to start with its grammar. This is as true with JavaScript as it is with Italian. You already know a little JavaScript grammar: you know about variables, semicolons, and commands. In this chapter, you'll learn some more.

We have five main topics to cover. First, we'll revisit variables, delving deeper into the types of values you can store in them and how to manipulate those values. Next we'll talk about conditionals. I've already snuck a couple of conditions past you. They're the statements that start with "if." They're forks in the road that let your Expressions veer in two or more directions, depending on what's going on at the time. Then, we'll touch on loops, which let you automate repetitive tasks. After loops, we'll take a quick look at user-defined functions. Yes, you can finally implement doggy JavaScript by creating fetch() and sit()! We'll end this chapter by exploring some of the limitations of Expressions JavaScript. After all, it's just as important to know what you can't do as it is to know what you can.

VARIABLES

In Part 1, I likened variables to boxes in the attic. Here, I'll switch metaphors: variables are like soup pots on the stove. The variable itself is the pot. The value you're storing in it is the soup itself.

Imagine that whenever you cook soup, you put a piece of masking tape on the outside of the pot and write a label on it: "chickenSoup," "lentilSoup," "grandmasSecretReceipe." Those labels are the variable names:

```
var chickenSoup = ingredients;
```

In the following section, I want to talk about the ingredients, which are the values you're storing in the pot. Just as you wouldn't put nails in a soup pot, there are only certain legitimate values you'd ever store in a variable: numbers, strings, booleans, arrays, and objects.

Values

JavaScript may seem complex, but each part of it falls into one of only two categories: tools and data. Variables are tools (pots). They allow you to store data (ingredients). In this section, we're concerned with the data itself.

In JavaScript, the data are whatever comes after the equals sign:

var variableName = data

By the way, there's a subtle difference between equal signs in math and in JavaScript. In math, equal signs imply equivalency. When I write the mathematical statement

```
1 + 1 = 2
```

I'm implying that, in some way, 1 + 1 and 2 mean the same thing: they're equal to each other. But if I write

```
var xPosition = 15;
```

I don't mean that xPosition and 15 are the same thing. After all, xPosition is a storage container (a tool); 15 is what I'm storing in that container (data).

In JavaScript, the equal sign is called the assignment operator. "var xPosition = 15" means "I'm assigning 15 to the variable xPosition." You could also call it the storage operator: "I'm storing 15 in xPosition."

If you have a pot with chicken soup stored in it, there's nothing stopping you from dumping the soup into the trash and replacing it with a totally different kind of soup, maybe French onion. However, 1 + 1 will always equal 2.

Hopefully, you'll never store tennis shoes in a soup pot. Similarly, here's something you're not allowed to store in a variable:

```
var xPosition = $;
```

You can't store a dollar sign in a variable. You can only store numbers, strings, Booleans, arrays, and objects.

Numbers

You know what a number is. But just to make sure you're thinking about the full range of possibilities, check out the following legal statements, all of which are numbers or resolve to numbers:

```
var xPosition = 150;
var yPosition = 23 + 4;
var spinAmount = 10 - (3 * 4);
var offset = 23.2;
var width = -17;
var rollOfTheDice = ease(time,0,10,0,360);
```

Strings

String is short for "string of characters." A character is anything you can type on your keyboard: b, B, 2, $, and so on. Strings are multiple characters strung together: cat, dog, 123, 99skidoo, @#%&!, and the like.

In JavaScript, you always wrap strings in quotation marks (double or single quotes): "cat", 'dog', "123", "99skidoo," and "@#%&!" to name a few. Why? Because many strings look suspiciously like variables. They're not variables. Variables are tools for storing data; strings *are* data. If you omit the quotation marks, After Effects will get confused and think you're talking about a variable instead of a string:

```
var myName = "marcus";
```

229

In that statement, I'm storing the string "marcus" in the variable myName. Compare that example with the following:

```
var marcus = 43;
myName = marcus;
```

Because I omitted the quotation marks, I'm *not* storing "marcus" in myName; I'm storing 43 in myName. Why? Because I'm first storing 43 in a *variable* called marcus. Then I'm storing the value of that variable in myName. Variable names and strings are both made out of characters. If you want to use a string, make sure you put quotation marks around it. Otherwise, AE might mistake it for a variable.

You probably won't use strings as often as you'll use numbers. But you have seen them a few times already. For instance,

```
thisComp.layer("flyingSaucer").transform.position
```

In that Expression, "flyingSaucer" is a string. You're feeding that string to the layer() command, which will use it to locate a layer in the Comp. For no good reason, other than to illustrate strings stored in variables, you could rewrite that Expression as

```
var layerName = "flyingSaucer";
thisComp.layer(layerName).transform.position
```

In the second statement, AE will understand that layerName is a variable, because it's not surrounded by quotation marks. AE will then think, "Hmm. A variable. I wonder what's stored in it. Oh, I can see from the line above that the string 'flyingSaucer' is stored in it. Okay, I'll look for a layer called 'flyingSaucer.'"

Everything will go haywire if you put quotation marks around layerName in the second statement:

```
var layerName = "flyingSaucer";
thisComp.layer("layerName").transform.position
```

Now, AE will ignore the first statement and go looking for a layer called "layerName" in the Comp.

Booleans

Booleans are very simple values. There are only two of them: true and false:

```
var catsLikeBaths = false;
var whalesCanSwim = true;
```

Note the subtle difference between that last statement and the following:

```
var whalesCanSwim = "true";
```

"true" is not a Boolean value. "true" is a string. It's a string of the characters t,r,u, and e. True Booleans are more like on/off switches than strings. You can also think of Booleans as checkboxes: true means checked; false means not checked.

To see a Boolean in action, open Chapter05. aep, Comp1:

1. Select the layer and type EE.

I applied the Beam effect to the layer and added an Expression to the Composite On Original property. As you may recall, Composite On Original tells Beam whether or not to display the original layer. If it's on, you'll see the layer and the beam; if it's off, you'll just see the beam.

My Expression is the Boolean true. So you see the beam and the layer.

2. Edit my Expression, changing true to false.

The layer vanishes, leaving only the beam.

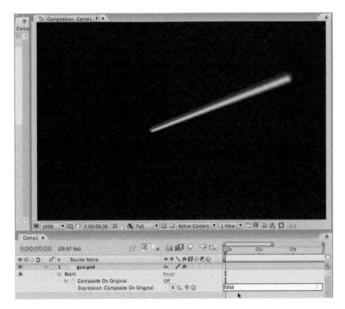

3. Now change the value from false to "false".

AE throws a nasty error at you. Just as the Blurriness property of Fast Blur will only accept numbers, Composite on Original will only accept Booleans, and "false" is a string, not a Boolean.

Arrays

Arrays are lists of values separated by commas. You must enclose the entire list inside square brackets:

```
var myList = [100, 200, 300];
```

Values inside arrays can be any of the types we've discussed (and types we haven't discussed yet), and you can even mix types within a single array. The following are all examples of legal arrays:

```
var someNumbers = [15, 67.987, -4, 0, 23];
var someMoreNumbers = [2 + 3, 100-50, 8];
var oneNumber = [410];
var someStrings = ["cat", "dog", "moose"];
var someBooleans = [false, true, true, false, true];
var someArrays = [ [1, 2, 3], ["cat", "dog"], [true, false] ];
var mixedNuts = ["cat", 100, false, [10, 9, 8] ];
var moreMixedNuts = [transform.position, 44 ,random(), "moose"];
```

Arrays can also hold variables. For instance,

```
var red = .5;
var green = 1;
var blue = 0;
```

```
var alpha = 1;
var myColor = [red, green, blue, alpha];
```

Or they can hold mixtures of variables and values:

```
var xPosition = 310;
[xPosition, 40]
```

Each value in an array has an index number:

```
var animals = ["cat", "dog", "moose", "whale"]
    Index:        0      1       2        3
```

You can access a particular value in an array via its index. For instance, in the animals array, you can access "moose" with `animals[2]`. And you can access "cat" with `animals[0]`. You may remember accessing x and y values with `transform.position[0]` and `transform.position[1]`. This tells you that AE stores a layer's position as an array. When you access x and y separately, you're accessing specific values in that array.

You can also access a value by using a variable as the index. For instance,

```
var breakfast = ["eggs", "bacon", "toast", "milk"];
var myIndex = 2;
```

I can now access toast via `breakfast[myIndex]`. (Remember, indexes start at 0: "eggs" is 0; "bacon" is 1; "toast" is 2.)

By the way, I didn't just call that variable myIndex to be cute. You can't name a variable "index," because "index" is a reserved word. Like the word "position," it's been co-opted by the Expressions language.

Most programmers simply use the variable-name i to store index numbers. For instance,

```
var breakfast = ["eggs", "bacon", "toast", "milk"];
var i = 2;
```

Now, I can access "toast" via `breakfast[i]`.

One more thing about indexes: sometimes you need more than one. Most arrays you'll encounter will contain a list of simple values, but it's possible for an array to be a list of other arrays:

```
var xyPositions = [ [100, 200], [250, 80], [0, 350] ];
```

233

Here's are the index numbers:

```
                          0              1              2
var xyPositions = [ [100, 200], [250, 80], [9, 350] ];
                     0   1        0   1        0   1
```

To access the 9, I'd type `xyPositions[2][0]`. Or, in a slightly longer form, I'd type

```
var xyPositions = [ [100, 200], [250, 80], [9, 350] ];
var mainIndex = 2;
var subIndex = 0;
xyPositions[mainIndex][subIndex]
```

To see value access at work, open Chapter05.aep, Comp2.

1. Select the layer and type EE.

There's an Expression on Rotation. If necessary, pull the Expression's lip down so that you can see all of it:

```
myArray = [45, 90, 270, -15, 11];
myArray[2]
```

Counting from 0, item two in the array is 270, so the layer is rotated 270 degrees.

2. Try changing the index in the second statement.

To rotate the layer 45 degrees, you'll need to change the second statement to "myArray[0]."

How would you change the index number if you wanted to rotate the layer to −15 degrees? What happens if you change the index number to 57?

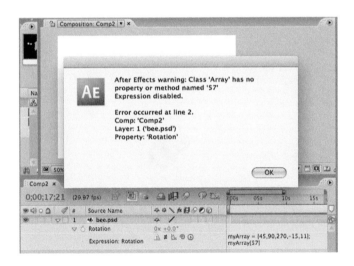

Here's a more advanced (and more fun) example of value access:

1. Open Chapter05, Comp3, select the one layer and type EE.

You'll see this Expression:

```
var myArray = [10, 20, 30, 40, 50];
var i = Math.floor(time);
if (i > myArray.length - 1) i = myArray.length - 1;
myArray[i]
```

2. Preview the Comp.

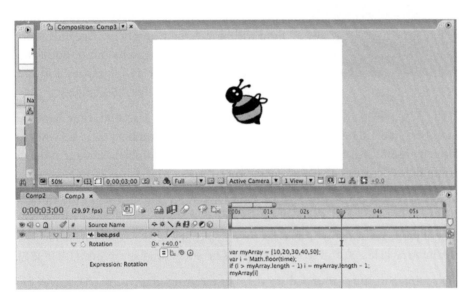

As you can see, the layer pops to a new rotation degree each second, up until the fifth second, when it stops rotating.

The first statement in the Expression should make complete sense to you:

```
var myArray = [10,20,30,40,50];
```

Here, I created an array, myArray and populated it with five values. Notice that in the final statement, myArray[i], I'm accessing one of those values.

In the second statement, I'm using a method called Math.floor(). Math.floor() gets rid of fractions by rounding down. So, for instance, if you type Math.floor(5.3), the method spits out 5. Math.floor(87.9999) spits out 87.

(Incidentally, there's another method called Math.ceil(); "ceil" is short for ceiling. Math.ceil() rounds up. So if you feed it 87.9999, it spits out 88. There's yet another method called Math.round(). Math.round() rounds according to the conventional rules of rounding. It rounds 3.2 down to three; it rounds 3.5 up to 4.)

I'm feeding Math.floor() time. At each frame, time will be a certain number of seconds, starting at 0. Math.floor(0) spits out 0. But as the Current Time Indicator (CTI) moves forward, time becomes numbers like 0.63766433.

Math.floor(0.63766433) is still 0. Eventually, after 1 second, time becomes numbers like 1.038483. Math.floor() changes such numbers to 1. So whereas time by itself gets set to all sorts of wacky fractional numbers, sticking it inside Math.floor() ensures a neat progression: 0,0,0,0… 0,1,1,1… 1,2,2,2,2….

I need a neat progression, because I'm saving the value of time in the variable called i, and I'm using i as an index to myArray. Array indexes can't have fractional parts. Because myArray is set to [10, 20, 30, 40, 50], myArray[0] is 10, myArray[1] is 20 and so on, but there's no such thing as myArray[1.838337].

By setting i to time (rounded down), I'm ensuring that as the CTI moves forward, i will get higher and higher. That is, i will start out as 0; then, when the CTI gets to 1 second, i will get set to 1. At 2 seconds, i will get set to 2, and so on.

Because my final statement is myArray[i], as the CTI moves, the Expression will get set to myArray[0], myArray[1], myArray[2], and so on. And because those values are 10, 20, 30, and so on, Rotation will get set to 10, 20, 30, and so on. At each second, Rotation will get a new value.

There's only one problem: time will keep marching on, but there are only five values in myArray, [10, 20, 30, 40, 50]. Eventually, i will get set to 5, 6, 7, 8,

and so on. If i is 8, then the final statement, myArray[i], will be the same as myArray[8]. There is no such value in the array, so I'll get an error.

One way to deal with it is to simply add more values to the array: var myArray = [10, 20, 30, 40, 50, 60, 70, 80, 90, 100]. But I decided to solve it another way. I decided to stop i from ever getting set to a number higher than 4:

```
if (i > myArray.length - 1) i = myArray.length - 1;
```

Translated into English, this statement says, "if i is a higher number than the last index in the array, make i equal to the last index in the array.

The highest index is myArray.length − 1. length is a property of arrays. It knows how many items there are in the array. In this example,

```
var animals = ["cat", "dog"];
```

animals.length is 2.

And in this example,

```
var names = ["Bill", "Mary", "Cuthbert", "Lisa"]
```

names.length is 4.

But notice something funny: the index numbers of each item run as follows:

```
["Bill", "Mary", "Cuthbert", "Lisa"]
   0       1        2          3
```

That's right. The array has four values in it, but the highest index number is 3. Because index numbers start at 0, the highest one is always one-less-than the length of the array.

So when I typed

```
if (i > myArray.length - 1) …
```

myArray.length is 5, because there are five values in [10, 20, 30, 40, 50], but the highest index number is 4. Which is the same as myArray.length − 1.

So if i is greater than 4, we don't want it to get set to 5—because there is no index number 5 in this array. So

```
if (i > myArray.length - 1) i = myArray.length - 1;
```

This statement does the same thing as

```
if (i > 4) i = 4;
```

"If the index number is greater than 4, make it equal to 4."

239

But I prefer the former version. It's more versatile. If I add or remove values from the array, the former version will adjust itself. But the latter version assumes that the highest index will definitely be 4.

Putting it all together:

- I defined an array containing five values.
- I used time (rounded down) to set an index.
- I made sure that index never got higher than 4.
- I used the index to get at one of the values in the array:

```
var myArray = [10,20,30,40,50];
var i = Math.floor(time);
if (i > myArray.length - 1) i = myArray.length - 1;
myArray[i]
```

Objects

Without calling them by their proper name, we've seen plenty of objects. Objects are the things that have properties and methods. For instance, thisComp is an object. If I type thisComp.layer("Solid 4")..., I'm calling the layer() method of the object called thisComp. Likewise, transform is the object that has properties like position and rotation. And although position and rotation are properties of the transform object, they are also objects themselves. I know this because both have a valueAtTime() method, as in ...position. valueAtTime(time − 1).

You may be confused, because, as you know, position is also an array. We access x position via transform.position[0] and y position via transform.position[1]. Those sure look like index numbers.

Actually, there's no contradiction. In JavaScript, arrays are special types of objects. Whereas most objects have properties and methods, array objects have properties, methods, *and* index numbers. By the way, when we access myArray.length, we're accessing the length property of the myArray object. Math is an object. When I want to round down, I call its floor method, as in Math.floor(17.23). In doggy JavaScript, we might access a breed property, as in Rover.breed. Or we might call a fetch method, as in Rover.fetch("stick").

JavaScript also lets you store objects in variables; for example,

```
var myComp = thisComp;
```

You can also use variables to store properties and the values spit out by methods.

240

In Chapter05.aep, Comp4, on the only layer's Opacity property, I've typed this silly Expression:

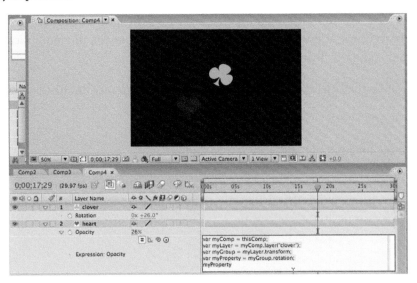

```
var myComp = thisComp;
var myLayer = myComp.layer("clover");
var myGroup = myLayer.transform;
var myProperty = myGroup.rotation;
myProperty
```

That Expression does the same thing as

```
thisComp.layer("clover").transform.rotation
```

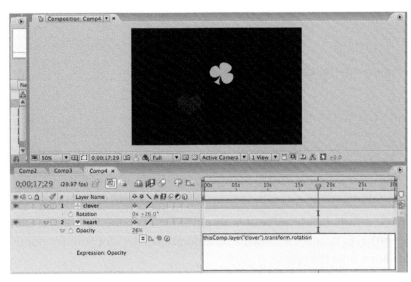

OPERATORS

Operators are little "machines" that alter or compare values. The ones you know best are the arithmetic operators: +, −, *, and /. Those are called, respectively, the addition operator, the subtraction operator, the multiplication operator, and the division operator.

The values they operate on are called operands. For instance, in the statement

```
var myAge = 40 + 3;
```

+ is the operator; 40 and 3 are the operands.

Here are a few lesser-known but important operators: +=, −=, *=, and /=. += is just a shorthand for adding two numbers together. The following two Expressions do the same thing:

```
var ducks = 5;
ducks += 2; //that means add 2 to ducks
```

and

```
var ducks = 5;
ducks = ducks + 2;  //that means set ducks to what
                    //it already is (5) plus 2
```

Either way, ducks winds up being seven.

I bet you can guess what −= does:

```
var cookiesInTheJar = 10;
cookiesInTheJar −= 9; //there's only one cookie left!
```

You can use *= for quick multiplication:

```
var dollarsInMyAccount = 50;
dollarsInMyAccount *= 2; //I now have $100
```

You can use /= for quick division:

```
var dollarsInMyAccount = 50;
dollarsInMyAccount /= 5; //Now I only have $10
```

It will be awhile before we're able to put these operators to good use, but in Chapter05.aep, Comp5, I crafted a little demonstration for you. It's not useful, but it shows how the operators work.

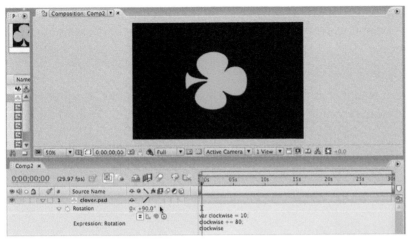

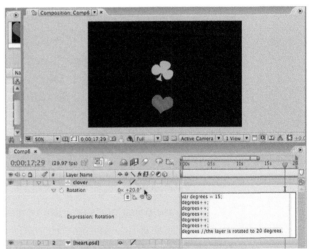

Now, ++ is the increment operator. It adds 1. If you open Chapter05.aep, Comp6, you'll see (if you select the top layer and type EE) that I've set Rotation in a silly (but informative) way:

```
var degrees = 15;
degrees ++;
degrees ++;
degrees ++;
degrees ++;
degrees ++;
degrees //the layer is rotated ⌐
to 20 degrees.
```

And −− is the decrement operator. It subtracts 1. Here's the Expression on the lower layer's Rotation property:

```
var degrees = 15;
degrees --;
degrees --;
degrees --;
degrees --;
degrees --;
degrees //the layer is rotated to ⌐
10 degrees
```

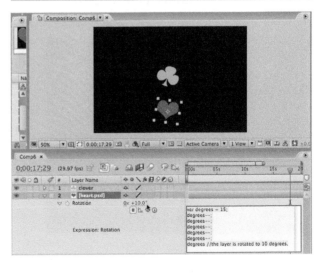

243

The last two operators that I'll cover for now are tricky. One of them is the not operator, and its symbol is an exclamation point. You only use not for boolean values:

```
var iLoveChocolate = !false;
```

You can read that as "not false," which is the same as true. The preceding statement means exactly the same thing as

```
var iLoveChocolate = true;
```

If you think of Booleans as coins, ! flips them, changing heads to tails and tails to heads:

```
var heads = true;
heads = !heads; //heads is now false
heads = !heads; //heads is now true
heads = !heads; //heads is not false
```

The final operator I'll show you (for now) is called the modulo operator, and its symbol is the percent sign. This is a little unfortunate, because *it has nothing to do with percentages*. Of course, the not operator uses an exclamation point, and it has nothing to do with exclamations:

```
var temp = 9 % 2; //temp is 1
```

Why is temp 1? Well, what would you get if you divided 9 by 2? Well, 2 goes into 9 four times, with 1 left over:

```
9 divided by 2 is 4 (with 1 left over)
```

Modulo just gives you the remainder (the leftover part) of a division problem; 9 % 2 is like saying, "Hey, After Effects. Divide 9 by 2 but don't tell me the answer. I don't care how many times 2 goes into 9. But I do about how much is left over. Tell me that."

How is this useful? One use is to do something different on just even or just odd seconds. Even seconds are numbered

```
0, 2, 4, 6, 8,…
```

Odd ones are numbered

```
1, 3, 5, 7, 9,…
```

You can tell if a number is even or odd by dividing it by 2. If the remainder is 0, the number is even. If the remainder is anything else, the number is odd. For instance,

```
2 % 2 is 0—even
3 % 2 is 1—odd
25 % 2 is 1—odd
4824 % 2 is 0—even
```

In Chapter05.aep, Comp7, I used this technique to make a lighthouse beacon shine once every other second (on the even-numbered seconds only). To see the Expression, select the beacon layer and type EE.

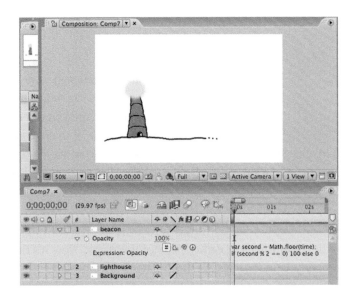

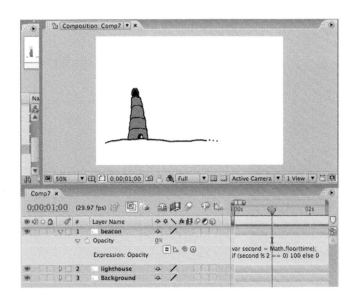

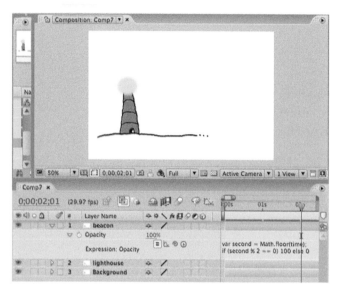

On Opacity:

```
var second = Math.floor(time);
if (second % 2 == 0) 100 else 0
```

The first statement stores time in a variable called seconds, discarding the fractional part. The second statement divides seconds by 2, using modulo, to see if the remainder is 0 or not. If it is, Opacity is set to 100; if it's not, Opacity is set to 0.

That double equal sign is not a mistake. In JavaScript, you can read a double equal as "is-equal-to." And you can read the second statement as "If the remainder of second divided by 2 is equal to 0, set Opacity to 100; otherwise set it to 0." The == is yet another operator. It's a comparison operator. I'll discuss comparisons in the next section, which is about "if" statements, otherwise known as conditionals.

CONDITIONALS

I've flirted with conditionals in earlier parts of this book. Now it's time to delve into them properly. Conditionals are those statements that start with "if," such as

```
if (second % 2 == 0) 100 else 0.
```

Here's a template for conditionals:

```
if (TRUE_OR_FALSE_STATEMENT)
{
    FIRST_THING_TO_DO_IF_STATEMENT_IS_↴
    TRUE;
    SECOND_THING_TO_DO_IF_STATEMENT_↴
    IS_TRUE;
    ETC.
}
else
{
    FIRST_THING_TO_DO_IF_STATEMENT_↴
    IS_FALSE;
    SECOND_THING_TO_DO_IF_STATEMENT_↴
    IS_FALSE;
    ETC.
}
```

As we'll soon see, conditionals don't always employ the entire template. Many parts of it are optional.

Chapter05.aep, Comp8, has a nice conditional in it. To see it, you'll need to select the layer and type EE.

On position:

```
if (time < 5)
{
  var xPosition = 200;
  var yPosition = 100;
}
else
{
  var xPosition = 200;
  var yPosition = 400;
};
[xPosition, yPosition]
```

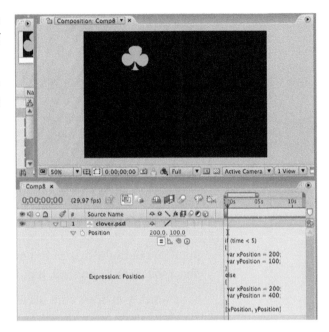

> Note: I indented the var statements by pressing the tab key before typing each one. You don't have to do that, but I think it makes the conditional statement easier to read.

247

The < in the TRUE_OR_FALSE_STATEMENT is the less-than comparison operator. If time is less than 5 seconds, the TRUE_OR_FALSE_STATEMENT is true, and the statements within the first set of curly braces will run. If time is 5 seconds or more, the TRUE_OR_FALSE_STATEMENT is false, and only the statements in the second set of curly braces (after the else) will run.

The if-statement ends after the second close-curly brace (notice the semicolon), so [xPosition, yPosition] is not part of it. Because [xPosition, yPosition] is not part of the conditional, it will run regardless of whether or not the TRUE_OR_FALSE_STATEMENT is true or false.

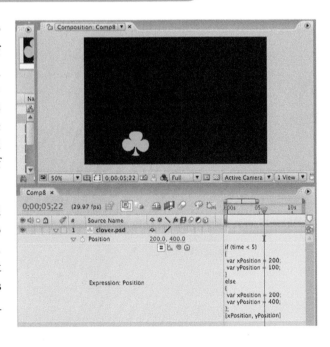

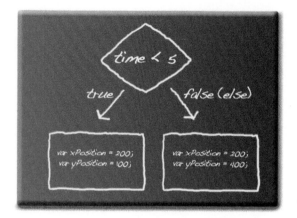

By the way, if statements don't require ending semicolons, most programmers don't bother with them. These two statements work exactly the same way:

```
if (1 < 2) { 100 } else { 200 };
//notice the semicolon
if (1 < 2) { 100 } else { 200 }
//notice the missing semicolon
```

If there's only one thing you want to happen when the TRUE_OR_FALSE_STATEMENT is true or false, you don't even need to include the curly braces:

```
if (1 < 2) 100 else 200;
```

But if you omit the braces, you must include a semicolon. For AE to understand that a statement is finished, it must see a close curly brace, a semicolon, or both.

Sometimes, you don't even need the else part:

```
var xPosition = 10;
var yPosition = 20;
if (time > 8)
{
  xPosition = 100;
  yPosition = 200;
}
[xPosition,yPosition]
```

If the TRUE_OR_FALSE_STATEMENT is false, no else statements will run, because there aren't any. Instead, xPosition will stay at 10, and yPosition will stay at 20.

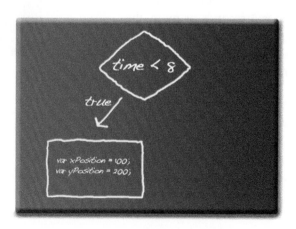

Before moving on from ifs, let's look at the rest of the comparison operators:

```
 < less than
 > greater than
<= less then or equal to
>= greater than or equal to
== equal to
!= not equal to
```

In the following examples, imagine that the CTI is at exactly 5 seconds:

```
var xPosition = 100;
var yPosition = 0;
var seconds = Math.floor(time);
if (seconds < 5) yPosition = 200;
[xPosition, yPosition] //yPosition stays at 0
                       //because 5 is not less than 5
```

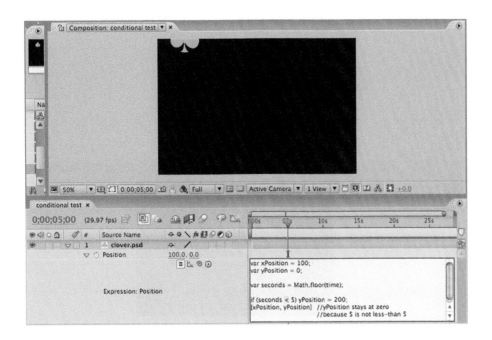

```
var xPosition = 100;
var yPosition = 0;
var seconds = Math.floor(time);
if (seconds <= 5) yPosition = 200;
[xPosition, yPosition] //yPosition changes to 200
```

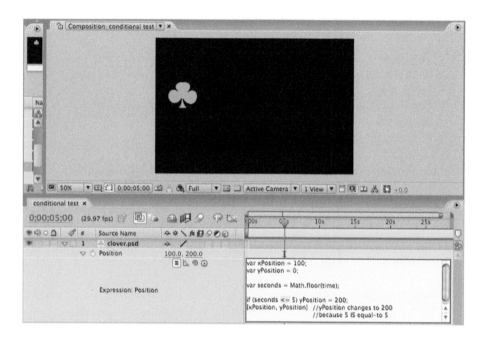

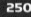

```
var xPosition = 100;
var yPosition = 0;
var seconds = Math.floor(time);
if (seconds > 5) yPosition = 200;
[xPosition, yPosition]
//yPosition stays at 0
```

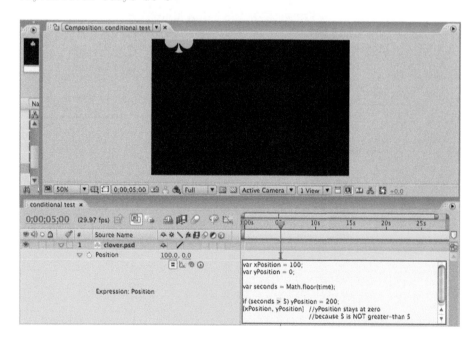

```
var xPosition = 100;
var yPosition = 0;
var seconds = Math.floor(time);
if (seconds >= 5) yPosition = 200;
[xPosition, yPosition] //yPosition changes to 200
```

```
var xPosition = 100;
var yPosition = 0;
var seconds = Math.floor(time);
if (seconds != 4) yPosition = 200;
[xPosition, yPosition] //yPosition changes to 200
```

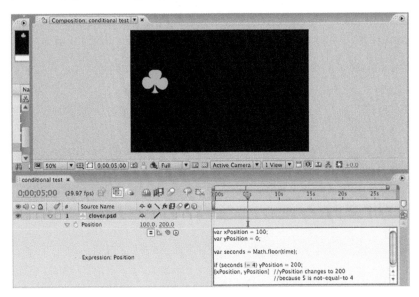

```
var xPosition = 100;
var yPosition = 0;
var seconds = Math.floor(time);
if (seconds == 5) yPosition = 200;
[xPosition, yPosition] //yPosition changes to 200
```

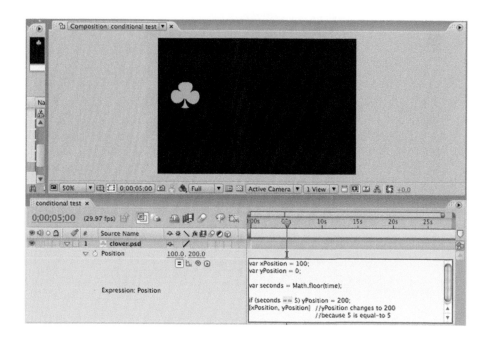

Be careful with that last operator. Many programmers accidentally type = instead of ==. Keep in mind that = is the assignment operator, and you should only use it when you're assigning values to variables. However, == is the comparison operator, and you should only use it in a conditional.

Finally, you need to know about the && and || operators:

```
&& means "and"
|| means "or"
if (seconds > 1 && seconds < 6) yPosition = 200;
```

Assuming the CTI is still at 5 seconds, yPosition will be changed to 200, because 5 is greater than 1 and less than 6. But if the CTI moves onto 8 seconds, yPosition will not be changed, because though 8 is greater than 1, it's not less than 6:

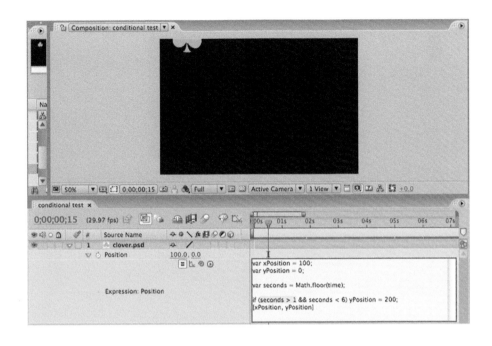

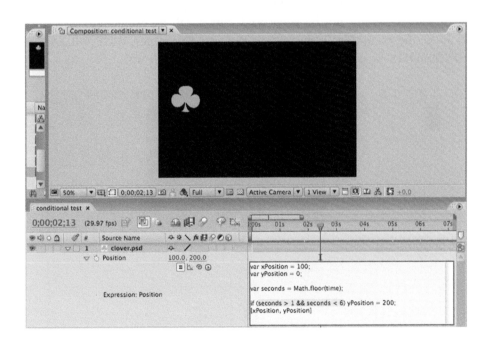

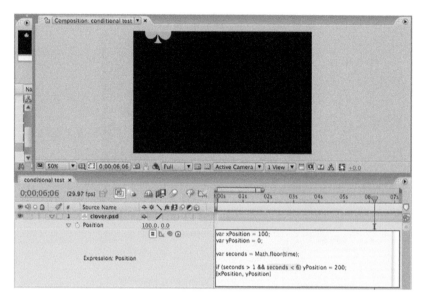

```
if (seconds == 3 || seconds == 9) yPosition = 200;
```

If the CTI is at 5 seconds, yPosition won't change, because 5 is not equal to 3 or 9. However, when the CTI moves to 9 seconds, yPosition will change. At 9 seconds, time will not be equal to 3, but it will be equal to 9, and since || is in the condition, only one of the two (or more) TRUE_OR_FALSE_ STATEMENTS must be true for the whole condition to be true.

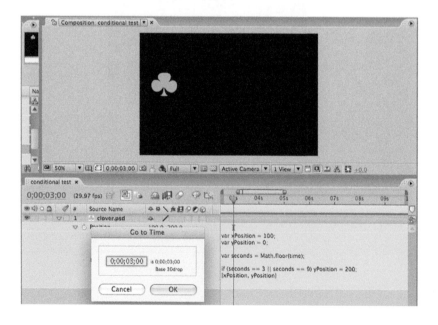

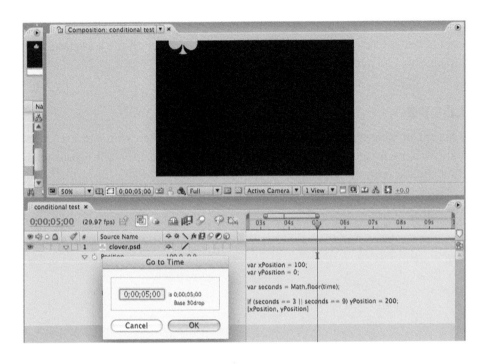

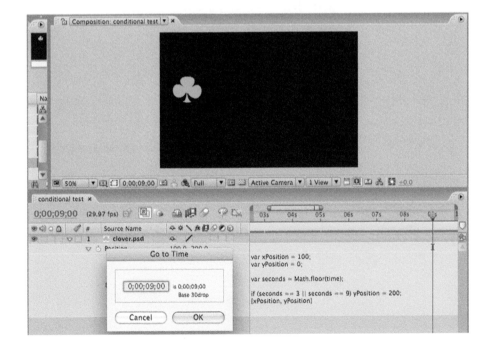

Incidentally, || is two "pipe" symbols. On most keyboards, the pipe is located right above the Return (PC: Enter) key. It shares its key with the backslash. The pipe is Shift + backslash.

LOOPS

My goal in Chapter05.aep, Comp9, was to fill the screen with random, constantly changing letters and numbers. You'll see how I achieved it if you reveal the Expression on the Type layer.

On Source Text:

```
posterizeTime(3);
var randomNumber = random(48,122);
var myText = String.fromCharCode(randomNumber);
myText
```

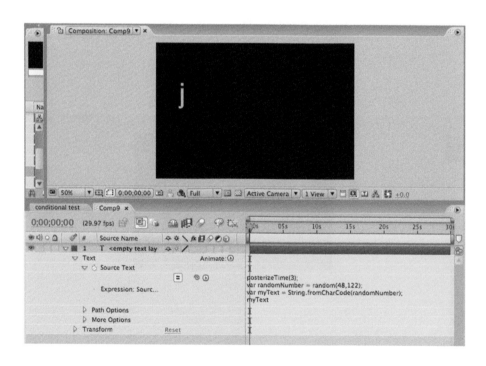

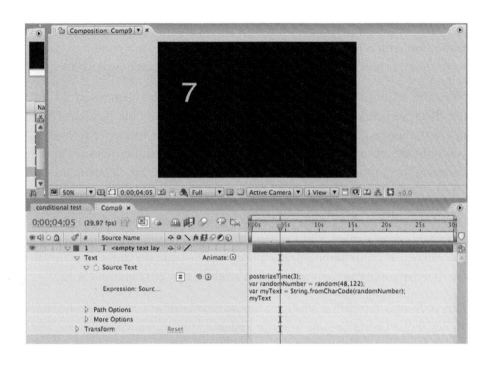

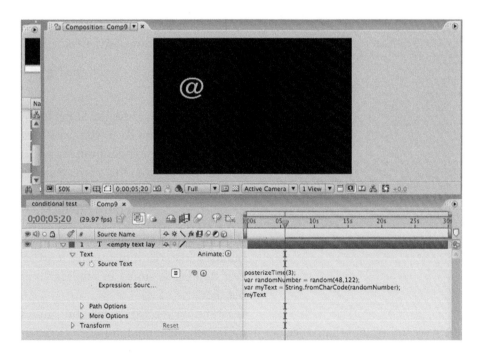

As you'll see, if you preview the Comp, I've fallen far short of my goal. The Expression creates just a single changing character. Still, it's a good foundation, so let me go through it statement by statement and explain how it works.

Normally, Expressions rerun on each frame. If I let this Expression do that, the character would change so fast, it would look like a blur. posterizeTime() is a slow-motion command. You feed it the number of times per second that you want the Expression to run. posterizeTime(3) limits the character to only changing three times per second, which is fast enough. Try changing the 3 to lower or higher values to see what happens.

In the second statement, I store a random number between 48 and 122 in the variable randomNumber. Why between 48 and 122? Because every character (that you can type on your keyboard) has a code number, and the codes for all the letters, numbers, and common punctuation symbols start at 48 and end at 122.

This code-system is called ASCII (pronounced *ask-ee*), and as it's useful to have an ASCII chart lying around. You can find one at http://en.wikipedia.org/wiki/ASCII. Note that each character has several codes, but you should only use the decimal ones, often labeled DEC.

Note: If you want this Expression to just output random lowercase letters, try

```
var randomNumber = random
(97,122);
```

The next statement uses the String.fromCharCode() method. If you pass that method one of the codes from the ASCII chart, it spits out the corresponding character. For instance, String.fromCharCode(115) spits out a capital M.

Instead of feeding the method a set number, like 115, I'm feeding it whatever number is stored in randomNumber. Because of posterizeTime(3), AE is rerunning the Expression three times every second (rather than once per frame). Each time, random(97,122) generates a new random number, and String.fromCharCode(randomNumber) spits out a different character.

I store that character in a variable called myText and, in the final statement, use myText to set the Source Text for the layer.

Note: Originally, I named the variable "text," but it turned out that like "index," "text" is a reserved word.

In Chapter05.aep, Comp10, I got a little closer to my goal.

Here's the amended Expression:

```
posterizeTime(3);
var randomNumber = random(48,122);
var myText = String.fromCharCode(randomNumber);
randomNumber = random(48,122);
myText += String.fromCharCode(randomNumber);
randomNumber = random(48,122);
myText += String.fromCharCode(randomNumber);
randomNumber = random(48,122);
myText += String.fromCharCode(randomNumber);
randomNumber = random(48,122);
myText += String.fromCharCode(randomNumber);
randomNumber = random(48,122);
myText += String.fromCharCode(randomNumber);
randomNumber = random(48,122);
myText += String.fromCharCode(randomNumber);
myText
```

This time, I keep generating new random numbers and using them to grab new characters. I append each new character onto myText, using the += operator.

But this only gets me a few characters. If I really want to fill the screen, I'll have to repeat those statements many more times. Whenever you find yourself typing the same thing over and over again in an Expression, a warning bell should clang in your brain. Humans shouldn't have to repeat themselves. That's what computers are for. To get the computer to repeat those statements for you, you'll have to place them inside a loop.

260

Here's a simple example of a loop:

> In: Chapter05.aep, Comp11
> On: Rotation

```
var degrees = 10;
var i = 0;
while (i < 3)
{
  degrees +=5;
  i ++;
}
degrees
```

Notice that at the top of the Expression, I created a variable called degrees and set it to 10. Yet the layer is rotated to 25 degrees. Why? Because the code inside the curly braces ran 3 times. Note that the first statement inside the braces is degrees += 5. Because that statement runs three times, it first raises degrees from 10 to 15, then from 15 to 20 and finally from 20 to 25.

Before the loop, I set a variable called i to 0. The loop itself is controlled by a while statement, which is very much like an if statement. In an if, the statements inside the braces run only when the TRUE_OR_FALSE_STATEMENT is true. The while statement works the same way, except when AE reaches the close-curly brace, it goes back up and runs the statements within the braces over again. Every time it reaches the close brace, it loops back to the open brace. It will only stop if the TRUE_OR_FALSE_STATEMENT becomes false.

Here is a loop that will run forever (an infinite loop):

```
while(100 < 200)
{
  degrees += 5;
}
```

Because 100 will always be less than 200, the TRUE_OR_FALSE_STATEMENT will never be false. This is exactly the kind of loop you don't want

in your Expressions. In certain circumstances (in other applications), infinite loops can crash your computer. Don't worry: AE won't crash if you accidentally write an infinite loop. When AE encounters one, it hangs for a bit and then spits out an error message. Still, infinite loops won't help you. Loops need a way to stop, a way out.

The way out is to initialize a variable to 0 before the loop starts:

```
var i = 0;
```

And then each time through the loop, increment that variable by 1:

```
i++;
```

Finally, for your TRUE_OR_FALSE_STATEMENT, test to see if the variable is less than some number:

```
while (i < 3)...
```

i will start out less than 3 (because it starts at 0), so the loop will run. But because i++ will run each time the loop runs, i will get set to 1, then 2, then 3. When it reaches 3, the loop will stop, because the TRUE_OR_FALSE_STATEMENT will be false (3 is not less than 3).

Here's a template for loops:

```
INITIALIAZE_A_VARIABLE;
while(TRUE_OR_FALSE_STATEMENT)
{
  STATEMENTS_YOU_WANT_TO_LOOP;
  INCREMENT VARIABLE;
}
```

Getting back to my goal of filling the screen with letters, take a look at this Expression:

In: Chapter05.aep, Comp12
On: Source Text

```
posterizeTime(3);
var myText = "";
i = 0;
while (i < 500)
{
  var randomNumber = random(48,122);
  myText += String.fromCharCode(randomNumber);
  i++;
}
myText
```

Instead of typing the "random()" and "myText +=" statements over and over, I only had to type them once. Because they're in a loop, they automatically run over and over. The i is incremented each time the loop runs, and the loop stops running when i reaches 500. So SourceText will be 500 characters long!

Notice that I start the Expression by initializing myText to an empty string:

```
var myText = ""; //those are open and close quotation
                 //marks with nothing in between them
```

You must initialize a string this way if you want to add characters onto it, later, as I do with the += command in the loop.

The only problem left to tackle is inserting line breaks. Currently, all 500 characters are on one long line. Here's the solution:

In: Chapter05.aep, Comp13
On: Source Text

```
posterizeTime(3);
var myText = "";
i = 0;
while (i < 500)
{
    var randomNumber = random
    (48,122);
    myText += String.fromChar
    Code (randomNumber);
    if (myText.length % 50 ==0)
    myText +="\r";
    i++;
}
myText
```

myText.length stores how many characters are currently in myText. Each time the loop runs, that number will get bigger and bigger (until it reaches 500). Whatever the number is, I divide it by 50, using modulo, and check the remainder. If the remainder is 0, the length must be some multiple of 50: 50, 100, 150, and so on. In any of these cases, I add a line break onto myText. Line breaks look like this: "\r". So every 50 characters, the cursor moves to the next line.

Here's a final rewrite, assigning some of the numbers to variables:

In: Chapter05.aep, Comp14
On: Source Text

```
var rate = 3; //number of times the characters should
change per second
var totalCharacters = 1000;
var lineBreakEvery = 50;
var startAsciiRange = 48;
var endAsciiRange = 122;

posterizeTime(rate);

var myText = "";
i = 0;
while (i < totalCharacters)
{
    var randomNumber = random(startAsciiRange,endAsciiRange);
    myText += String.fromCharCode(randomNumber);
    if (myText.length % lineBreakEvery == 0) myText +=  "\r";
    i++;
}
myText
```

Writing Expressions this way is a really good idea. It gives you a sort of control panel at the top of the Expression. If you want to alter something, say the posterizeTime() rate, you can just change a value at the top. You don't have to dig down into the guts of the Expression.

Before we leave loops, I'd like to show you a couple of alternate versions of this Expression: what if you wanted some the random letters to be drawn from a pool of specific characters. Say you wanted each character to be A, B, C, D, or E? Here's a rewrite that will achieve that goal:

In: Chapter05.aep, Comp15
On: Source Text

```
var rate = 3; //number of times the characters should ⮕
change per second
var totalCharacters = 1000;
var lineBreakEvery = 50;

posterizeTime(rate);

var selectionSet = ["A", "B", "C", "D", "E"];
var myText = "";
var i = 0;
while (i < totalCharacters)
{
  var randomNumber = random(0,selectionSet.length);
```

```
myText +=selectionSet[Math.floor(randomNumber)];
if (myText.length % lineBreakEvery == 0) myText +="\r";
i++;
}
myText
```

Now, randomNumber is being set to a number between 0 and one less than the length of the selectionSet array. That means randomNumber is a valid index number in selectionSet.

Because I used selectionSet.length, the Expression will adjust itself if you add or remove items from the array. Try changing it to ["A", "B", "C"] or ["A", "B", "C", "D", "E", "F"] and see what happens.

Here, I'm using the same Expression. I've simply changed the font to a dingbat. As you can see, that minor change creates a heck of a difference.

One final word about loops: as an alternative, you can use a for loop (instead of a while loop). A for loop's template look like this:

```
for (INITIALIZATION; TRUE_OR_FALSE_STATEMENT; INCREMENT)
{
  STATEMENTS_TO_LOOP_OVER_AND_OVER;
}
```

I debated as to whether or not to include for loops in this book. They're basically shorthand versions of while loops. You can use either one. In the end, I'm

showing you for loops, because many programmers like them. If you understand how they work, you'll understand how to read and modify other people's Expressions.

Here, again, is the template for while loops:

```
INITIALIAZE_A_VARIABLE;
while(TRUE_OR_FALSE_STATEMENT)
{
  STATEMENTS_YOU_WANT_TO_LOOP;
  INCREMENT VARIABLE;
}
```

Notice that both the for and while loops contain the same parts: INITIALIZATION, TRUE_OR_FALSE_STATEMENT, LOOP_STATEMENTS, and INCREMENT. Here are two examples, one a for and one a while, that do exactly the same thing:

```
var degrees = 0;          var degrees = 0;
var i = 0;
while (i < 3)             for(var i = 0; i < 3; i++)
{                         {
  degrees += 5;             degrees += 5;
  i++;
}                         }
```

267

Here, I rewrote the Source Text Expression, using a for loop, so that you can compare the two sorts of loops.

In: Chapter05.aep, Comp16
On: Source Text

```
var rate = 3; //number of times the characters should ⬎
change per second
var totalCharacters = 1000;
var lineBreakEvery = 50;

posterizeTime(rate);

var selectionSet = ["A", "B", "C", "D", "E"];
var myText = "";
for (var i = 0; i < totalCharacters; i++)
{
  var randomNumber = random(0,selectionSet.length);
  myText += selectionSet[Math.floor(randomNumber)];
  if (myText.length % lineBreakEvery == 0) myText +=  "\r";
}
myText
```

FUNCTIONS

You've seen plenty of methods (also known as commands). Examples include wiggle(), loopOut(), random(), and layer(). Those are built-in functions, meaning that they are already part of AE's vocabulary. You can add to AE's vocabulary by typing user-defined functions.

Here's the template for a user-defined function:

```
function FUNCTION_NAME(INPUT)
{
  return OUTPUT;
}
```

Example:
 In: Chapter05.aep, Comp17
 On:SourceText

```
function spaceAlienName(planet)
{
  if (planet ==  "Mars")
  {
    return "Beeper";
  }
  else
```

```
  {
    return "Booper";
  }
}
spaceAlienName("Mars")
```

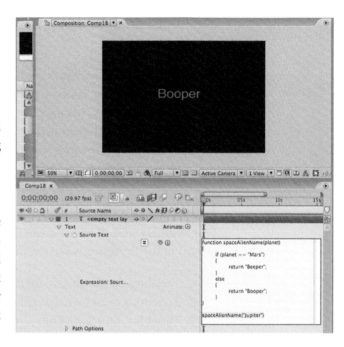

In Chapter05.aep, Comp18, I've repeated the exact same Expression, changing only the final line:

```
spaceAlienName("Jupiter")
```

Whatever planet name you pass the function spaceAlienName(), the function will save in the variable called planet. The function will then spit out (return) either the Martian name or the alternate name, depending on what planet you passed it.

In Chapter05.aep, Comp19, I use the function twice. The last line is

```
"my two alien friends are" + spaceAlienName("Mars") +
"and" + spaceAlienName("Venus")
```

269

Note that in the function definition, the word planet is a variable:

```
function spaceAlienName(planet)...
```

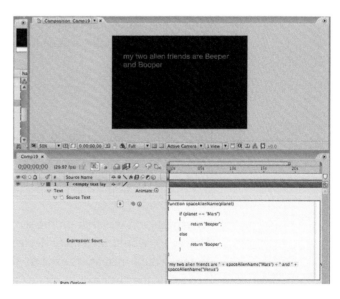

It's a special variable that acts as an input into the function. When you call the function via spaceAlienName("Venus"), it's just like typing

```
var planet = "Venus";
```

I wish, in the function definition, you could type

```
function spaceAlienName(var
planet)...
```

because then it would be clear that planet is a variable. But AE will hit you

over the head with an error if you do that. So in the case of these input variables only, no "var".

The truth is, though user-defined functions are a major piece of the puzzle in most JavaScript-based systems (web browsers, Flash, etc.), you'll rarely need them for Expressions. I wanted you to see them, because you will run into them occasionally. User-defined functions aren't likely to become a major tool in your belt until Adobe fixes some big limitations.

LIMITATIONS

Programmers with previous JavaScript Experience will notice three major limitations in the Expressions version of the language:

1. Variables do not sustain their values from frame to frame.
2. Functions must be redefined in every Expression.
3. Variables and functions from one Expression cannot be accessed from another Expression, even if both Expressions are in the same Composition or file.

These three problems all stem from one larger problem: Expressions are little computer programs that rerun every time a new frame plays. On each subsequent frame, After Effects resets all variables and redefines all functions. And both variables and functions are local to whatever layer they're typed on.

When I first started messing around with Expressions, I tried this test. In a new Comp, I created a solid and added this Expression to its Rotation property:

```
var degrees = 0;
degrees++;
degrees
```

Here's what I figured would happen. Reading my first statement, AE would initialize degrees to 0. Via my second statement, AE would increment degrees from 0 to 1. The final statement would actually control the Rotation property, and so it did. On the first frame, rotation was set to 1.

My expectation was that on the second frame, the Expression would rerun and degrees++ would increment degrees from 1 to 2, and then on the third frame, degrees would increase from 2 to 3, and so on. I expected that as degrees kept increasing, the layer would rotate (1 more degree in each frame).

In fact, the layer stayed locked at one degree for the entire Comp. You can see an example in Chapter05.aep, Comp20.

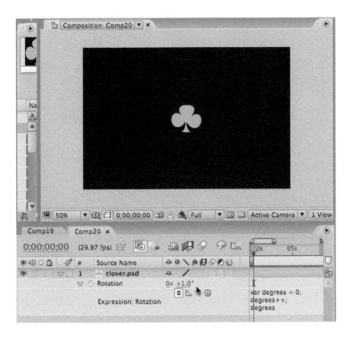

271

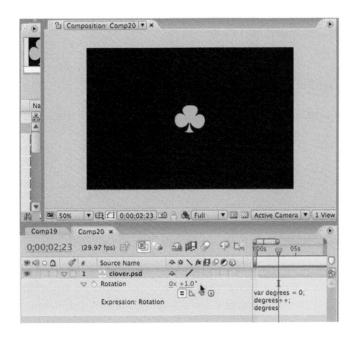

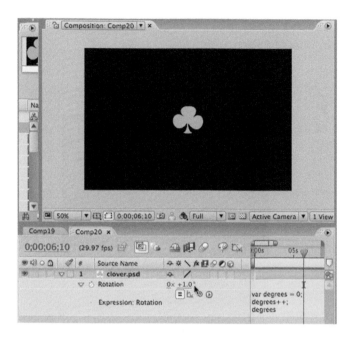

Here's why. In frame 1, my Expression runs. As I requested in the first statement, AE initializes degrees to 0. It then increments degrees to 1. In the second frame, my entire Expression reruns: degrees is initialized to 0 and increments to 1. In the third frame, once again, degrees is initialized to 0 and incremented to 1. Because this line runs on every frame,

```
var degrees = 0;
```

degrees is reset to 0 on every frame.

I tried to get around this by omitting that statement. My Expression now read:

```
degrees++;
degrees
```

Alas, this produced an error. You can't increment a variable that isn't already holding a number. So that forced me to add back the "var degrees = 0;" statement, which, again, reran each time a frame played. There's no way around this problem; variables are redefined on each frame.

The trick, if you want some kind of counter that increases each time a new frame plays, is to use a naturally increasing value like time. As you may remember from Chapter 4, you can make a layer rotate by letting time control an ease() function.

In: Chapter05.aep, Comp21
On: Rotation

```
ease(time,0,2,0,360);
```

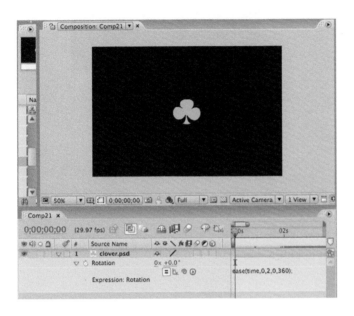

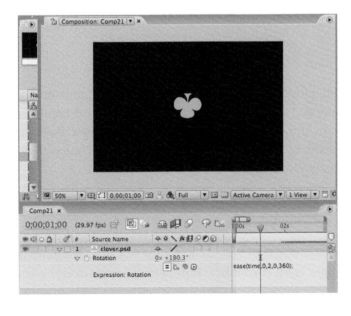

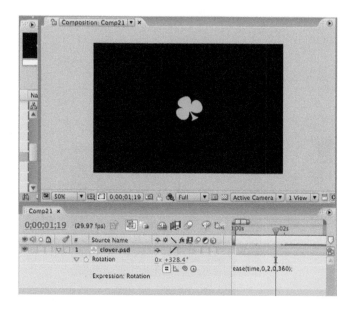

You'll find more limitations in Chapter05.aep, Comp22, where I placed an Expression on Rotation that reads as follows:

```
function pickRandomNumber(arrayOfNumbers)
{
  var randomNumber = random(arrayOfNumbers.length);
  var myIndex = Math.floor(randomNumber);
  return arrayOfNumbers[myIndex];
}

var myArray = [10,20,30,40,50,60];
pickRandomNumber(myArray);
```

The function pickRandomNumber() chooses a random number from any array (of numbers) you pass into it. Below the function definition, I created an array called myArray and, in the final statement, called pickRandomNumber(), handing it myArray. This worked like a charm. On each frame, the layer rotated to a different, random degree.

I added a second layer (the lower one) and added this Expression to Rotation:

```
pickRandomNumber(myArray);
```

I figured that AE would be able to access the function definition and variable from the upper layer. It couldn't. Instead of a second rotating later, I got an error.

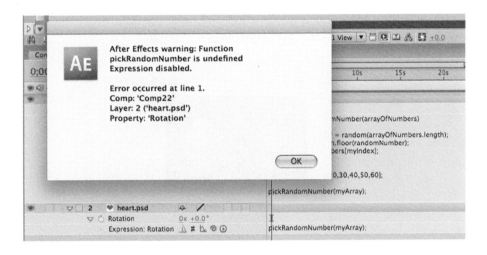

Alas, the only way to fix this problem is to redefine the function and variable on both layers, as I did in Chapter05.aep, Comp23.

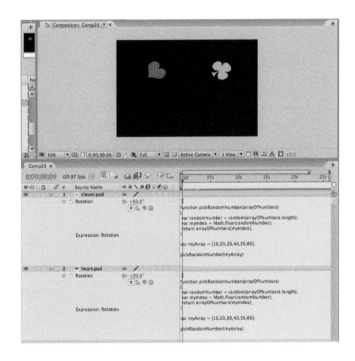

This almost renders functions useless in Expressions, because the whole point of a function is supposed to be that you only have to define it once. In fact,

I ultimately decided to ditch the function and paste the following Expression on both layers (as you can see in Chapter05.aep, Comp24):

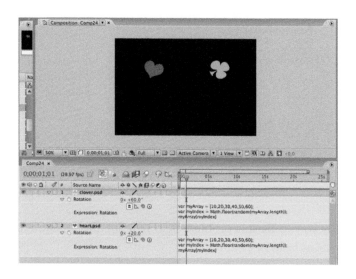

```
var myArray = [10,20,30,40,50,60];
var myIndex = Math.floor(random(myArray.length));
myArray[myIndex]
```

Now that you know all of these JavaScript features and limitations, you're ready to go full speed ahead with advanced Expressions. Almost. Before I let you express anything you want, I have to go over one other topic: math for Expressions. And that's the topic for the next chapter. So turn the page. I'll wait for you!

CHAPTER 6

Math Is Your Friend

Or maybe not. I flunked high school math. After that, I avoided numbers, formulas, and calculations whenever I could. Expressions enticed me back. I found that to do the really cool stuff, I had to use a little math. And I want to share that little bit with you. It's not much, it's not all that hard, and the pay-off is immense. So I hope you'll stay on board. And remember, you're using a computer! Its job is to compute. It will do all the heavy lifting.

DEGREES AND RADIANS

Let's start with something you know: there are 180 degrees in a circle. Imagine you're a grandfather clock. Your arms and hands are the clock's hands. It's 3 pm, so point to the 3. Let's call that 0 degrees. Now, point to the 6 at the bottom of the clock face. That's 90 degrees. The 9—as in 9 pm—is 180 degrees (and notice that it's right across from where you first pointed, at the 3). Midnight (or noon) is 270 degrees. Finally, if you bring your hand back to the 3 again, you'll be at 360 degrees—a full circle.

Degrees are useful in everyday speech ("The atheist did a 180 and joined the Catholic Church!"), and in After Effects, you use them to set Rotation properties, but degrees can make certain calculations difficult. Along the same lines, inches and yards may feel friendly, but they're a nightmare if you want to use them for complex calculations. So to calculate distance, scientists tend to use centimeters and meters, because they're simpler than inches and yards. For the same reasons, mathematicians often use radians instead

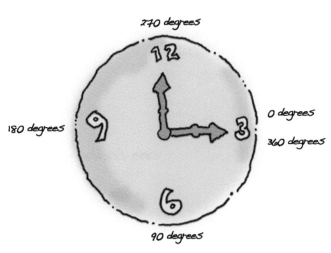

270 degrees

180 degrees

0 degrees

360 degrees

90 degrees

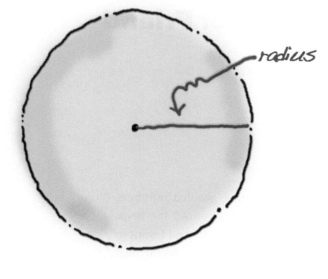

of degrees. Radians are another way of measuring distance around a circle.

JavaScript uses radians to represent angles. After Effects uses degrees. So your first hurdle (not a very high one as it turns out) will be learning to convert between the two systems. In other words, how many radians is 180 degrees?

The word "radian" comes from "radius." A circle's radius is the distance from its center to its edge.

Imagine plucking the radius from inside of a circle and bending it so that it curls around the circle's edge. You'd be looking at 1 radian.

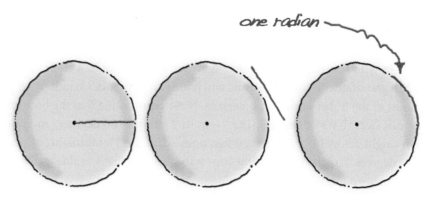

Or, you could roll a wheel in the mud and stop when the track it makes is equal to the length of its radius. At that point, the wheel has rolled 1 radian.

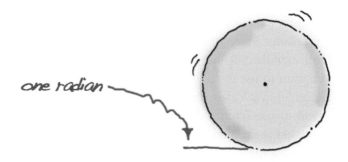

If you copied that line, or track in the mud, over and over, placing the copies end to end until they wrapped around the whole circle, you'd have to make approximately 6.28 copies to wrap all the way around; 360 degrees equals 6.28 radians. If you roll the wheel one complete revolution, the track it makes will equal 6.28 radians.

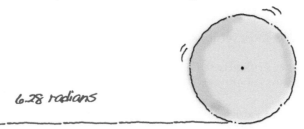

6.28 radians

As you can see from the following illustration, if you use radians to travel from the top of the circle to the bottom, 180 degrees, you'll travel about 3.14159 radians. Some of you may have queasy memories of that number. It's called Pi. Pi is defined as the ratio of a circle's circumference divided by its diameter. This value is the same for all circles.

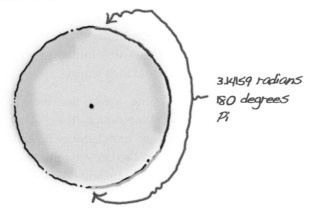

3.14159 radians
180 degrees
Pi

Pi isn't really 3.14159. Pi goes on forever. It's more like 3.14159265358979323846… (note the dot-dot-dot at the end). But in JavaScript, you don't ever have to type it out. Instead, you can use Math.PI. (Remember to capitalize the M, P, and I.) Because with radians, Math.PI is half-way around the circle, all the way around is 2 times Math.PI – or 6.28298….

If you want to convert degrees to radians or vice versa, you can use these formulas:

```
radians = degrees * Math.PI/180
degrees = radians * 180/Math.PI
```

For example, how many radians is 90 degrees?

```
? radians = 90 degrees * Math.PI/180
? radians = 90 * 3.14159265358979323846…/180
```

Tapping the keys on my trusty calculator, I get 1.57079633 radians. So 90 degrees is equal to about 1.57079633 radians ("about" because we had to use an approximate value for Pi).

I won't waste your time by calculating degrees from radians. You can try converting 1.57079633 back into degrees if you want. But Expressions JavaScript (unlike most versions) has built-in conversion functions:

```
degreesToRadians()
radiansToDegrees()
```

So in an Expression, if you need to convert 90 degrees into radians, just type degreesToRadians(90).

SINE WAVES

Close your eyes and think of the ocean. Can you picture the waves? They crest and fall, crest and fall. That's what waves do. They go up and down. Sine Waves do the same. They are mathematical waves of rising and falling numbers. Specifically, they start at 0, rise to 1, sink to 0, sink further to −1, rise back to 0, and then repeat.

Sine waves are incredibly useful in Expressions. They allow you to create undulations: pendulums, bounces, and so on. Anything that goes back and forth, up and down, left and right, there and back.

In JavaScript, you can generate a sine wave with Math.sin(). But you have to hand the method a number, for example, Math.sin(5). It's best to hand Math.sin() radians, because there's a cool relationship between radians and sine waves.

You can wrap a sine wave around a circle, starting at 0 degrees or 0.0… radians:

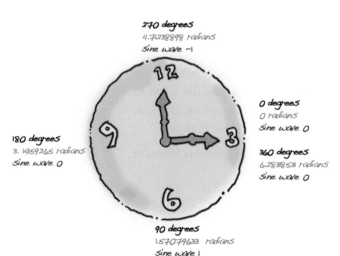

280

```
0   degrees = 0.0 = sine wave value of 0.
90  degrees = 1.57079633 radians = sine wave of 1.
180 degrees = 3.14159265 radians = sine wave of 0.
270 degrees = 4.71238898 radians = sine wave of −1.
360 degrees = 6.28318531 radians = sine wave of 0.
```

As you can see, as you travel around the circle, you get a whole sine wave: 0, 1, 0, −1, 0…. Because half a circle is Math.PI radians, a whole circle is 2 * Math.PI radians. That means you can create an entire sine wave by feeding Math.sin() numbers between 0 radians and 2 * Math.PI radians.

By the way, sine waves aren't always spitting out 1, 0, and −1. Those are just the boundaries. For instance, as the wave plummets from 1 to 0, it passes through all the fractional numbers in between. For instance, the sine wave for 95 degrees (between sine 1 and sine 0) is 0.996194698:

```
95 degrees = 1.65806279 radians = sine wave of 0.996194698
```

Note that 0.996194698 is in between 0 and 1.

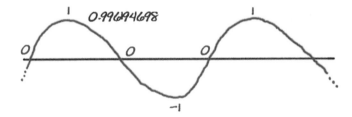

We now know enough math to build some interesting Expressions. So let's open up AE and get to work. In Chapter06.aep, Comp1, you'll see a circle with this Expression on its Position property:

```
var x = transform.position[0];
var y = Math.sin(time);
[x,y]
```

My goal here is to make the circle move up and down, like a bouncing ball. So I'm using a sine wave to make the ball undulate in its y dimension. First, I keep it's x dimension where it is, by setting x to what its current value is (var x = transform.position[0]). Then I use the sine of time to calculate y.

Why time? Well, I need the sine to be different on every frame—otherwise there won't be any animation. Time changes on each frame, as the Current Time Indicator (CTI) moves forward, so it seems like a reasonable candidate for the Math.sin() method. Imagine all the seconds of time arranged around a circle. As time progresses, Math.sin() will spit out numbers from 1 to −1 and back again.

Yet nothing happens when you preview the Comp. Well, that's not exactly true. If you look really *really* closely, you'll see the layer moving up and down a fraction of an inch. The movement is more obvious if you check the numbers for y in the Timeline or check out the Expression in the graph editor.

That's a whole lot of graph for a microscopic bit of movement. The problem is that because sine waves only veer between 1 and −1, my Expression is setting the layer's y value to those miniscule numbers. We need to find some way of amplifying the wave, so that its peaks are higher and its valleys are lower.

That's easy enough, as you can see in Chapter06.aep, Comp2:

```
var amplitude = 100;
var x = transform.position[0];
var y = amplitude * Math.sin(time);
[x,y]
```

Now I'm creating a variable called amplitude (for amplifying the wave), setting it to 100 and multiplying the sine wave by it. This means that sometimes 100 will be multiplied by 1, sometimes by 0, sometimes by −1 and sometimes by all of the fractional numbers in between. The result will be used for y.

So when the sine wave is at 1, y will be 1 times 100. Because 1 times 100 equals 100, y will be 100 pixels from the top of the Comp. And because 0 times 100 is 0,

when the wave spits out 0, y will be 0 (the top of the Comp window). When the wave spits out −1, y will be at −1 * 100 = −100, which is 100 pixels above the top of the Comp. So the circle will bounce from 100 pixels below the top of the Comp to 100 pixels above it.

By modifying the Expression just a tiny bit, we can move the circle away from the top of the Comp to wherever we want it. Check out Chapter06.aep, Comp3:

```
var amplitude = 100;
var x = transform.position[0];
var y = transform.position[1] + (amplitude * Math.sin(time));
[x,y]
```

Now, for the y, I'm just adding the sine-wave movement to whatever the y already happens to be. So the circle will move up and down from wherever you drag the layer with the mouse.

Now it would be nice to be able to control the speed. Currently, the frequency of waves is controlled by time. Whenever time changes, the wave changes. If you take a look at Chapter06.aep, Comp4, you'll see how I gained more control:

```
var amplitude = 100;
var frequency = 5;
var x = transform.position[0];
var y = transform.position[1] + amplitude *
Math.sin(frequency * time);
[x,y]
```

In Chapter06.aep, Comp5, I added a second circle. Both layers have the same Expression, but I changed the value of frequency from 5 to 1 in the left one. As you can see in the graph editor, that tiny change yields major results.

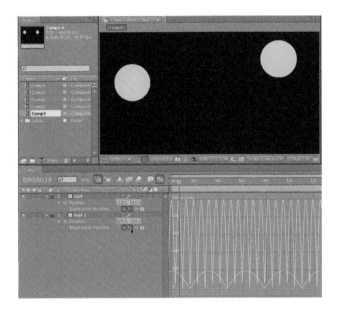

When working with sine waves, think of amplitude as how high and low the wave moves; think of frequency as how fast the wave moves.

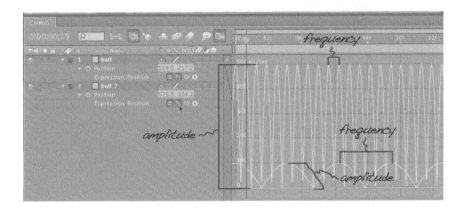

It's great to be able to think of frequency as waves-per-second. That way, you can say "I want so-and-so number of bounces each second," and you can set frequency to that number. The trouble is, as the Expression now stands, frequency isn't that easy to control. We need a way to make sure that if frequency is 1, there will be only one wave each second; if it's 2, there will be two waves each second; and so on.

Our old friend radian comes to the rescue. There are 2 * Math.PI radians in one complete sine wave. That means if we want five undulations (bounces or

whatever), we can guarantee that's what we'll get by changing the Expression as it reads in Chapter06.aep, Comp5:

```
var amplitude = 100;
var frequency = 5;
var x = transform.position[0];
var y = transform.position[1] + amplitude *
Math.sin(frequency * time * 2 * Math.PI);
[x,y]
```

Because frequency is set to 5, and I'm multiplying frequency * time by 2 * Math.PI, I'm guaranteed to get five bounces. If that's confusing to you, don't fret. You can just plug frequency * time * 2 * Math.PI into your Expressions and know you'll get frequency number of bounces each second.

As usual with Expressions, you don't need to confine yourself to properties in the Transform group. In Chapter06.aep, Comp6, I used a sine wave to animate the Blurriness property of Fast Blur. (Remember to select the layer and type EE to see the Expression). Here's how I did it:

```
var amplitude = 16;
var frequency = .5;
var blurAmount = amplitude
* Math.sin(frequency *
time * 2 * Math.PI);
Math.abs(blurAmount)
```

There are a couple new twists here. First of all, I set frequency to .5. That's half an undulation every second—or one every 2 seconds, depending on how you want to look at it.

Because I set amplitude to 16, the sine wave (multiplied by amplitude) is spitting out numbers between 16 and negative 16. But unlike position, Blurriness doesn't accept negative numbers. So I used another math method, Math.abs(), to keep the number positive; "abs" stands for "absolute value." The absolute value of −5 is 5; the absolute value of 13 is 13. In other words, if a number is positive, Math.abs() leaves it alone; if it's negative, Math.abs()

makes it positive. My amplified sine wave starts at 16 and drops down to 0. Then it plunges to −1, −2, and so on. Math.abs() changes those numbers to 1, 2, and so forth. So I wind up getting 16 to 0, 0 to 16, over and over, with no negatives.

EXPONENTIAL CHANGE

My undulations never stop. This is okay if you want, well, undulations that never stop. But generally we want our bouncing balls to stop bouncing after a while. Math.exp() will help us here. It causes exponential change. In the real world, things rarely change at a steady rate. They accelerate or decelerate. Or, to use animation lingo, they ease in or ease out. For easing, you need an exponential curve.

Here's a normal curve:

Notice that the exponential one gets steeper more quickly. It accelerates. It eases in.

In the case of our bouncing ball, we want the opposite. We want it to start fast and gradually get slower.

In Chapter06.aep, Comp7, I've used Math.exp() to do just that:

Here's an exponential one:

```
var amplitude = 100;
var frequency = 2;
var x = transform.position[0];
var y = transform.position[1] ⤵
+ amplitude *
Math.sin(frequency * time * 2 * ⤵
Math.PI) / Math.exp(time);
[x,y]
```

Here, I'm taking the entire wave calculation and dividing it by Math.exp(time). As I'm sure you know, if you divide something, you get a smaller something. So the wave divided by Math.exp(time) is smaller than the wave by itself. So the ball bounces less. As time gets bigger, the ball bounces less and less (exponentially), until finally it stops.

By the way, if you want the ball to bounce higher and higher over time, use the Expression in Chapter06.aep, Comp8 instead:

```
var amplitude = 100;
var frequency = 2;
var x = transform.position[0];
var y = transform.position[1] + amplitude *
Math.sin(frequency * time * 2 * Math.PI) * Math.exp(time);
```

The only difference here is that we are multiplying instead of dividing.

In Chapter06.aep, Comp9, I've added more control via a variable called decay. I multiply time by decay in Math.exp(decay * time). Try playing around with decay's initial value. The bigger you make it, the faster the ball will slow down:

```
var amplitude = 100;
var frequency = 2;
var decay = 0.5;
var x = transform.position[0];
var y = transform.position[1] + amplitude *
Math.sin(frequency * time * 2 *
Math.PI)/Math.exp(decay * time);
[x,y]
```

In Chapter 4, I introduced you to this Expression from Dan Ebbert's site, www.motionscript.com:

```
veloc = 7;
amplitude = 80;
decay = .7;
amplitude * Math.sin(veloc * time)/Math.exp(decay * time)
```

I've applied it to Rotation in Chapter06.aep, Comp10 (after moving the layer's anchor point to the top of the pendulum). You now know everything you need to know to understand this Expression (and to play with it). Study it for a while and see if you can figure it out.

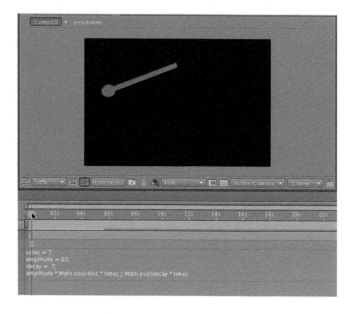

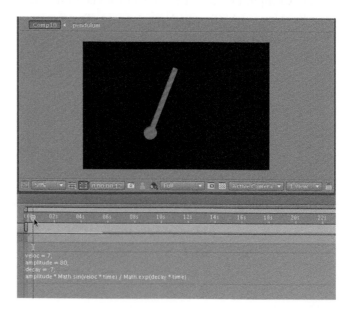

A couple of notes to help you: First of all, unlike me, Dan isn't using var before declaring his variables. Remember, that's optional. I'm more anally retentive than Dan, so I use var, and he doesn't. Fair enough.

Also notice that Dan has snuck in an extra variable called veloc, which is short for "velocity." He uses amplitude to set a base peak for his wave. Then he uses velocity (multiplied by time) to make the wave get higher and higher. Of course, decay is countering that, making the wave get lower and lower. I've had a lot of fun playing with Dan's variables, pitting amplitude and velocity against decay (which, as in life, tends to win in the end).

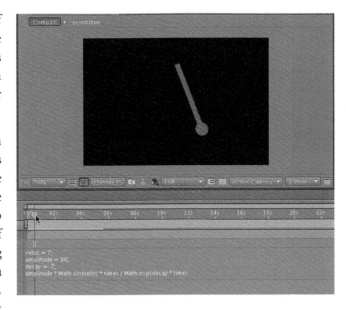

COSINE: ANOTHER WAVE

A cosine—or Math.cos()—is another wave, and it works just like Math.sin(). The only difference between the two waves is that they're out of phase with each other. Remember, a sine wave starts at 1, goes to 0, goes on to −1, and then returns to 0 and then 1 again. The cosine wave is the same wave, except it starts at 0:

293

 Sine: 0, 1, 0, −1, 0, 1, 0, −1, 0, 1…
 Cosine: 1, 0, −1, 0, 1, 0, −1, 0, 1, 0…

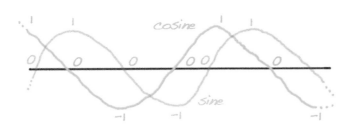

In Chapter06.aep, Comp11, I've applied almost the same Expression to both layers, except the left layer uses Math.sin() and the right uses Math.cos(). Preview and see how the bounces are out-of-phase with each other.

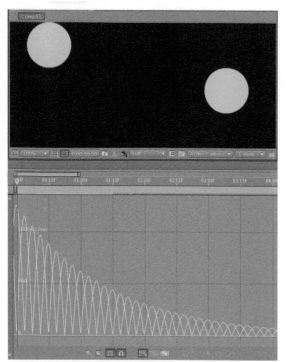

Left layer's position property:

```
var amplitude = 100;
var frequency = 2;
var decay = 0.7;
var x = transform.position[0];
var y = transform.position[1]
+ amplitude *
Math.sin (frequency * time * 2 *
Math.PI)/Math.exp(decay * time);
[x,y]
```

Right layer's position property:

```
var amplitude = 100;
var frequency = 2;
var decay = 0.7;
var x = transform.position[0];
var y = transform.position[1]
+ amplitude *
Math.cos (frequency * time * 2 *
Math.PI)/Math.exp(decay * time);
[x,y]
```

As I prove in Chapter06.aep, Comp12, you can combine sine and cosine to make a layer move in a circle.

On Position:

```
var pivotX = thisComp.width/2;
var pivotY = thisComp.height/2;
var distanceFromPivot = 200;
var frequency = 2;
var x = pivotX + (Math.sin
(frequency * time * 2 *
Math.PI) * distanceFromPivot);
var y = pivotY + (Math.cos
(frequency * time * 2 *
Math.PI) * distanceFromPivot);
[x,y]
```

294

Spend some time playing with this Expression. If you change either of the plus signs to minus signs, the layer moves clockwise instead of counterclockwise:

```
var pivotX = thisComp.width/2;
var pivotY = thisComp.height/2;
var distanceFromPivot = 200;
var frequency = 2;
var x = pivotX + (Math.sin(frequency * time * 2 * ↴
Math.PI) * distanceFromPivot);
var y = pivotY - (Math.cos(frequency * time * 2 * ↴
Math.PI) * distanceFromPivot);
[x,y]
```

The vars pivotX and pivotY set the point the layer rotates around. I've made it rotate around the center of the Comp by grabbing the width of the Comp, thisComp.width, and dividing it by 2. Half the width is the center of the Comp, horizontally. I've found the vertical center the same way, using thisComp.height instead of thisComp.width.

Here's a fun variation (in Chapter06.aep, Comp13):

```
var randomizer = wiggle(.5,300);
var pivotX = randomizer[0];
var pivotY = randomizer[1];
var distanceFromPivot = 200;
var frequency = 2;
var x = pivotX + (Math.sin(frequency *
time * 2 * ↴
Math.PI) * distanceFromPivot);
var y = pivotY - (Math.cos(frequency *
time * 2 * ↴
Math.PI) * distanceFromPivot);
[x,y]
```

Now the layer is circling around a randomly changing point.

> **Note:** The only reasonable way for me to show you this effect in a book was to convert the Expression to keyframes. With Expressions, you don't see motion paths in the Comp window.

Note that distanceFromPivot controls how far the layer is from the point it's orbiting. This variable is similar to amplitude in our earlier examples. If we didn't include it, the orbits would be tiny, using the pure sine and cosine waves to rotate between 1 and −1 pixel away from the pivot.

Try giving x and y different distances, as I've done in Chapter06, Comp 14:

```
var pivotX = thisComp.width/2;
var pivotY = thisComp.height/2;
var distanceFromPivotX = 300;
var distanceFromPivotY = 100;
var frequency = 1;
var x = pivotX + (Math.sin (frequency * time * 2 *↴
Math.PI) * distanceFromPivotX);
var y = pivotY − (Math.cos (frequency * time * 2 *↴
Math.PI) * distanceFromPivotY);
[x,y]
```

This makes the layer move in an ellipse, rather than in a circle.

Finally, this Expression, in Chapter06, Comp 15, makes the layer move in a sensuous wave instead of a circle:

```
var pivotX = thisComp.width/2;
var pivotY = thisComp.height/2;
var distanceFromPivotX = 300;
var distanceFromPivotY = 100;
var frequencyX = 1;
var frequencyY = 3;
var x = pivotX + (Math.sin (frequencyX * time * 2 *
Math.PI) * distanceFromPivotX);
var y = pivotY - (Math.cos (frequencyY * time * 2 *
Math.PI) * distanceFromPivotY);
[x,y]
```

I got it to move this way by using different frequencies for x and y. How did I know using two frequencies would make the layer move this way? I didn't. I played around and stumbled onto the effect. When you can play around with Expressions such as this—making little changes, seeing what happens—you know that math really is your friend!

> **Note:** The only reasonable way for me to show you this effect in a book was to convert the Expression to keyframes. With Expressions, you don't see motion paths in the Comp window.

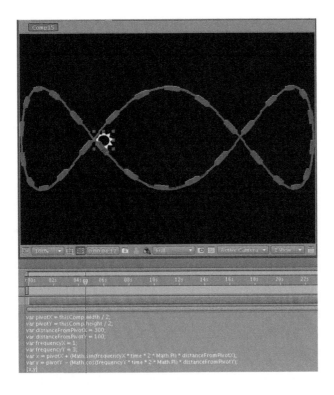

ARRAY ARITHMETIC

Just as 1 plus 1 equals 2, [1,1] + [1,1] = [2,2]. When you add two arrays together, each item in the first array is added to corresponding item in the second array. So

```
[3,4,10] + [2,0,3] = [5, 4, 13]
```

is like

```
  [3, 4, 10]
+ [2, 0, 3]
------------------
  [5, 4, 13]
```

Subtraction works the same way:

```
[10,8] - [1,1] = [9,7]
```

Array arithmetic allows you to simplify many Expressions. For instance, the bounce Expression in Chapter06.aep, Comp8,

```
var amplitude = 100;
var frequency = 2;
var decay = 0.5;
var x = transform.position[0];
var y = transform.position[1] + amplitude * ↴
Math.sin(frequency * time * 2 * ↴
Math.PI)/Math.exp(decay * time);
[x,y]
```

can become

```
var amplitude = 100;
var frequency = 2;
var decay = 0.5;
var y = amplitude * Math.sin(frequency * time * 2 * ↴
Math.PI)/Math.exp(decay * time);
[transform.position[0], transform.position[1]] + [0,y]
```

300

Here, I completely eliminated the x variable. In the final line, I'm adding the sine-wave calculation to the layer's current position, [transform.position[0], transform.position[1]]. I'm adding 0 to transform.position[0], because I don't want to change the x position at all.

Note that [transform.position[0], transform.position[1]] is the same as transform.position, so I can also rewrite the Expression as you'll find it in Chapter06.aep, Comp16:

```
var amplitude = 100;
var frequency = 2;
var decay = 0.5;
var y = amplitude * Math.sin(frequency * time * 2 * ↴
Math.PI)/Math.exp(decay * time);
transform.position + [0,y]
```

LOOK AT USING ARCTANGENTS

In Chapto06.aep, Comp17, I used wiggle to make a heart fly all over the place.

I wanted to make cupid point his arrow toward the heart, and for that, I need another math method called Math.atan2(). The "atan" in "atan2" stands for

arctangent. Like sine and cosine, arc tangent comes from a branch of math called trigonometry. In JavaScript, there are two methods for calculating arctangents: Math.atan() and Math.atan2(). I find the latter more useful, so it's the one I'll show you here.

If you want to gain a deep understanding of arctangents (and other trig concepts), you'll have to read a math book. Here, I'm less interested in what it is or how it works than I am in how you can use it. A major use of Math.atan2() in After Effects is to make one layer "look at" another. By "look at," I mean "turn to face."

By the way, when you draw your "arrow" layer, make sure the head of the arrow is facing 3 o'clock (due East) by default, as mine is in Comp17.

Because I want to make the arrow turn in a specific direction (toward the heart), I'll have to add an Expression to the arrow's Rotation property. First, I need to calculate the distance between the arrow and the heart. I need to know the x distance (the distance between the arrow's x and the heart's x) and the y distance (the distance between the two y's). I can do that as follows:

```
var dx = thisComp.layer("heart").transform.position[0]
 — transform.position[0];
var dy = thisComp.layer("heart").transform.position[1]
 — transform.position[1];
```

My variables dx and dy stand for "distance x" and "distance y." I'm setting dx to the x position of the heart minus the x position of the arrow. I'm doing the

same thing for dy, except I'm subtracting the y positions instead of the x's. Once I have the two distances, I can feed them to the mighty Math.atan2():

```
var dx = thisComp.layer("heart").transform.position[0]
- transform.position[0];
var dy = thisComp.layer("heart").transform.position[1]
- transform.position[1];
var radians = Math.atan2(dy,dx);
```

A couple of notes here: Math.atan2() accepts two parameters, y distance first and then x distance. Because we usually specify x before y, people constantly get Math.atan2() wrong. They type it Math.atan2(dx,dy). That won't work. That's because dy goes first—not dx.

If you give Math.atan2() the two distances, it spits out an angle. The trouble is, you can't use that angle to set Rotation, because it's in radians. Rotation needs degrees. So the final line in my Expression converts Math.atan2()'s radians to the more useful (for Rotation) degrees:

```
var dx = thisComp.layer("heart").transform.position[0]
- transform.position[0];
var dy = thisComp.layer("heart").transform.position[1]
- transform.position[1];
var radians = Math.atan2(dy,dx);
radiansToDegrees(radians)
```

You can see this Expression at work in Chapter06.aep, Comp17.

In Chapter06.aep, Comp18, I was feeling more cynical than romantic, so I made the arrow point away from the heart. All I had to do to end the love was to make dx and dy negative inside the Math.atan2() method:

```
var dx = thisComp.layer
("heart").transform .position[0]
```

```
 — transform.position[0];
var dy = thisComp.layer
("heart").transform.position[1]
 — transform.position[1];
var radians = Math.atan2
(—dy,—dx);
radiansToDegrees(radians)
```

LOOKAT IN 3D

If you want one 3D layer to look at another 3D layer, you don't even need to mess with arctangents. Simply add a lookAt() Expression to one of the layer's Orientation property.

The template for lookAt() looks like this:

```
lookAt(LOOKER_POSITION,LOOKEE_POSITION)
```

Presumably, the looker is that layer to which you apply the Expression. So for LOOKER_POSITION, you just want to type (or Pick Whip) transform.position. For the lookee, Pick Whip the other layer's position.

In Chapter06.aep, Comp 19, I placed two hearts in 3D space. The red heart flies around randomly, via wiggle. The yellow heart always turns to face the read heart. I added this Expression to its Orientation property:

```
lookAt(transform.position,
thisComp.layer("red heart").transform.position)
```

You may also want to check out Chapter06.aep, Comp20 and Comp21. In the former, I've made a camera lookAt() the heart. In the latter, I've made a light lookAt() it.

DISTANCE REVISITED: LENGTH()

It's often useful to know how much distance there is between two layers. Sure, you can do the dx, dy thing, but that gives you two distances (one for x and one for y). What if you simply want to know how many pixels there are between the anchor points of two layers?

Just use the length() Expression as I have in Chapter06.aep, Comp22. I added two layers, a ball and a checkerboard. The checkerboard is a big solid. I applied

Effect > Generate > Checkerboard to it. I turned on both layer's 3D switches and added this Expression to ball's position:

```
var moveAmount = wiggle(1,500);
var x = moveAmount[0];
var y = moveAmount[1];
var z = moveAmount[2];
if (z > 0) z *= -1;
[x,y,z]
```

It's pretty simple. It saves a wiggle() in the variable moveAmount and then takes the first two wiggle dimension (the first two dice rolls) for x and y. It takes the third for z, but, on the next line, I ensure z is always a negative number:

```
if (z > 0) z *= -1;
```

If z is greater than 0, it's positive. So in that case, I multiply z by −1. If you multiply a positive number by a negative number, it turns into a negative number.

> **Note:** I could have also used z = Math.abs(z) * −1; that would have turned z into its absolute value, which is always positive. It would have then multiplied that positive number by −1, flipping it into its negative opposite.

I want z to be negative, because a positive z would place the ball behind the checkerboard. I don't ever want that to happen. I want the ball to always be in front of the board.

The Checkerboard effect has a Width property that controls the width of each checker square. I applied this Expression to Checkerboard > Width:

```
var checkerboardPosition = transform.position;
var ballPosition = ⤵
thisComp.layer("ball").transform.position;
var distance = length(checkerboardPosition, ballPosition);
ease(distance,0,500,2,50)
```

First, I save the checkerboard and ball positions in variables. Then I use the famous length() function to calculate the distance between the two positions. I save the results of that calculation in the aptly named variable distance.

Finally, I use distance to control an ease() function. If the distance is 0, the width of each checkerboard square will be really tiny, just two pixels. As the distances gets bigger, so do the squares. I've ensured that the biggest the squares can ever get is 50 pixels wide.

The Comp looks best through a custom view (or you can add a camera), with the checkerboard viewed at an angle. As you preview, you'll see the squares change width as the ball gets closer and farther away.

GRIDS

While we're on the subject of checkerboards, let's take a look at grids. How can we use an Expression to lay out multiple layers in a regular grid or rows and columns?

When I was making Chapter06.aep, Comp23, I started with just one layer. To its position, I added this Expression:

```
var columns = 10;
var spaceBetweenLayers = thisLayer.width + 10;
var x = ((index−1) % columns) * spaceBetweenLayers;
```

```
var y = Math.floor((index-1)/columns) * spaceBetweenLayers;
var origin = [40,50];
origin + [x,y]
```

After adding the Expression, I selected the layer and typed Command + D (PC: Control + D) over and over, making many copies of the layer. Each copy (because it was a copy) had the same Expression on it.

The first thing you should know about the Expression is that it uses a special property: index. It's not a variable; it's a built-in property, like time. The index is always set to the layer number of the layer that houses the Expression. Did you know that each layer in a Comp has a number? Yup, layer numbers are listed just to the left of each layer name in the Timeline. The top layer is 1, the next one down is 2, and so on.

So even though each layer has an exact copy of the Expression that is on all the other layers, each layer interprets index to mean its own number. Note that in the Expression, I reference index − 1, meaning the index number of the layer *above* the current layer. To layer 2, index − 1 means layer 1. To layer 8, index − 1 means layer 7.

Going through the Expression, starting at the top, you can see I first set up two variables:

```
var columns = 10;
var spaceBetweenLayers = thisLayer.width + 10;
```

The first variable sets up how many columns I want. The second variable controls the spacing between layers. If the layers are 50 pixels wide, each layer is 50 + 10 (or 60) pixels away from the one before it.

The next line is complicated, so let's take a good look at it:

```
var x = ((index−1) % columns) * spaceBetweenLayers;
```

If this is the first layer (index = 1), then index −1 = 0. If it's the second layer, index −1 = 1 and so on. So as the layers progress downward in the Timeline, index − 1 is 0, 1, 2, 3, 4, and so forth.

Each of these numbers goes through a % calculation, which, as you may recall from Chapter 5, has nothing to do with percentages. Normally, the modulo operator (as % is called in JavaScript) returns the remainder of a division problem. But that's only when the number on the left side of % is bigger than the number on the right:

```
10 % 3 = 1
```

Think 10 divided by 3; 3 goes into 10 three times with 1 left over, and % returns the 1 left over. But in my Expression, the number of the left is smaller than the number on the right:

```
((index −1) % columns)
```

There are 10 columns. Index −1, for the first layer, is 0, so this is like typing

```
0 % 10
```

As index −1 changes its meaning on subsequent layers; we get

```
1 % 10
2 % 10
3 % 10
```

and so on. Why does modulo act strangely (in a useful way) when the number on the left is smaller than the number on the right? Because in such cases,

there's nothing but remainders. This is another one of those situations in which there's no penalty for not understanding why it works. It's enough that it does work, and I'll show you how it works:

```
0 % 10 = 0
1 % 10 = 1
2 % 10 = 2
3 % 10 = 3
4 % 10 = 4
5 % 10 = 5
6 % 10 = 6
7 % 10 = 7
8 % 10 = 8
9 % 10 = 9
10 % 10 = 0
11 % 10 = 1
12 % 10 = 2
13 % 10 = 3
14 % 10 = 4
15 % 10 = 5
16 % 10 = 6
17 % 10 = 7
18 % 10 = 8
19 % 10 = 9
20 % 10 = 0
21 % 10 = 1
```

and so on. Notice that the resulting numbers keep cycling: 0 through 9, 0 through 9, and so on. As the left number gets bigger, the result will get bigger too, but it will always stay smaller than the right number (10). When it gets to be as big as the right number, it starts over at 0, instead. Neat!

My Expression multiplies the result of this calculation by spaceBetweenLayers, which is 60:

```
0 % 10 = 0 times 60 = 0
1 % 10 = 1 times 60 = 60
2 % 10 = 2 times 60 = 120
3 % 10 = 3 times 60 = 180
```

and so on. Each layer is 60 pixels farther over to the left than the previous one. But once 10 layers have been placed this way, the next one goes back to 0 pixels, for the start of the next row:

```
10 % 10 = 0 times 60 = 0
```

Here's the next line of the Expression:

```
var y = Math.floor((index−1)/columns) * ↳
spaceBetweenLayers;
```

(index −1)/columns gets us

```
0/10 = 0
1/10 = 0.1
2/10 = 0.2
...
9/10 = 0.9
10/10 = 1
11/10 = 1.1
...
```

Notice that the first 10 calculations all yield results that are less than 1 (e.g., 0.2); the next 10 yield numbers less than 2, and so on.

Math.floor() rounds numbers down. For instance, Math.floor(2.999) spits out 2.[1] So by feeding Math.floor() that sequence of index − 1/columns numbers, we get 0 for y, over and over, until index − 1/columns resolves to 1 and 1-point-something numbers. Then, Math.floor() spits out 1 over and over, until the index − 1/columns calculation gets to 2 and 2-point-something. So every once in a while, when the number of columns has been reached, y moves down. How much does it move down? One times spaceBetweenLayers, two times spaceBetweenLayers, three times spaceBetweenLayers, and so on.

Here are the final two lines of the Expression:

```
var origin = [40,50];
origin + [x,y]
```

By adding that origin array to [x,y], I ensure that the leftmost layers are 40 pixels from the left edge of the Comp. And the layers highest up are 50 pixels down from the top. (I just chose 40 over and 50 down because I liked the way it looked.)

In Chapter06.aep, Comp24, I combined the grid Expression with the 2D look-at Expression to make a bunch of arrows point to a dollar sign. The dollar layer,

[1]Math.ceil() rounds up. Example: Math.ceil(3.1) spits out 4. Math.round() rounds up if the decimal part of the number is greater than 5; otherwise it rounds down. Math.round(2.3) spits out 2. Math.round(2.5) spits out 3.

which is at the bottom of the stack, has a simple wiggle() Expression controlling its Position property: wiggle(1,300).

After getting the dollar-sign moving, I made one arrow layer and added this Expression to its rotation property:

```
var dx = thisComp.layer("dollar").transform.position[0]
- transform.position[0];
var dy = thisComp.layer("dollar").transform.position[1]
- transform.position[1];
var radians = Math.atan2(dy,dx);
radiansToDegrees(radians)
```

That kept the arrow pointing at the dollar sign. Then, I added this Expression to the arrow's Position:

```
var columns = 12;
var spaceBetweenLayers = thisLayer.width + 10;
var x = ((index-1) % columns) * spaceBetweenLayers;
var y = Math.floor((index-1)/columns) *
spaceBetweenLayers;
var origin = [40,50];
origin + [x,y]
```

Then I duplicated the arrow over and over until a grid filled the Comp. Previewing this is a little slow, because there are so many layers and so many calculations. But I hope you agree it's pretty cool.

SIDEBAR
3D Grids

It's only slightly more arduous to make 3D grids. A 3D grid is really a series of grids, stacked on top of each other (or in front of each other) in 3D space.

Here's the Expression I placed on the first layer's Position property before duplicating the layer many times:

```
var columns = 4;
var rows = 3;
```

```
var spaceBetweenColumns = 110;
var x = ((index - 1) % columns) * spaceBetweenColumns;
var y = Math.floor((index - 1) % (rows * columns)/ ⬎
columns) * spaceBetweenColumns;
var z = Math.floor((index - 1)/(rows * columns)) * ⬎
spaceBetweenColumns;
var origin = [60,70,0];
origin + [x,y,z]
```

Just for kicks, I threw some lights (with shadows) and a camera into the mix. I turned "cast shadows" on for all the grid layers. The result is in Chapter06.aep, Comp25.

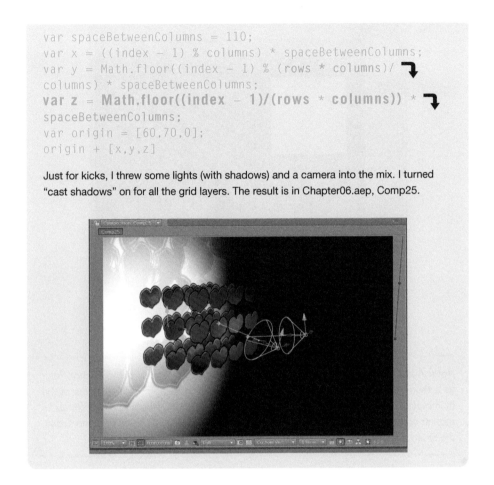

SPACE TRANSFORMATIONS

As you know, Comp space is measured from the upper-left corner of the Comp window. If a layer is at 50x, 100y, it's 50 pixels in from the left edge and 100 pixels down from the top.

But there's another kind of space in After Effects: layer space. In layer space, x and y start at the upper-left corner of the layer, not the Comp. For instance, if you apply the Write-on effect to a layer and move the brush to 10x, 70y, that would be 10 pixels in from the layer's left edge and 70 pixels down from its top. If the layer is at 100x, 5y in Comp space, the brush—translated into Comp space— is at 110x, 75y.

> **Note:** A layer's Position is the position of its Anchor Point. (I think of the Anchor Point as a thumbtack, pinning the layer to the Comp. Position is the x, y coordinates of the thumbtack.) In order to make this example simple, I moved the layer's Anchor Point to its top-left corner (0x, 0y). So the top-left corner of the layer is at 50x, 100y in Comp space; the brush position (the crosshair in the circle) is at 10x, 70y in *layer* space.

If that's confusing, fear not: functions like toComp() and fromComp() do the grunt work for you.

In Chapter06.aep, Comp26, I wanted to make it look as if a crayon layer was drawing on a piece of paper. The trouble is, the crayon is flying around—via wiggle()—in Comp space, whereas the Write-on effect, which is on the "paper" layer, uses layer space.

Because the paper doesn't fill the whole Comp window, and the crayon is roaming over the whole Comp, sometimes the crayon seems to be touching the paper, sometimes not. The top of the paper is at 100y. If the crayon is above that, say at 10y, I don't want it to draw on the paper. But if I just hook the crayon up to Write-on's brush with the Pick Whip, it will. When the crayon is at 10y in Comp space, the brush will be at 10y in layer space.

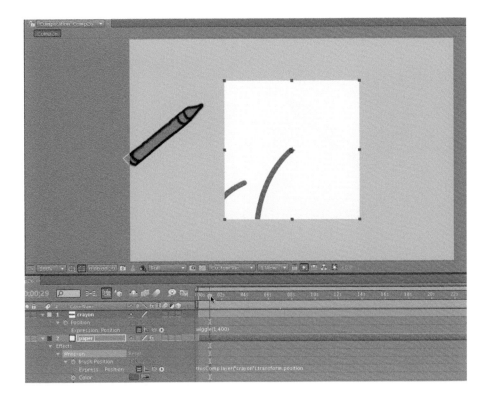

I don't want that. I don't want the brush to take the 10 literally. I want it to translate it from Comp space to layer space. If a layer's y is at 100, 10 in Comp space is −90 in that layer's space.

I made this translation work by adding this Expression to Write-on > Brush Position:

```
fromComp(thisComp.layer("crayon").transform.position)
```

I fed the crayon layer's position to the fromComp() function.

By the way, to make the line look more crayonish, I changed its color to the crayon's color and raised its brush size to 7. I haven't had so much fun since kindergarten!

I wish we'd had After Effects in kindergarten. Maybe I would have grown up loving math. Instead, my introduction to math came in elementary school, where I was forced to memorize the multiplication table and do endless arithmetic

problems that didn't seem to have any point. I didn't think math had much of a purpose until years later. Now I know it does: Math is for making balls bounce, making crayons draw, and making arrows point at hearts.

Math is my friend.

Advanced Techniques

TRIGGERS

Sometimes, you find a great Expression online—or you come up with one yourself—and it's perfect except it starts too early. You don't want it to affect the layer until 3 seconds have past. Or you want it to hold off until a layer keyframe-animates to a certain location. Or you want it to wait until a layer's scale reaches a specific percentage. In all of these cases, you need a trigger: some event that launches an Experssion when you're ready for it to be launched.

Split-Based Triggers

Or maybe not. Once you get into Expressions, there's always the risk you'll start overthinking everything. So before I delve into the nitty-gritty of triggers, let me whisper two simple words into your ear: split layers.

The easiest way to make an Expression affect a layer only after a specific point in time is to animate the layer, move the Current Time Indicator (CTI) to the trigger time, and then split the layer. You can split a layer by choosing Edit > Split layer. Or you can do it by typing Shift + Command + D (PC: Shift + Control + D). After the layer is split, apply the Expression to the half that comes after the split.

However, this technique won't always work. For instance, take a look at the Expression on Rotation in Chapter07.aep, Comp1:

```
value + 50*Math.sin(6*time)/Math.exp(time)
```

> **Note:** "value" means the current value of the property (i.e., before you added the Expression). Because the preceding Expression is applied to Rotation, "value" means the Rotation's pre-Expression value. That Expression has the same meaning and works identically to this one:
>
> ```
> transform.rotation + 50*Math.sin(6*time)/Math.exp(time)
> ```

If you preview the Comp, you'll see that the layer oscillates between counter-clockwise and clockwise twirls. Chapter 6 should have taught you why. The Math.sin() function is an oscillator.

But note that the oscillations don't go on forever. Math.exp() gradually slows them to a stop. By about 4 seconds into the Comp, the twirling has ended.

In Chapter07.aep, Comp2, I split the later at 5 seconds and applied the same Expression to the layer after the split. Now, if you preview, you'll see that nothing happens.

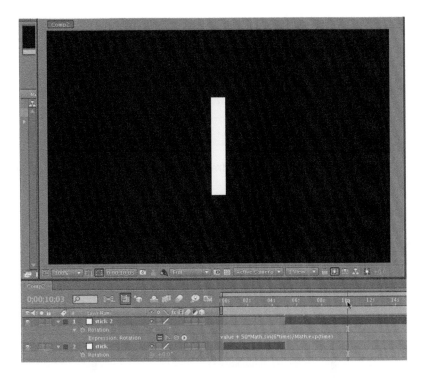

The Expression is based on time, and all the action happens at the beginning of the Timeline. By 5 seconds, the train has left the station.

Time-Based Triggers

In Chapter07.aep, Comp3, a layer starts wiggling 4 seconds into the Comp. The Expression on Position is

```
if (time > 4)
{
  wiggle(2,40)
}
else
{
  transform.position
}
```

Pretty straightforward, huh? If the CTI is at some time after 4 seconds, wiggle; otherwise, just go with the animated position.

One thing to watch out for: My first draft of this Expression was much simpler. It looked like this:

```
if (time > 4) wiggle(2, 40)
```

Remember, an if needn't be followed by curly braces when you only want one statement to occur when its condition is true. So I figured this would work. If time is greater than 4, wiggle. But when I applied the Expression, AE threw a cryptic error at me.

The trouble is, I only told the Expression what to do if the CTI was at a time after 4 seconds. The Expression doesn't know what to do at times before that. It doesn't assume "If I'm not told what to do, I'll do nothing." It just gets confused. So in almost all cases, if you're including an if statement, you'll need an else statement.

Now that you know the basic formula, you can add complexity to it. For instance, if you only want a layer to wiggle when the CTI is between 4 and 6 seconds, try what I tried in Chapter07.aep, Comp4:

```
if (time > 4 && time < 6)
{
  wiggle(2,40)
}
else
{
  transform.position
}
```

In a compound if statement, && means "and". So the wiggle will only happen if the CTI is greater than (after) 4 seconds *and* less than (before) 6 seconds.

327

Marker-Based Triggers

You can also use markers as triggers—layer markers or Comp markers. To access the marker that is closest to the CTI, type

```
thisComp.marker.nearestKey(time)
```

if you want the nearest Comp marker. Or type

```
thisLayer.marker.nearestKey(time)
```

if you want the nearest layer maker.

Markers have various properties. For instance, they have an index property. The first marker (the leftmost one) on the layer or Comp has an index of 1. The one after that has an index of 2, and so on.

Note that index numbers have nothing to do with the labels next to markers. Even if the leftmost marker is labeled 8, its index number will still be 1.

To access the index number of the marker closest to the CTI, you can type

```
thisComp.marker.nearestKey(time).index
```

In Chapter07.aep, Comp5, I only wanted wiggles when the CTI was near the second Comp marker. So I applied this Expression to Position:

```
if (thisComp.marker.nearestKey(time).index == 2)
{
  wiggle(2,40)
}
else
{
    transform.position
}
```

Here's another way to write the same Expression:

```
var closestMarker = thisComp.marker.nearestKey(time);
if (closestMarker.index == 2)
{
  wiggle(2,40)
}
else
{
    transform.position
}
```

You can access a marker's location in time via its time property. For instance, if you want to know the time of the marker closest to the CTI, use

```
thisComp.marker.nearestKey(time).time
```

or

```
thisLayer.marker.nearestKey(time).time
```

The double use of "time" is confusing. Remember, marker.nearestKey(time) accesses the marker nearest to the CTI. The .time at the end accesses the time property of that marker. A clearer version might be

```
var closestMarker = thisComp.marker.nearestKey(time);
```

You can then access that maker's time property via closestMarker.time.

In Chaper07.aep, Comp6, I wanted wiggling to start after the first (and only) marker. So I wrote this Expression:

```
var closestMarker = thisComp.marker.nearestKey(time);
var locationOfCTI = time;

if (locationOfCTI >= closestMarker.time)
{
  wiggle(2,40)
}
else
{
  transform.position
}
```

329

In Chapter07.aep, Comp7, I've adapted the oscillating Expression (from the beginning of this chapter) to be triggered by a layer marker. See the Expression on Rotation:

```
if (marker.numKeys > 0)
{
  var startingTime = marker.nearestKey(time).time;
  if (time > startingTime)
  {
    var t = time - startingTime;
    value + 50*Math.sin(6*t)/Math.exp(t)
  }
  else
  {
    value
  }
}
else
{
  value
}
```

That's one if statement inside another one. Programmers call that nested ifs.
Here's a chart that should make it less confusing:

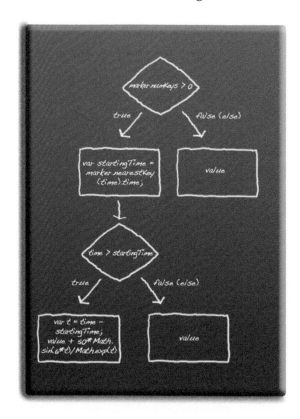

Threshold-Based triggers

For my final trigger demo, I decided to allow a layer to wiggle when its Position's x dimension was between 200 and 400. You can see how I did it in Chapter07.aep, Comp8:

```
var xPosition = transform.position[0];
if (xPosition >=200 && xPosition <= 400)
{
  wiggle(2,40)
}
else
{
  transform.position
}
```

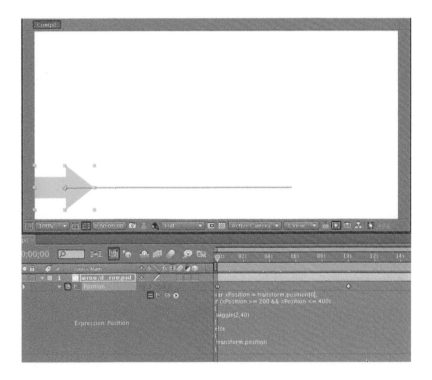

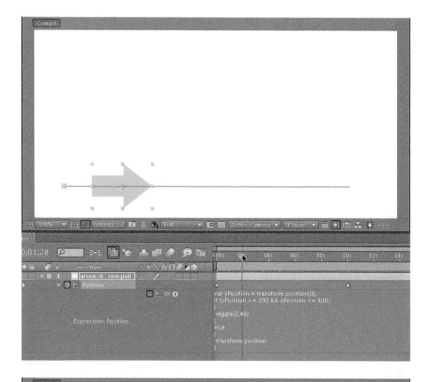

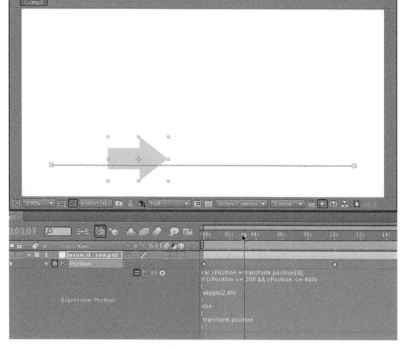

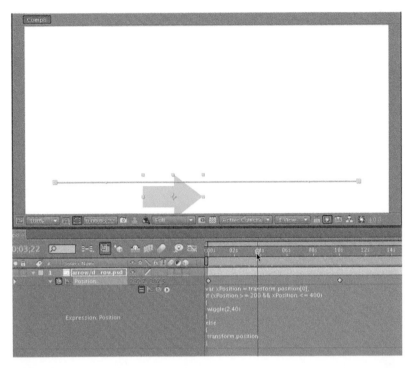

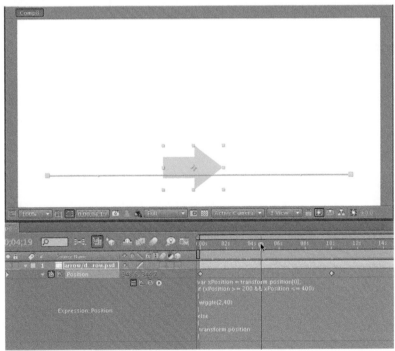

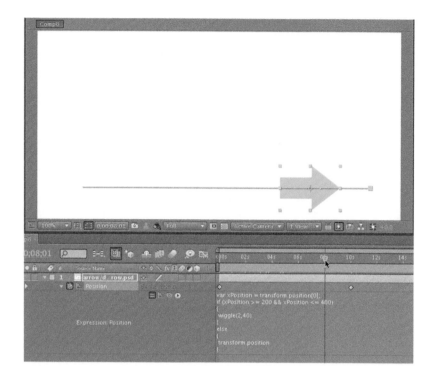

336

STRING MANIPULATION

A Counter

Some of the most creative Expressions manipulate Type Tool text. You always start these Expressions by twirling open a type layer, accessing the Source Text property, and Option clicking (PC: Alt clicking) its stopwatch.

After doing that, in Chapter07.aep, Comp9, I was able to make a minute second counter, similar to the famous one on the show *24*, by adding this Expression to a text layer's Source-Text property (it doesn't matter what the text says initially):

```
var seconds = Math.floor(time);
var minutes = Math.floor(seconds/60);
var secondsAsPartsOfAMinute = Math.floor(seconds % 60);
minutes + ":" + secondsAsPartsOfAMinute
```

AE already gives you the seconds since the beginning of the Comp (the location of the CTI) in the property called time. But time is a bit too accurate for my purposes. It stores fractions of a second. So I rounded it down to the nearest second, using Math.floor().

Next, I calculated minutes. Because there are 60 seconds in a minute, the total number of minutes (at any given time) is seconds divided by 60.

The only problem now is the fact that seconds won't tick over to 0 after counting up to 59. They'll just keep going. So if I just used minutes and seconds as is, I'd get times like 4:257—4 minutes and 257 seconds. I needed to make sure that seconds always stay within the bounds of 0 and 59.

So I created a new variable called secondsAsPartsOfAMinute, and, inside it, I stored the remainder of seconds divided by 60. Remember, % gives you the remainder of a division problem. In other words, it gives you what's left over when you divide a big number into even chunks of 60. You can forget all those chunks, because they're already accounted for in minutes. What's left over is the extra seconds you need to show.

Finally, I output minutes and secondsAsPartsOfAMinute, separated by a colon, as the source text:

```
minutes + ":" + secondsAsPartsOfAMinute
```

There are a couple of problems here. First of all, the length of the text will keep changing, because the number of digits will change. For instance, 2:2 is only three characters long; 2:13 is four characters long. Anyway, who writes times like 2:2? We're taught to pad single-digits with a 0, like this: 2:02.

I fixed this problem by creating a function called addZeros:

```
function addZeros(rawNumber)
{
  var finalNumber;
  if (rawNumber < 10)
  {
    finalNumber = "0" + rawNumber;
  }
  else
  {
    finalNumber = rawNumber;
  }
  return finalNumber;
}
```

It's pretty simple: When you call it, you give it a number, like this: addZeros(5) or addZeros(16). That number is stored in the variable rawNumber.

Let's say rawNumber is 5. If it is, then the if will be true, because 5 *is* less than 10. So a new variable, finalNumber, will be set to "0" plus the 5.

You might be thinking that 0 + 5 is 5. But I'm not adding 0 and 5. I'm adding the string "0", which is not a number, to 5. Which gives me the string "05". In JavaScript, if you add a string to a number, the result is always a string. (As opposed to when you add two numbers together, which always results in a number.)

At the end of the function, I return finalNumber. So in this example, I'd be returning 05—5 in, 05 out.

If I call the function like this

```
addZeros(16)
```

then rawNumber will be set to 16, and the if will be false; 16 is not less than 10. So, the else section will run. finalNumber will be set to rawNumber. Because rawNumber is 16, finalNumber will be 16 too—16 in, 16 out.

This cool little function pads a number with a 0 only if the original number is less than 10.

(Incidentally, you may wonder what's going on with this statement:

```
var finalNumber;
```

It's perfectly legal to define a variable without assigning it a value. It's also not required. I could have just typed finalNumber the first time I actually had use for it. But I often like to define all my variables at the top of an Expression or

339

function. To me, it's clearer. It's like laying all your cards on the table: "Here are all the variables I'll be using, even if I'm not ready to give some of them values yet.")

In Chapter07.aep, Comp10, I rewrote my earlier counter, this time including my addZero function:

```
var seconds = Math.floor(time);
var minutes = Math.floor(seconds/60);
var secondsAsPartsOfAMinute = Math.floor(seconds % 60);
function addZeros(rawNumber)
{
  var finalNumber;
  if (rawNumber < 10)
  {
    finalNumber = "0" + rawNumber;
  }
  else
  {
    finalNumber = rawNumber;
  }
  return finalNumber;
}
addZeros(minutes) + ":" + addZeros(secondsAsPartsOfAMinute)
```

Notice that it's the same as before, except that instead of outputting

```
minutes + ":" + secondsAsPartsOfAMinute
```

I output

```
addZeros(minutes) + ":" + addZeros(secondsAsPartsOfAMinute)
```

341

In Chapter07.aep, Comp11, I rewrote the function to make it a bit more compact. Here's the old version:

```
function addZeros(rawNumber)
{
  var finalNumber;
  if (rawNumber < 10)
  {
    finalNumber = "0" + rawNumber;
  }
  else
  {
    finalNumber = rawNumber;
  }
  return finalNumber;
}
```

Here's the new version:

```
function addZeros(rawNumber)
{
    if (rawNumber < 10) return "0" + rawNumber;
    return "" + rawNumber;
}
```

Where's the else? Well, I eliminated it by utilizing a JavaScript trick. A function will quit running (and return a result) when the first return statement runs.

Let's say rawNumber happens to be 3. In that case, if (rawNumber < 3) is true, the immediately following return statement will run: return "0" + rawNumber;

The JavaScript trick I mentioned will make the function quit at that point, so the following statement—return "" + rawNumber;—will never run.

On the other hand, if rawNumber is 12, the if statement will be false, so the return statement after it won't run. In that case, the function will move onto the next statement—the second return statement—and *it* will run. Either one return will run or the other will run, never both.

If rawNumber is 10 or greater, the second return statement will run:

```
return "" + rawNumber
```

But why did I write it that way, instead of this way?

```
return rawNumber
```

After all, if rawNumber is 12, I want to just return that 12, without any extra 0. But 12 is a number. I can't return a number, because the result is going to control a Source Text property. And the source text must be a string. So I'm adding an empty string—""—to rawNumber. That converts 12 to "12".

There's still one problem with the Expression. It's always going to start with 00:00. What if I want it to start with 09:04 and then tick up from there? In fact, that's what I make it do in my final rewrite, which is in Chapter07.aep, Comp12:

```
var startingMinute = 9;
var startingSecond = 4;

var seconds = Math.floor(time) + startingSecond;
var minutes = Math.floor(seconds/60) + startingMinute;
var secondsAsPartsOfAMinute = Math.floor(seconds % 60);
function addZeros(rawNumber)

{
    if (rawNumber < 10) return "0" + rawNumber;
    return "" + rawNumber;
}
addZeros(minutes) + ":" + addZeros(secondsAsPartsOfAMinute);
```

Words from a List

A client gave me a list of foods. He wanted one word from the list to be displayed every second-and-a-half. So I whipped up this Expression, which you can see in Chapter07.aep, Comp13:

```
var food = ["eggs","bacon","cheese","soup","cake","ice ↰
cream","apples","ham"];
var rate = 1.5;
var i = Math.floor(time/rate);

if (i >= food.length)
{
    i = Math.floor(i % food.length);
}

food[i]
```

I retyped my client's list as an array called food:

```
var food = ["eggs","bacon","cheese","soup","cake","ice ↴
cream","apples","ham"];
```

Remember, you can access array items via an index. So, food[0] is "eggs" and food[2] is "cheese".

Because a new food needs to display every 1.5 seconds, I needed my index to increment like this:

```
second          index
0               0
1               0
1.5             1
2               1
2.5             2
```

Here's the code I used to achieve that result:

```
var rate = 1.5;
var i = Math.floor(time/rate);
```

I simply divided time by 1.5 and rounded the result down to the nearest whole number. I could have stopped there, using the result as is for the index. Had I done that, the Expression would have looked like this:

```
var food = ["eggs","bacon","cheese","soup","cake","ice ↴
cream","apples","ham"];
var rate = 1.5;
var i = Math.floor(time/rate);

food[i]
```

344

The only problem is that i, the index, will eventually be bigger than the number of items in the array. There are eight items in the array, and the final one's index number is 7 (because the last, food[7], is ham). What happens when i is set to 8? Food[8] doesn't exist!

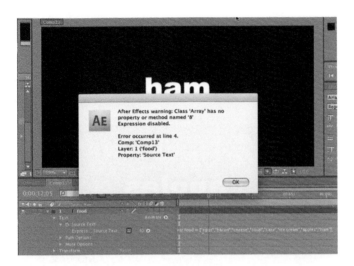

I need to deal with out-of-bounds indexes. And I need to ask myself, "What do I want to happen when the Expression reaches the last item on the list?" In this case, I decided that I wanted it to start over, displaying the first item again, and then the second, and so on. So I need i to increment like this: 0, 1, 2, 3, 4, 5, 6, 7, 0, 1, 2, 3, 4, 5, 6, 7, and so on. Here's how I kept i within those bounds:

```
if (i >= food.length)
{
   i = Math.floor(i % food.length);
}
```

If i gets bigger (or equal to) the length of the array (eight), change i so that it's equal to the remainder of itself divided by the array's length (eight). Once again, I only want what's left over.

Had I wanted the Expression to hold on the last item (ham) once it reached the end, I would have written my if statement as follows:

```
if (i >= food.length)
{
   i = food.length - 1;
}
```

food.length is 8, so food.length − 1 = 7. The final item in the array (ham) is item 7.

In Chapter07.aep, Comp14, I rewrote the Expression to make it more concise:

```
var food = ["eggs","bacon","cheese","soup","cake","ice
cream","apples","ham"];
var rate = 1.5;
var i = Math.floor(time/rate) % food.length;
food[i]
```

Secret Code

When I was a kid, I spent hours making words on my calculator. For instance, I would spell "glob" as "6108" (Stare at it long enough, and it will make sense.) What can I tell you? I was a weird kid.

Darn! The Mac calculator uses a modern font. "6108" just looks like numbers.

Years layer, on a slow day at work, I replicated my old hobby in After Effects. This time, I decided to allow some letters to stay letters. There's no good numeral equivalent for an "m", so the word moose would be m0053.

You can revert to childhood with me by checking out Chapter07.aep, Comp15:

```
var finalText = "";
var originalText = text.sourceText;
var currentChar;
var i = 0;
while (i < originalText.length)
```

```
{
  currentChar = originalText.charAt(i);
  if (currentChar.toUpperCase() =="O") currentChar = "0";
  if (currentChar.toUpperCase() =="L") currentChar = "1";
  if (currentChar.toUpperCase() =="S") currentChar = "5";
  if (currentChar.toUpperCase() =="E") currentChar = "3";
  if (currentChar.toUpperCase() =="G") currentChar = "6";
  if (currentChar.toUpperCase() =="T") currentChar = "7";
  if (currentChar.toUpperCase() =="B") currentChar = "8";
  finalText 15 currentChar;
  i ++;
}

finalText
```

I start by setting a variable called finalText to the empty string "". That's two double-quotation marks, one immediately following the other. It's the string version of setting a number variable to 0. I can now add characters onto final-Text. Had I not initialized finalText to "", I wouldn't be able to add onto it.

Next, I capture the original text (that I typed when after clicking with the Type tool) in a variable called originalText. I then start up a loop. Each time through the loop, the index i is incremented. It keeps incrementing until it's equal to originalText's length. All strings (and variables that hold strings) have a length property. The length of the string "cat" is 3. Strings also have a charAt() method. So "cat".charAt(0) is "c"; cat.charAt(2) is "t".

I capture one character of originalText in a variable called currentChar. So if originalText is "cat", the first time through the loop, i will be 0 and originalText.charAt(i) will be "c". So currentChar will be "c". The next time through the loop, i will be 1, so currentChar will be originalText.charAt(1), which is "a". The final time through the loop, currentChar will be originalText.charAt(2), which is "t". Then the loop will stop, because i ++ will make i 3, which is the length of "cat".

Whatever the value of currentChar is, it's added onto finalText. In fact, I could have written the Expression like this:

```
var finalText = "";
var originalText = text.sourceText;
var currentChar;
var i = 0;
while (i < originalText.length)
```

349

```
{
  currentChar = originalText.charAt(i);
  finalText += currentChar;
  i ++;
}

finalText
```

The only problem is that "cat" would become "cat", so this version would waste time doing nothing. It would essentially pull a letter off the word and then stick it back on, as is.

But I want to convert certain letters to numbers, so before sticking currentChar onto finalText, I run these conditionals:

```
if (currentChar.toUpperCase() ==  "O") currentChar = "0";
if (currentChar.toUpperCase() ==  "L") currentChar = "1";
if (currentChar.toUpperCase() ==  "S") currentChar = "5";
if (currentChar.toUpperCase() ==  "E") currentChar = "3";
if (currentChar.toUpperCase() ==  "G") currentChar = "6";
if (currentChar.toUpperCase() ==  "T") currentChar = "7";
if (currentChar.toUpperCase() ==  "B") currentChar = "8";
```

The third one,

```
if (currentChar.toUpperCase() ==  "S") currentChar = "5";
```

says if currentChar is an "S", make it a "5". Well, not quite. I'm using the toUpperCase() method to convert currentChar to an uppercase version of itself. All strings have a toUpperCase() method. So "cat".toUpperCase() is "CAT"; "DOG".toUpperCase() is "DOG"; "doG".toUpperCase() is "DOG"; and "DOG".toLowerCase() is "dog". I just snuck that last one in to see if you were paying attention.

My conditional is really saying "if you convert currentChar to an uppercase version of itself, is it equal to 'S'? If so, convert it to '5' instead."

Why am I converting currentChar to uppercase? Because I want both "s" and "S" to be turned into "5". My strategy is to say, "Hey, don't worry about whether the character is upper or lowercase. Just convert it to uppercase and compare it to 'S'".

Now that I've let you in on my secret code, you know too much. I'll either have to kill you, or I'll have to unleash you on some really pro-level Expressions. If you're curious to know which choice I'll make, read the next chapter!

Randomness

ANOTHER LOOK AT WIGGLE()

Up to now, we've been using wiggle() to generate all of our random numbers. I'm a big wiggle() fan, but sometimes I need more control. For instance, what if I want to generate a random Rotation between 90 and 180 degrees? It's hard to make wiggle() stay within a specific range. The range for wiggle() always starts with the property's default value.

I could get what I want, but I'd have to first set Rotation to 0. Then, I'd have to apply the wiggle() Expression as follows (Chapter08.aep, Comp1):

```
135 + wiggle(1,45)
```

Starting from a default of 0, this Expression sets Rotation to 135 plus a random number. That random number could be any number from −45 to 45. If it's negative 45, then the Expression resolves to 135 + −45. Adding a negative number is the same as subtracting a positive number, so we can rewrite the resolved Expression as 135 − 45. Which further resolves to 90.

If the random number is 45, then we get 135 + 45, which is 180.

Here's a more general formula, for keeping wiggle() within a specific range (Chapter08.aep, Comp2):

```
//make sure the property value is set to 0
var howOften = 1;
var rangeMin = 90;
var rangeMax = 180;
var rawRange = rangeMax 2 rangeMin;
var howMuch = rawRange/2;
var offset = howMuch 1 rangeMin;
wiggle(howOften, howMuch) + offset
```

The first real work this Expression does is to calculate the difference between your desired minimum and maximum values for the wiggle():

```
var rangeMin = 90;
var rangeMax = 180;
var rawRange = rangeMax - rangeMin;
```

If you keep rangeMin and rangeMax at 90 and 180, this sets rawRange to 90.

Next, the Expression divides rawRange by 2 and stores the result in howMuch. Given my example starting values (90 and 180), howMuch will be 45:

You can check this against the first Expression in this chapter:

```
135 + wiggle(1,45)
```

Now we need to generate that 135. We do that by adding howMuch (45) and rangeMin (90):

```
var offset = howMuch +
rangeMin;
```

We now have all the values we need, and we can wiggle() away, assured that the result will always stay within the desired range. Try changing rangeMin and rangeMax to see what happens.

RANDOM()

Let me introduce you to one of the most versatile random-number generators in After Effects: the random() function. One of its templates (it has several) looks like this:

```
Template: random(START_OF_RANGE, END_OF_RANGE)
```

so you can easily use it to generate a random number between 90 and 180 like this:

```
random(90,180)
```

START_OF_RANGE and END_OF_RANGE can also be arrays, as in

```
random([100,1000],[500,5000])
```

That example might spit out [323, 1040] or [189, 4577].

That's just one way to use random(). You can also call random() this way:

```
Template: random(END_OF_RANGE)
Example: random(180)
```

If you give random() just one parameter, it assumes you want values between 0 and that number. So my example would generate a number between 0 and 180.

Finally, you can call random with no parameters, like this:

```
random()
```

That generates a random number between 0 and 1, such as 0.32322 or 0.98322.

So that you can compare the results, in Chapter08.aep, Comp3, I've set the left layer's rotation to random(90,180), the middle rotation to random(90), and the right rotation to random().

 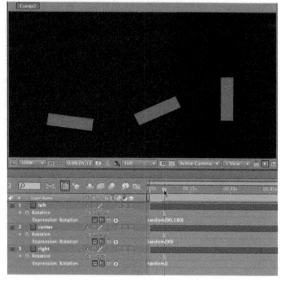

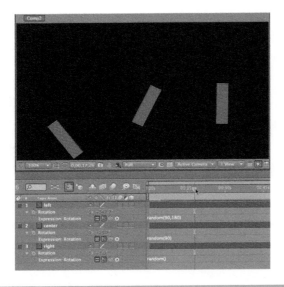

> **Note**: If you preview this Comp, you'll notice that the layers don't animate smoothly as they would with wiggle(). Instead, they frantically hop from random rotation to random rotation. Unlike wiggle(), random() doesn't autoanimate back to the default value. Random() doesn't have a HOW_OFTEN property. Its built-in HOW_OFTEN is once every frame. We'll gain more control over this behavior shortly.

355

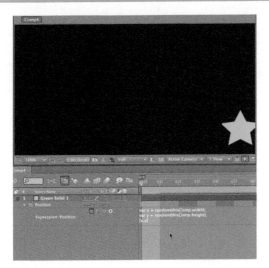

Now I want to generate a random position. If I'm working in 2D, Position needs two values: x and y. Here's one way to generate them (Chapter08.aep, Comp4):

```
var x = random(thisComp.width);
var y = random(thisComp.height);
[x,y]
```

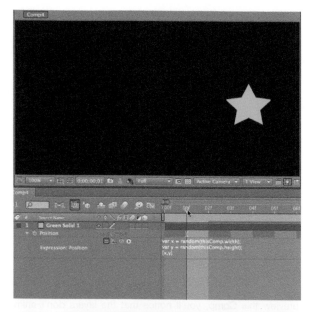

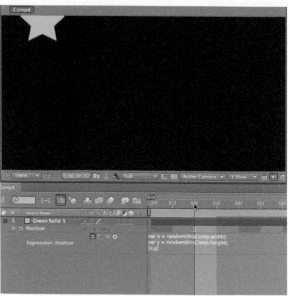

width and height are properties of thisComp. They hold (you guessed it) the width and height of the current Comp. Because I'm working in NTSC D1 (standard TV dimensions in the U.S.), my width is 720. I'm using the single-parameter version of random(), so var x = random(thisComp.width) is the same as var x = random(720). Either generates a random number between 0 and 720. I like the thisComp.width version better. It's more portable. I could paste the

Expression into a PAL (standard TV dimensions in the UK) or widescreen Comp, and it would adjust itself accordingly.

In the preceding Expression, I call random() twice, once for x and once for y. There's really no reason to do this. Here's a rewrite. It controls Position in Chapter08.aep. Comp5:

```
random([thisComp.width, thisComp.height])
```

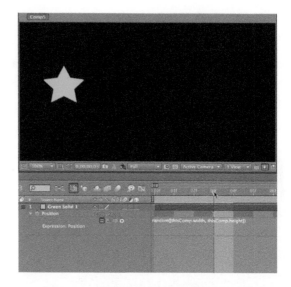

This generates random arrays between [0,0] and [720,486] (in an NTSC D1 Comp).

In Chapter08.aep, Comp6, I tighten the range to within the title-safe region by using the two-parameter version of random(): random(START_OF_RANGE,END_OF_RANGE):

```
var wMinPosition = thisComp.width * .1; //10% of width
var hMinPosition = thisComp.height * .1; //10% of height
var wMaxPosition = thisComp.width * .9; //90% of width
var hMaxPosition = thisComp.height * .9; //90% of height
random([wMinPosition, hMinPosition], [wMaxPosition,
hMaxPosition])
```

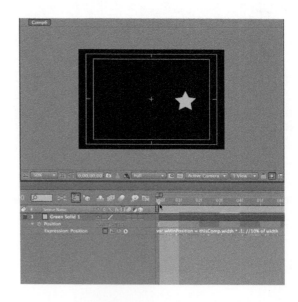

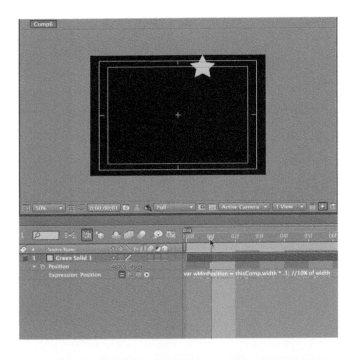

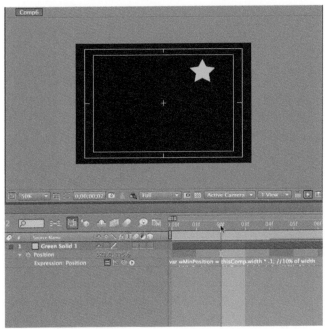

Actually, my 10%, 90% calculations won't quite work to always keep the entire layer within the safe region. My layer is 100 pixels wide. Let's say that wMinPosition

is set to 72, which is just at the 10% of width point. After Effects positions layers by their anchor points, which are (by default) at layers' centers. So my layer's center will be at 72, which means its left edge will be left of 72. Oops!

Half of my layer—the half to the left of center—is hanging out of the title-safe range. So I need to nudge the layer half its width to the right in order to keep it in the safe zone.

When layers move all the way to the right, I'll have to make the same move in reverse, nudging the layer to the left by half its width.

The revised Expression, in Chapter08.aep, Comp7, ensures the layer always stays completely in my target range:

```
var halfWidth = thisLayer.width/2;
var halfHeight = thisLayer.height/2;
var wMinPosition = (thisComp.width * .1) + halfWidth;
var hMinPosition = (thisComp.height * .1) + halfHeight;
var wMaxPosition = (thisComp.width * .9) - halfWidth;
var hMaxPosition = (thisComp.height * .9) - halfHeight;
random([wMinPosition, hMinPosition],[wMaxPosition,
hMaxPosition])
```

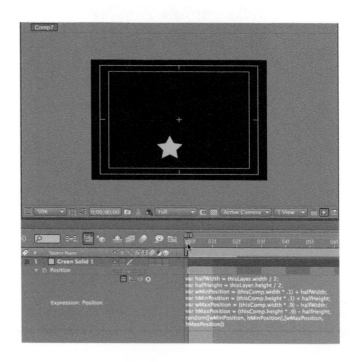

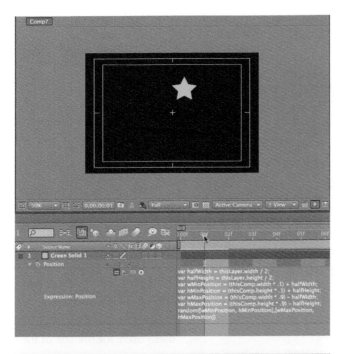

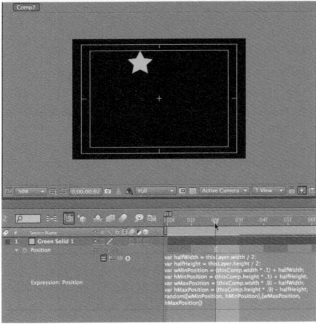

Now, I'd like to use an Expression to randomly position fish in a 3D space. It's fairly trivial to port the 2D Expressions we've used so far into 3D, as you can see in Chapter08.aep, Comp8.

First, I turned on the 3D switch and placed this Expression on one fish's Position:

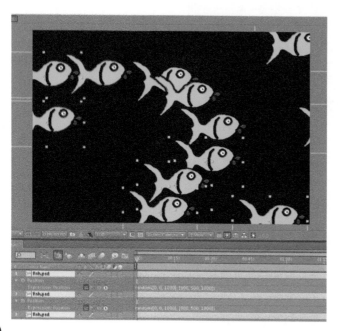

```
random([0, 0, 1000], [800, 500,
-1000])
```

Then I duplicated the layer many times, giving me a tank full of randomly spaced fish.

The trouble is, random() chooses a different random position on each frame, so when I preview, my fish look a bit over-caffeinated. Let's say my goal is still fish. If you think that's odd, imagine they're dead fish. (We'll create live ones soon enough.) How can I pick a random starting position for my fish and then hold them there for the rest of the Comp?

The answer is called seedRandom(). Its template looks like this: seedRandom (NUMBER, ALWAYS_THE_SAME). NUMBER can be any number, and we won't worry about that parameter right now. We'll just use 0. (Don't worry; I'll explain the purpose of NUMBER soon.) ALWAYS_THE_SAME is a Boolean, so it should be set to true or false. That gives us seedRandom(0,true) or seedRandom(0,false).

An ALWAYS_THE_SAME of true means "roll the dice just one time." (Or, to be more precise, because Expressions always rerun on every frame, it means "make the dice come up with the same number each time they're rolled.") So if you type seedRandom(0,true) before typing random(), the property controlled by the Expression will be randomized just once. Then it will hold at that randomly chosen value.

In other words, an ALWAYS_THE_SAME of true means that if the dice roll a 3 the first time you use them, they'll roll 3 every time you use them.

As you might guess, seedRandom(0,false) means that random() will rerandomize on each frame. But this is already the default behavior, so you'll rarely find yourself setting ALWAYS_THE_SAME to false.

In Chapter08.aep, Comp9, I added the following Expression to a fish's Position
and then duplicated the fish many times:

```
seedRandom(0,true);
random([0,0,1000], [800,500,-1000])
```

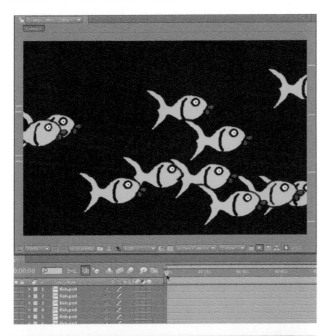

As you can see, the fish pick their random positions, and like good little stiffs, they stay there.

So what's the NUMBER parameter for? Try changing it to 1 (see Chapter08.aep, Comp10):

```
seedRandom(1,true);
random([0,0,1000], [800,500,-1000])
```

The fish all choose different random positions. As in Comp9, they hold in those positions from the first frame on. After all, ALWAYS_THE_SAME is still true (see Chapter08.aep, Comp11):

```
seedRandom(675884,true);
random([0,0,1000], [800,500,-1000])
```

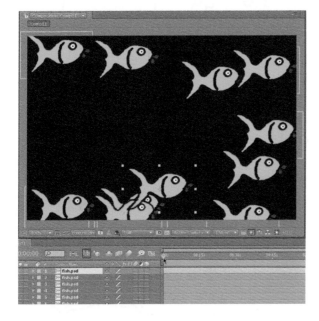

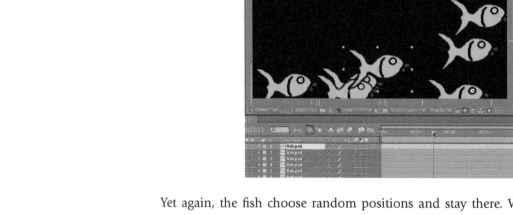

Yet again, the fish choose random positions and stay there. What's going on here? Well, imagine you have a book called *Random Numbers*. Each page of the book is filled with random numbers. Pages 0 (the page numbering in this odd book starts at 0) and 1 looks like this:

Pages 675884 and 675885 look like this:

The NUMBER in seedRandom(NUMBER, ALWAYS_THE_SAME) tells random() which "page" to get its random numbers from. If you set NUMBER to 1 and roll the dice, you'll get random numbers from page 1. If you then change NUMBER to 5, and roll the dice again you will get numbers from a different page in the book. But if you then realize that you preferred the first set of random numbers, all you have to do is set NUMBER back to 1 and roll the dice again.

One strange thing: If all the fish are using this same NUMBER—for example, in Comp11, they all have a seedRandom(675884,true)—why aren't they all in the same place? Because each layer gets its own unique book. Each layer's book has different random numbers in it. Layer 1's page 675884 has different random numbers on it than layer 2's page 675884.

Now let's say we'd like our fish to choose a new position every second (and then hold in that position until the next second). The solution is in Chapter08. aep, Comp12:

```
var changeRate = 1;
var seedNumber = Math.floor(time/changeRate);
seedRandom(seedNumber,true);
random([0,0,1000], [800,500,-1000])
```

367

For the first second, time is a fraction of 1: 0-point-this, 0-point-that. If you take 0-point-whatever and divide it by 1 (changeRate), you get 0-point-whatever. Math.floor() rounds 0-point-whatever down to 0. So for all the frames up until 1 second, NUMBER is 0 and the random numbers all come from the same page of the book—page 0.

Then, at 1 second up until 2 seconds, Math.floor(time/changeRate) resolves to Math.floor(1-point-something/1); Math.floor() rounds all 1-point-some-things-divided-by-1s down to 1. So the fish choose new random positions (from page 1 rather than 0) and stay there until, at 2 seconds, Math.floor(time/ changeRate) starts resolving to Math.floor(2-point-something/changeRate).

Okay, let's make the fish move (see the example in Chapter08.aep, Comp13):

```
Property: Position.
var startPosition;
var endPosition;
seedRandom(1,true);
startPosition = random([thisComp.width,thisComp.height])
endPosition = random([thisComp.width,thisComp.height])
ease(time, 0, 5, startPosition, endPosition)
```

After defining two variables, startPosition and endPosition, the Expression flips the randomSeed "book" to page 1. It uses the first page 1 value to grab a random starting position for the layer. It then uses the second page 1 value to grab another value for the ending position.

Note that the seedRandom() functions sets ALWAYS_THE_SAME to true. If ALWAYS_THE_SAME were false, the Expression would choose new start and end positions on every frame! We don't want that. We want the fish to choose one starting position, one ending position, and then to spend 5 seconds scooting from that start to that end.

After choosing starting and ending positions, the Expression uses our old friend Ease to move the fish.

> **Note**: To get the fish to face the direction it's moving, I cheated and, with the layer selected, chose Layer > Transform > Auto-orient.

NOISE()

The Noise() function generates Perlin Noise, a sort of pseudo-randomization invented by computer scientist Ken Perlin. Perlin's equation lurks under the

hood of many computer-generated effects, including AE's Fractal Noise effect. It was used in the movie *Tron*, for which Ken Perlin won an Academy Award for Technical Achievement. Now you have access to it in your Expressions!

Note that noise(SOME_NUMBER) spits out a number between −1 and +1. So, for instance, noise(5) might spit out −1, 0.3493, 0.989, or 1. But noise(17) might spit out those numbers too. I'll explain the point of the SOME_NUMBER parameter in a moment, but remember that no matter what number you give it, noise will only spit out numbers in a range of −1 through +1.

You can see noise() in action in Chapter08.aep, Comp14.

Here, I've created four type layers and added Expressions to their Source Text properties: The top layer's text is controlled by noise(5), text for the next layer down is controlled by noise(42), text for the following layer is controlled by noise(5000), and text for the bottom layer is also controlled by noise(5000).

As you can see, the bottom two layers share the same text: same SOME_NUMBER, same output. As you can also see, noise() doesn't change its values once they're set. I can scrub the CTI to any point in time, and the Source Text property always looks the same.

To get noise() to output different values on each frame, you have to give it different SOME_NUMBERs on each frame, which is what I've done in Chapter08. aep, Comp15:

In this Comp, I've added time (which is different on each frame), to SOME_NUMBER:

374

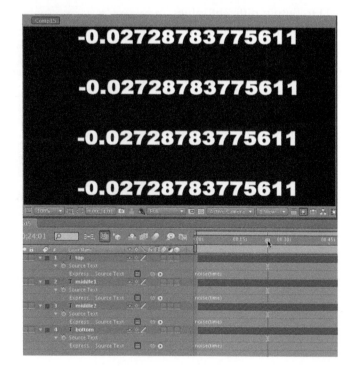

Note: The numbers with "e" in them are using Scientific Notation. It's a compact way of expressing large numbers.

As you can see, because time is the SOME_NUMER for the layers, all the layers have the same source text, but that text does change as the CTI moves forward. The moral is that to make noise both different on every frame and different on every layer, you need to give it a different number on every layer, and that number has to change on every frame.

In Chapter08.aep, Comp16, the Source Text Expressions are noise(time+1), noise(time+2), noise(time+3) and noise(time+4).

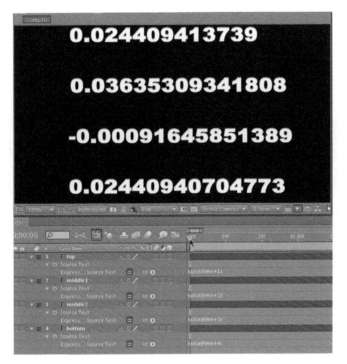

Here's a pop quiz for you: Can you think of a way of making the noise() Expression the same on all layers and yet getting different numbers for each layer?*

*Give each layer's Source Text the Expression noise(time+ index). Since index (the index number of the layer) is different for each layer, the noise will be different for each layer. See Chapter08, Comp17 for an example.

But the wonderful thing about noise() is that if you give it two similar inputs (two similar SOME_NUMBERs), the two outputs will also be similar—not identical, but similar. This can be really useful for physical simulations, such as wind blowing on grass. The wind should affect each blade of grass differently—but not all *that* differently.

In Chapter08.aep, Comp18, I've added a single blade of grass to the bottom of the Comp. Using the Pan Behind tool, I moved its anchor point to its bottom, so that when it rotates, it will pivot around its bottom edge.

I then added this Expression to its Position:

```
seedRandom(1,true);
[random(thisComp.width), value[1]]
```

Then I duplicated the blade many times.

I'm choosing random numbers from "page" 1 and making sure those numbers always stay the same. Then I'm setting the x Position to a random number between 0 and the width of the Comp. I'm setting the y Position to what it already is (I want the grass to stay at the bottom of the Comp, where I dragged it). Instead of value[1], I could have kept the y Position static with `transform.position[1]` or a hard-coded value, such as 450.

That's great, as long as I'm happy with static grass.

In Chapter08.aep, Comp19, I've added the same Expression to Position. But now I've also added this Expression to Rotation:

```
noise(time + transform.position[0]) * 45
```

Let's pick that Expression apart: `transform.position[0]` means the current value of x Position (as set by the Expression on Position). Since `transform.position[0]` is being randomized by an Expression, it's a different number for every layer. That means noise will be different for every layer. So Rotation will be different for every layer.

But two blades of grass that are close to each other will have similar x-position numbers. Let's say one blade has an x of 10 and another has an x of 12. Their Expressions resolve to noise(time + 10) and noise (time + 12). Because noise() randomizes similarly when given similar inputs, those two layers will be rotated similar (but not identical) amounts. The idea here is that if wind is blowing on grass, blades that are near each other will be blown in similar ways.

Looking at the Expression, again, it's noise(SOME_NUMBER) * 45. Why am I multiplying the result of noise() by 45? Because, remember, noise() outputs really small numbers: numbers between −1 and positive +1. If I let such numbers control Rotation, the grass will barely move. So I'm using * 45 to amplify the effect. (I chose 45 via trial and error. Try other values.)

I'm calling noise() like this noise(time + SOMETHING). Because time changes on every frame, using time as an input to noise() ensures that noise() will spit out a different value on every frame.

Let's say I didn't add the SOMETHING to noise. Let's say the Expression was just noise(time) * 45.

You can see the result in Chapter08.aep, Comp20. In that Comp, I duplicated the blade of grass several times. As you can see, time is making noise() spit out different values on each frame. But because time is the same for all layers, each blade is rotating exactly the same way each other blade rotates.

What if I just use x Position? What if I leave out time? You can see what happens in Chapter08.aep, Comp21:

```
noise(transform.position[0])* 45
```

Rotation *is* different for each layer, because `transform.position[0]` is different for each layer (it's randomized via an Expression). But each layer's transform.position[0] stays the same for all frames. So each layer's noise() is getting the same input on all frames.

Indeed, each layer is rotated in a slightly different manner from its neighbors, but it stays at that rotation for the entire Comp. There's no movement at all.

That's because each layer's noise() is always getting the same SOME_NUMBER—in this case, the layer's x position.

ONE LAST LOOK AT WIGGLE()

Our old friend wiggle() has a few more tricks up its sleeve. Remember those extra, rarely used parameters?

```
wiggle(freq, amp, octaves = 1,amp_mult = .5)
```

I've already translated "freq" and "amp" into the more user-friendly HOW_OFTEN and HOW_MUCH. Keeping with tradition,

```
octaves translates to HOW_MUCH_EXTRA_DETAIL.
```

```
amp_mult translates to HOW_CRAZY_IS_THE_EXTRA_DETAIL.
```

To show these two parameters at play, I've animated the Write-on effect in Chapter08.aep, Comp22.

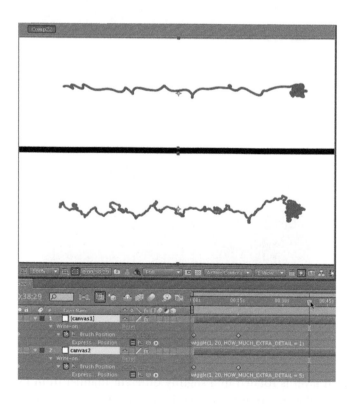

At the top, I animated Brush Position without any Expression. Below that, I copied the same animation and added this Expression:

```
wiggle(1, 20, HOW_MUCH_EXTRA_DETAIL = 1)
```

Below that, so you can see the difference, I copied the animation again, changing the Expression to

```
wiggle(1, 20, HOW_MUCH_EXTRA_DETAIL = 5)
```

Note that the "HOW_MUCH_EXTRA_DETAIL" text is optional. These Expressions all do the same thing:

```
wiggle(1, 20, HOW_MUCH_EXTRA_DETAIL = 5)
wiggle(1, 20, 5)
wiggle(1, 20, octaves = 5)
wiggle(1, 20, banannas = 5)
```

You could even write it this way:

```
var detailAmount = 5;
wiggle(1, 20, detailAmount)
```

In Chapter08.aep, Comp23, I contrast

```
wiggle(1, 20, 5, HOW_CRAZY_IS_THE_EXTRA_DETAIL = .5)
```

with

```
wiggle(1, 20, 5, HOW_CRAZY_IS_
THE_EXTRA_DETAIL = 1)
```

Again, the all-caps text is optional. You could subdue it to

```
wiggle(1, 20, 5, amp_mult = 1)
```

or even

```
wiggle(1, 20, 5, 1)
```

Now, if you're using wiggle() to make a layer wander around the Comp, you can control whether it drank two gin and tonics or just one; you can even control the ratio of gin to tonic!

381

CHAPTER 9
Physical Simulations

With Expressions, you can easily animate bounces, jiggles, and bumps. In this chapter, that's just what we'll be doing. Most of the Expressions here build on concepts I've already explained, such as sine and cosine. I won't repeat those explanations here. Rather, I'll show you how to set up the Expressions, note key details, and suggest a few variations you can try.

In the following Expressions, I'll list variables at the top, followed by a double space, followed by code that uses the variables. The top variables are for you to play with. Please have fun changing their values, previewing, and watching how your new values alter the way the Expressions work.

> **Note:** In some cases, I've converted the Expressions to keyframes. I've done this just to make the illustrations in this book clearer. With keyframes, you can see motion paths in the Comp window.

ORBITS

- Example Comp: Chapter09.aep, Comp1.
- Setup: Add two layers, Sun and Earth.
- Expression on Earth's Position:

```
var center = thisComp.layer("sun").transform.position;
var distanceX = 100;
var distanceY = 150;
var orbitSpeed = 2;
center + [Math.sin(orbitSpeed * time)*distanceX, -Math.⮑
cos(orbitSpeed * time)*distanceY];
```

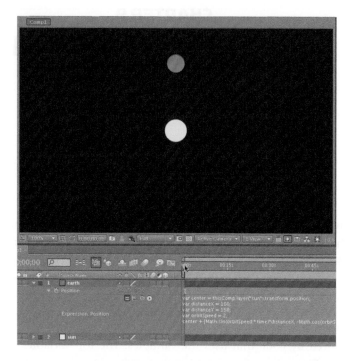

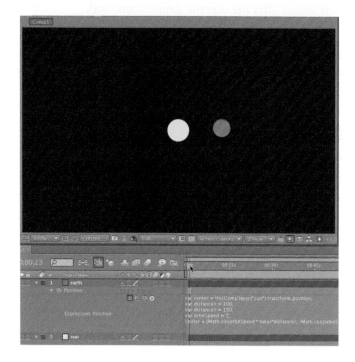

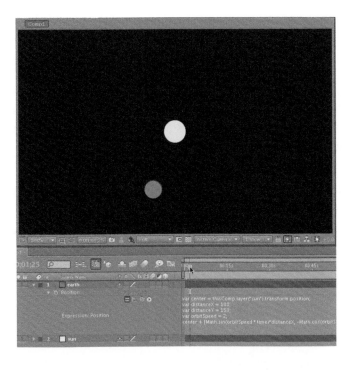

> **Note:** If you want Earth to rotate in a perfect circle (instead of an ellipse), set distanceX and distanceY to the same value.

Originally, I called one of the variables "speed". That confused After Effects, because there's a built-in property called "speed". This means "speed" is a reserved word. You shouldn't use it as a variable name. Same with "velocity". That's why I used "orbitSpeed" instead.

- Variations:
 1. [Chapter09.aep, Comp1a] For a "drunk" effect (maybe useful for a bee buzzing around a flower), add randomness to the orbit:

    ```
    var centerX = thisComp.layer("sun").transform.↴
    position[0];
    var centerY = thisComp.layer("sun").transform.↴
    position[1];
    var distanceX = 100;
    var distanceY = 150;
    var orbitSpeed = 2;
    var randomMax = 10;
    [centerX , centerY] + [Math.sin(orbitSpeed * time) ↴
    *distanceX, —Math.cos(orbitSpeed * time)*distanceY] +↴
    random([randomMax, randomMax]);
    ```

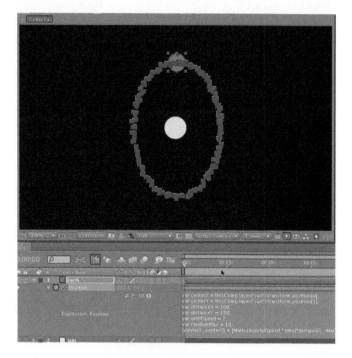

2. [Chapter09.aep, Comp1b] Or, you can try a spiral:

```
var pivotX = thisComp.layer("sun").transform.↴
position[0];
var pivotY = thisComp.layer("sun").transform.↴
position[1];
var distanceX = 200;
var distanceY = 250;
var orbitSpeed = 2;
var spiralSpeed = 2;
distanceX = distanceX - (time * spiralSpeed);
if (distanceX < 0) distanceX = 0;
distanceY = distanceY - (time * spiralSpeed);
if (distanceY < 0) distanceY = 0;
[pivotX , pivotY] + [Math.sin(orbitSpeed * time) ↴
*distanceX, -Math.cos(orbitSpeed * time)*↴
distanceY]
```

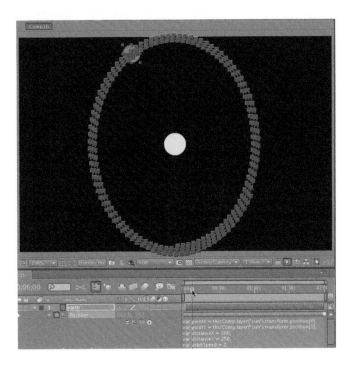

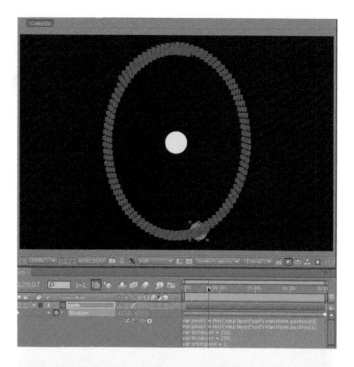

BOUNCES

- Example Comp: Chapter09.aep, Comp2.
- Setup: Add two layers, ball and floor. Position the ball so that it's resting on the floor.
- Expression on Ball's Position:

```
var bouncesPerSecond = 1.5;
var bounceStrength = 200;
var decayRate = .5;
var floor = thisComp.layer("floor").transform.⤷
position[1];
var bounceOffset = Math.abs(Math.cos(bouncesPerSecond ⤷
* time * 2 * Math.PI));
var y = bounceStrength * bounceOffset/Math.exp(decay⤷
Rate * time);
floor = floor - (height/2);
[position[0], floor] - [0,y]
```

Note: As you may recall, Math.cos() generates values between 1 and negative −1. By wrapping a cosine inside Math.abs(), we guarantee the resulting value will be positive. This means that instead of generating numbers between 1 and −1, we'll be generating numbers between 1 and 0. So bounceStrength (the full height of the bounce) will either be multiplied by 1 (in which case the ball will be as far above the floor as it can get), 0 (in which case the ball will be on the floor) or somewhere in between.

- Variations:

 1. [Chapter09.aep, Comp2a] Keyframe-animate the ball moving from left to right (or right to left) so it travels horizontally while it bounces up and down.

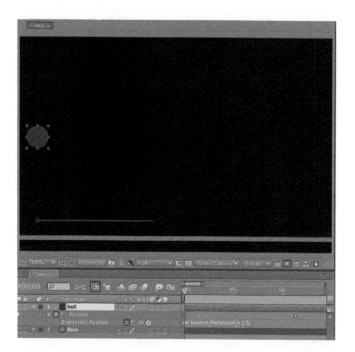

394

2. [Chapter09.aep, Comp2b] Animate the ball's X position within the Expression, so that it naturally stops traveling horizontally when it stops bouncing:

```
var bouncesPerSecond = 1.5;
var bounceStrength = 200;
var decayRate = .5;
var floor = thisComp.layer("floor").transform.↴
position[1];
var startX = 100;
var endX = 600;
var bounceOffset = Math.abs(Math.cos(bouncesPerSecond ↴
* time * 2 * Math.PI));
var y = bounceStrength * bounceOffset/Math.↴
exp(decayRate * time);
var x = ((endX-startX) - (endX-startX)/Math.↴
exp(decayRate * time)) + startX;
floor = floor - (height/2);
[x, floor] - [0,y]
```

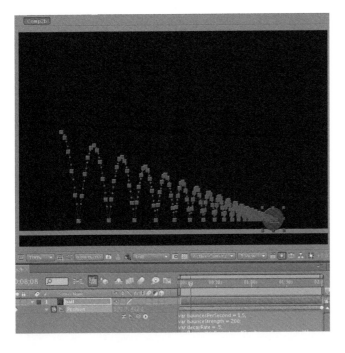

3. [Chapter09.aep, Comp2c] Because bounce and decay calculations are based on time, they'll get messed up if you start the ball layer later than 00;00;00;00. For instance, the decay will be too far advanced at the beginning. You can solve this problem by calculating time from the layer's in-point, rather than from the beginning of the Comp. The Expressions language gives us the handy property inPoint, which holds the time when the layer starts:

```
var bouncesPerSecond = 1.5;
var bounceStrength = 200;
var decayRate = .5;
var floor = thisComp.layer("floor").transform.
position[1];
var startX = 100;
var endX = 600;
var timeOffset = time - inPoint;
var bounceOffset = Math.abs(Math.cos(bouncesPerSecond *
timeOffset * 2 * Math.PI));
floor = floor - (height/2);
y = bounceStrength * bounceOffset/Math.exp(decayRate *
timeOffset);
```

```
x = ((endX-startX) - (endX-startX)/Math.exp(decayRate *
timeOffset)) + startX;
[x, floor] - [0,y]
```

JIGGLES

Here's a simple "squash and stretch" jiggle you can add to any layer:

- Example Comp: Chapter09.aep, Comp3.
- Setup: Create a single Jello layer. Move its anchor point to its bottom edge.
- Expression on Scale:

```
var maxJiggleAmount = 20;
var jiggleSpeed = 15;
var decayRate = 1.2;
var x = transform.scale[0] + maxJiggleAmount * Math.⤵
sin(jiggleSpeed * time)/Math.exp(decayRate * time);
var y = transform.scale[0] * scale[1]/x;
[x,y]
```

- Variation:

[Chapter09.aep, Comp3a] As with bouncing, you may want to replace all time-based calculations with ones based on the layer's in-point:

```
var maxJiggleAmount = 20;
var jiggleSpeed = 15;
var decayRate = 1.2;
var timeOffset = time - inPoint;
var x = transform.scale[0] + maxJiggleAmount * Math.
sin(jiggleSpeed * timeOffset)/Math.exp(decayRate * timeOffset);
var y = transform.scale[0] * scale[1]/x;
[x,y]
```

BOUNCE AND JIGGLE

When balls bounce, they squash as they hit the floor. The amount they squash depends on the hardness of the ball and the floor and how fast the ball is traveling. It's a bit tricky to forge a bounce/jiggle Expression, because you don't want the ball to jiggle until it hits the floor. If you just add the jiggle Expression (shown earlier), the ball will jiggle as it's falling, before it hits the floor, and that will look odd.

Here's a bounce-jiggle Expression I stole from Dan Ebberts's endlessly useful site, www.motionscript.com. Combine it with the bounce Expression from earlier in this chapter, and you'll get a highly realistic simulation:

- Example Comp: Chapter09.aep, Comp4.
- Setup: Once again, a ball and a floor—the ball resting on the floor.
- Expression on Ball's Position:

```
var bouncesPerSecond = 1.5;
var bounceStrength = 200;
var decayRate = .5;
var floor = thisComp.layer("floor").transform.position[1];
var startX = 100;
var endX = 600;
var bounceOffset = Math.abs(Math.cos(bouncesPerSecond *
time * 2 * Math.PI));
var y = bounceStrength * bounceOffset/Math.exp(decayRate *
time);
var x = ((endX-startX) - (endX-startX)/Math.exp(decay
Rate * time)) + startX;
floor = floor - (height/2);
[x, floor] - [0,y]
```

400

■ Expression on Ball's Scale:

```
var freq = 1.5; // make sure this matches ⤵
bouncesPerSecond, above
var squashFreq = 4.0;
var decay = 5.0;
var masterDecay = 0.4;
var amplitude = 25;
delay = 1/(freq*4);
if (time > delay)
{
  bounce = Math.sin(squashFreq*time*2*Math.PI);
  bounceDecay = Math.exp(decay*((time - ⤵
  delay)%(freq/2)));
  overallDecay = Math.exp(masterDecay*(time - delay));
  x = scale[0] + amplitude*bounce/bounceDecay/⤵
  overallDecay;
  y = scale[0]*scale[1]/x;
  [x,y]
}
  else
  {
    scale

  }
```

401

SWAYS AND UNDULATIONS

Let's say you want to simulate a boat riding on a wave or a rubber ducky bobbing up and down in a tub. The following Expressions are great for gentle swaying motions:

- Example Comp: Chapter09.aep, Comp5.
- Setup: One layer, a boat.

■ Expression on Position:

```
var waveHeight = 30;
var wavesPerSecond = .3;
var waveSpeed = 150;
var wavelength = waveSpeed/wavesPerSecond;
var xOffset = ((transform.position[0] % wavelength)/
wavelength) * 2 *
Math.PI;
var y = waveHeight * Math.sin(2 * Math.PI * wavesPer
Second * time + xOffset);
transform.position + [0,y]
```

■ Expression on Rotation:

```
var wavesPerSecond = .3;
var waveSpeed = 150;
var damping = 15;
var wavelength = waveSpeed/wavesPerSecond;
var xOffset = ((transform.position[0] % wavelength)/
wavelength) * 2 * Math.PI;
var rotationAmount = Math.atan(Math.cos(2 * Math.PI *
wavesPerSecond * time + xOffset));
radiansToDegrees(rotationAmount)/damping;
```

403

Note the variable xOffset in both Expressions. It's calculated using the layer's original x-position value. This allows variations, as follows:

- Variations:

 1. [Chapter09.aep, Comp5a] Duplicate the boat three times, dragging each duplicate to a different horizontal position. Because the xOffset calculation takes each layer's x position into account, each layer will realistically ride a different part of the wave.

2. [Chapter09.aep, Comp5b] It would be nice to see the wave, wouldn't it? You can create three wave layers, positioning each one below a different boat. Make sure the waves slightly overlap their boats' bottoms, covering just a bit of each boat, so it looks like the boats are in the water. Finally, parent each wave to its boat, so the boat is the parent and the wave is the child.

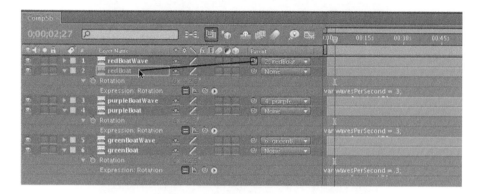

3. [Chapter09.aep, Comp5c] The same technique works equally well with
a sea monster. Instead of boats, you can use upside-down, U-shaped,
neck segments. In the example, the head is an embedded Comp
[Chapter09.aep, MonsterHead]. The eyes and mouth are randomized via
Expressions you've seen in earlier chapters.

COLLISION DETECTION

If you want to know if two circular layers are colliding, you need to first calculate how close they can get to one another without touching. This is actually pretty simple: You find the widths of both circles, add them together, and divide by 2.

Here's a little function that does just that, returning true if the circles are colliding and false if they're not:

```
function circleCollisionTest(circle1,circle2)
{
  var minDistance = (circle1.width + circle2.width)/2;
  if (length(circle1.position, circle2.position) <=
  minDistance)
```

➐

```
   {
      return true;
   }
   else
   {
      return false;
   }
}
```

I decided to use this function in a Comp with five circles all milling about at random. If any two circles touch, I want their opacity to dim to 50%. Here's the solution:

- Example Comp: Chapter09.aep, Comp6.
- Setup: Create one circular layer, adding a wiggle() Expression to its Position property. I used wiggle(1,400).

After adding the following Expression to the layer's Opacity property, duplicate the layer four times. (Make sure you duplicate the layer *after* typing the Expression so that all the duplicates have copies of it on their Opacity properties.)

- Expression on Opacity:

409

```
var myOpacity = transform.opacity;
var totalLayers = thisComp.numLayers;
var otherLayer;
function circleCollisionTest(circle1,circle2)
{
    var minDistance = (circle1.width + circle2.width)/2;
    if (length(circle1.position, circle2.position) <= ⮬
    minDistance)
    {
        return true;
    }
    else
    {
        return false;
    }
}
for (var i = 1; i <= totalLayers; i++)
{
    if (i != index)
    {
        otherLayer = thisComp.layer(i);
        if (circleCollisionTest(thisLayer, otherLayer) == ⮬
        true)
```

```
                    {
                        myOpacity = 50;
                        break;
                    }
                }
            }
        myOpacity
```

> **Note:** The Expression loops through all layers, doing nothing when the loop hits the current layer. (It would be stupid to test if a layer is colliding with itself.)

The loop potentially calls the circleCollisionTest() function once for each other layer. But the "break" statement stops the loop after circleCollisionTest() detects a collision. After all, if circle A is colliding with circle B, who cares whether or

not it's also colliding with circle C. If it's colliding with *any* other circle, I want to dim its opacity.

By the way, the word "thisLayer" in circleCollisionTest (thisLayer, otherLayer) is a special property that's built into the Expressions language. It means "this layer"—the layer that the Expression is on. So each time through the loop, I'm testing to see if the layer with the Expression is colliding with one of the other layers.

Actually, all layers have a copy of the Expression. Each layer thinks of "thisLayer" as itself, the same way that you and I can both say "me" and mean ourselves. Each layer tests to see if itself (thisLayer) is colliding with the other layers:

■ Variation:

Of course, not all layers are circular. Testing collisions between irregularly shaped layers is possible but not easy. Luckily, Dan Ebberts comes to the rescue again. This time, I won't give you his code here. Part of becoming an Expressions master involves venturing out onto the wild, wild Web and finding other people's Expressions. But I'll give you a hint: www.motionscript.com/design-guide/collision.html.

Dan's site will get you started as you stretch your imagination and skill set beyond what I've shown you in this book. But if you're interested in physical simulations, the sky is the limit. You can get as involved as you want. At some point, should you want to go beyond the basics, you'll need to learn some trigonometry and physics.

411

I recommend Keith Peters's book, *Actionscript Animation*. It was written for Flash developers, but Flash's language (Actionscript) is an offshoot of JavaScript. You'll feel a bit like an American reading a British novel—sometimes you'll have to translate pounds to dollars, but the basic concepts are the same. And maybe Peters will suck you into the world of Flash. If you enjoy making animations with code, After Effects is a good launching pad, but Flash is your home planet. But no matter what planet you're from, JavaScript is the universal language.

For more Expressions, check out these sites:

http://forums.creativecow.net/forum/adobe_after_effects_expressions

http://www.mographwiki.net/After_Effects_expressions_library

http://aenhancers.com/

http://www.colinbraley.com/tutorials.html

http://toolfarm.stores.yahoo.net/afefexb1bu.html

http://jjgifford.com/expressions/

http://livedocs.adobe.com/en_US/AfterEffects/8.0/ (Click Expressions in the right-hand frame.)

http://aeportal.blogspot.com/2007/08/scripts-galore-and-as-panels-in-ae-cs3_25.html

Index

417

Printed and bound by CPI Group (UK) Ltd, Croydon, CR0 4YY

21/10/2024

01777057-0002